DEAD AIR

Nancy,
I cherish our
long-running friendship,
cemented over piles of books!
Lots of love,
Beth

DEAD AIR

The Disappearance of Jodi Huisentruit

BETH BEDNAR

BEAVER'S
POND
PRESS

Photos provided by the Huisentruit family collection.

ISBN 10: 1-59298-392-8
ISBN 13: 978-1-59298-392-6
e-book: 978-1-59298-409-1

Library of Congress Catalog Number: 2011925866

Printed in the United States of America.

First Printing: 2011

15 14 13 12 11 5 4 3 2 1

Cover and interior design by James Monroe Design, LLC.

Beaver's Pond Press, Inc.
7104 Ohms Lane, Suite 101
Edina, MN 55439–2129
(952) 829-8818
www.BeaversPondPress.com

To order, visit www.BeaversPondBooks.com
or call (800) 901-3480. Reseller discounts available.

To the past:
Joe and Alex
". . . memory is more indelible than ink."

To the present and future:
Donn, Brit, and Marilyn
with love and gratitude

Contents

AN OPEN LETTER TO THE PERSON(S) RESPONSIBLE FOR THE ABDUCTION OF JODI HUISENTRUIT:

Rest assured, I do not know who you are (although I wish I did). To this date, you remain unnamed and uncharged in connection with this case, and no information contained herein will likely change that.

I am merely the reporter. This book represents a compilation of facts and conjecture collected about Jodi and her disappearance in 1995. It draws from numerous items that make up the public record, items available to anyone who chooses to seek them out. It also contains objective and subjective observations, speculation, and opinions put forth by many who knew Jodi, as well as those who were involved in the investigation into her disappearance. If I have unwittingly uncovered the truth or elements of the truth in telling this story, it might be appropriate under the circumstances to quote the time-honored phrase, "Don't shoot the messenger." I do not lie in wait to expose you.

And a word to my other readers:

If, upon reading this work, you realize that you have any information that could lead to a fresh look or a resolution to this old case, I encourage you to contact the Mason City Police Department, the Iowa Division of Criminal Investigation, or the Federal Bureau of Investigation.

"After all, the eleventh commandment (thou shalt not be found out) is the only one that is virtually impossible to keep in these days."

—Bertha Buxton, *Jenny of the Princes*

FOREWORD

by Don Shelby

Those of us who have had the great privilege of reporting and anchoring television newscasts belong to a very small club. As much as television is a part of our culture today, TV is only in its adolescence. So, there have been relatively few of us who have made a career out of reading the news over this ubiquitous household appliance. And, we have been the lucky ones. Lucky to have worked in such an exciting industry, and lucky to have had the opportunity to give audiences what is referred to as the "first draft of history."

I spent 45 years on the air and always understood how fortunate I was to find a job I loved, and to have been trusted to read some extremely tough lines. As my glass began to run low, I began to reflect on another element of our good fortune. While nightly reporting the most ghastly tragedies with too many victims, it occurred to me that I had never been one of them. My house never burned down. My child wasn't shot to death. No one I knew was ever kidnapped or raped. I didn't lose my life savings in a Ponzi scheme. I didn't lose a limb to an improvised explosive device. Yet, night after night, we behind the desk, told stories about others who had suffered life's worst. Whatever insult to humanity we reported, it was an inescapable fact that it always happened to someone else.

Maybe that is why Jodi Huisentruit's disappearance and presumed death hit so close to home. She was one of us. And, when she was taken from the parking lot outside her apartment in Mason City, Iowa it struck us all as tragic and awful and frightening. It also lets us know the cold reality that, we the reporters, have always been as vulnerable as those countless victims on whom we had been calmly reporting.

Beth Bednar, the author of this book about Jodi and the crime, knows exactly what I'm talking about. As you read these pages, you will know why Beth understands Jodi's case so well. You will learn why Beth cannot ever let the image of the morning of June 27, 1995 fade from her memory.

The only thing worse than a kidnapping and killing, is an unsolved kidnapping and killing, and with Jodi's case, the gnawing uncertainty of how she died, and if she died. The law says one thing. The imagination says another. Beth Bednar is haunted by Jodi's disappearance, and she has sought for years to understand what happened, and who might have been responsible. You will be given some clues in this book, but the answer we all seek is still out there—undiscovered.

Beyond her drive to find the person or persons responsible for Jodi's disappearance is Beth's dedication to keeping Jodi's memory alive, and to bring a young woman, gone these 16 years, to life again in these pages. You will like Jodi. You will like her innocence and naiveté. You will like her spunk and her dreams. You will find yourself, parent-like, saying, "Jodi, don't do that." Jodi Huisentruit will become for you, thanks to Beth Bednar, a complete, fragile, complicated and vulnerable three-dimensional woman. That means you will see Jodi in another dimension than simply the frame of a television screen.

Everyone who watched her thought they knew her. Many felt, without any base in reality, that she was a friend—a member of the family. One person claimed a fatal ownership. Who was that person? Will we ever know?

There is only one thing that drives a journalist. It is curiosity. The best journalists can't sleep nights with questions unanswered banging off the insides of their heads. I know reporters who keep a laptop by their beds and wake up three or four times a night to Google answers to questions that weren't there when they went to sleep. Curiosity is what has driven Beth Bednar to write this book.

I speak from some experience—she will spend the rest of her life trying to find answers. Someone out there knows the truth. It is the reporter's job to keep seeking it. Beth will never stop looking.

SECOND FOREWORD

by Doug Merbach

I knew there was a book to be written. I thought at one time I might be the author. But as the years passed, so did that idea. Would I need to devote too much time? Would I need to spend too much emotional energy? Did I really want to relive such an awful crime again and again, as any good reporter would have to do to get the absolute, complete story?

But Jodi's story was no "one-day wonder." That's what we called certain stories in the newsroom. These were the kind for which you got the idea in the morning, made your contacts, then went out and shot your interviews and b-roll. Back to the TV station to write and edit and put the finished story on the air for the six o'clock news. A one-and-a-half-minute video masterpiece!

But not Jodi's story. Not this time.

When Beth Bednar called to tell me she was working on a book about Jodi and her disappearance, I thought "Great, it's about time." But, at the same time, old suspicions came to the surface. As the person who hired Jodi to come to Mason City as the morning anchor at KIMT, I had seen too many people try to use the event of her abduction for their own agenda: TV stations hyping ratings, private investigators looking to get their name out there to drum up

business, or even the so-called psychics boosting their egos and name recognition with all kinds of crazy theories.

I knew Beth as someone I used to compete against. I was at KIMT in Mason City while she was at KAAL in Austin. Different cities, different states, same television market. Beth was the main anchor for all those years through the 1980s and '90s while I was a news reporter, sports director, and later news director across the border in Mason City. Beth was a local institution on the Minnesota side of the market. Then, after twenty-five years in broadcasting, I was back in television, working at Beth's former station after a seven-year sidetrack as an insurance agent.

The call came and we scheduled a time to sit down to talk. Beth told me that she was working on a book about Jodi's disappearance, with the help of former KAAL news director Gary Peterson. We talked for several hours that day, and it was after only several minutes that the suspicions I had melted away.

Many people have tried to report Jodi's story. Few got it right. Caroline Lowe at WCCO-TV in Minneapolis was one who got it right, and so was Elizabeth Vargas of ABC's *20/20*. Maybe it took the perspective of a female television news reporter to make it real, to engage a level of empathy known only by those who walked in Jodi's shoes.

I could tell after talking to Beth that she would get it right, too. I knew from our conversation that she really cared and that she (and Gary) had done an incredible amount of background work. Hard work replaced the hyperbole and hypotheses I had seen in so many other stories about Jodi.

Maybe it had to take someone who had worked in a small-market TV station, a hometown girl who was loved by her hometown audience. This describes Jodi and I'm sure it also describes Beth.

Except Beth is a survivor. Jodi was a victim.

Not many days go by where I don't wonder what happened to Jodi. Why can't this crime finally be solved? With all of the forensic

files and cold cases that seemed to get solved in *48 Hours* on TV, why can't *this* crime against Jodi have a resolution once and for all?

Maybe this book will help in that direction. If not, it still helps us remember Jodi—not Jodi as a victim, but as a vibrant, talented young woman with her future still ahead of her, a woman whose dreams of being a television news anchor had just come true.

PROLOGUE

This may come as radical information to some younger people, but women didn't anchor television news broadcasts in any real numbers until the mid-1970s. Before that, in the days of television giants like Walter Cronkite, Chet Huntley, and David Brinkley, the gravitas or dignity provided by an older man was viewed as preferable for the delivery of weighty news. Lower-pitched male voices were deemed to be more believable and credible, so the general consensus at the time was that a woman could not adequately project the authority necessary to anchor a news broadcast. This attitude prevailed, despite the fact that women had long before infiltrated the ranks of print journalism.

But in the 1970s, in the wake of the burgeoning women's movement and the Equal Rights Act, all that began to change when the Federal Communications Commission (FCC) mandated that local stations around the United States put more women on the air. I was fresh out of college in that heady time, and despite the changes making their way onto television screens, my mentors, instructors, and bosses still encouraged me to keep the pitch of my voice lower (i.e., more masculine) when I snared my first professional job on TV.

I became a weather girl! And contrary to what some might believe, I made the salary of a pauper.

In those days, one didn't have to be a meteorologist to present

the weather on TV—one simply had to be able to walk and talk at the same time. It was also helpful if one could manage to look reasonably attractive while doing so. I filled the bill. I could walk and talk and still look fairly presentable, all at the same time.

So I borrowed a couple of books from the local library (keep in mind that these were pre-Internet days) and crammed my brain full of facts about cold fronts, high-pressure systems, and what a dropping barometer meant. After that, I was eminently qualified (!) and ready to make the most of it.

That was my entry into the rarefied world of TV news. In the beginning, relating weather conditions and the forecast to the television audience on the local six and ten o'clock evening newscasts was really only a fraction of my workload, and I earned every cent of my paltry salary. I worked hard and was willing to do whatever was asked of me in addition to my weather duties, like ripping and sorting miles-long sheets of Associated Press news copy (international, national, and local news, as well as weather and sports) from a machine that printed and spit out copy twenty-four hours a day, seven days a week. I also produced, wrote, and hosted five-, ten-, and fifteen-minute FCC-mandated public affairs talk shows that we pretaped and aired during predawn weekday or mid-afternoon weekend time slots. Clearly, they did not contain the most compelling stuff!

I also hosted special-event programming as the community events calendar warranted: Miss Minnesota pageant specials, Jerry Lewis Labor Day Telethons, Profiles in Survival for the American Cancer Association, and others too numerous to mention. And I did some reporting, too, though that was a lesser part of my duties. But I stayed serious about the job, learned to ask for advice, listened to willing mentors, and managed to maintain a friendly and credible on-air presence as I yakked every day about the weather.

Within a year or two, my efforts were rewarded with a promotion to the news desk and an evening anchor job, my initial target all along. From there, I worked my way further up the ranks. Over the

years, in addition to my duties anchoring the evening newscasts, I also served in the newsroom as a producer, executive producer, and news director. My salary, thankfully, grew along with me—though it never reached the stratospheric levels earned by some broadcasters in the bigger TV markets or at the network level.

My career began at a time in the broadcast business when objectivity was the primary focus in reporting the weather or the news. I remember mentors counseling and encouraging me to remain calm and neutral in my approach to both—to maintain an "it is what it is" mentality—and not to let my emotions show or my viewpoint creep into whatever I happened to report. In my estimation, that earlier standard of objectivity has gone by the wayside, lessening considerably in today's more sensational, scandal-and opinion-oriented, and entertainment-driven culture. I am not alone in thinking that opinion seems to be displacing news to a large degree in today's broadcasts.

Fifteen years after I made my start, Jodi Huisentruit made her grand entrance onto the television stage as a news reporter. Like my initial job, hers was not the most glamorous gig, but it got her foot into the door.

Working the general-assignment beats as an intern and cub reporter in Iowa and Minnesota, she no doubt was sent out to report on a variety of topics. The stories that make up the news in any television market, whether urban or rural, sometimes range from the sublime to the ridiculous, or at least from the mundane to the exciting. The daily events reflected on the assignment editor's storyboard include the police blotter, local crime, politics, accidents, construction, weather, traffic, crop statistics, business news, tax rates, health scares, local controversies, and human-interest stories. Because of the sheer number and variety of stories, a good general assignment reporter is not encouraged to be a specialist.

Like others in her position, Jodi Huisentruit would have learned that it's preferable to be a generalist, one who knows a little bit about a lot of topics. Reliability, flexibility, and a curious nature are key,

because many times, a reporter covers more than one story per day, learns to write on the fly, and meets deadlines to get those stories on the air.

In some very small markets, like the ones Jodi worked in, some of the local male and female reporters essentially worked as "one-man bands." A one-man band is just what it sounds like: a person who drives to the scene of the story solo, schlepping the video and audio equipment needed to shoot it all by him-or herself. Back at the station, the reporter then writes the story and voices and edits it for newscast. Through that baptism-by-fire process and out of necessity (and maybe because of some sheer dumb luck), a plucky general-assignment reporter learns to work fast to get the story on the air by news time.

Jodi was a quick study and, by most accounts, was an affable and eager young reporter who yearned to move up in her chosen field. She really wasn't all that interested in reporting current events; what she really wanted to do was work in front of the camera. Jodi's early work pounding the pavement netted her the better job she wanted in a slightly larger town: anchoring the morning and noon newscasts. I suspect she was making the same pittance I earned in my early days, perhaps adjusted a bit for inflation.

She started her career at a time when the standards for objectivity and what was considered newsworthy were changing. And more importantly, she achieved a noteworthy personal and professional goal early in her promising career: she got in front of the camera. Finally in the public eye, she was ready to begin her climb to the top. She never got the chance.

Jodi entered television at a different time and in a different world than I did; she experienced fewer FCC mandates and a woman on the air was the status quo—just business as usual. What happened to Jodi, though, was anything but business as usual. This is her story.

CHAPTER ONE

INTRODUCTION: CONUNDRUM

> *"One of the drawbacks of fame is that one can never escape from it."*
>
> —Nellie Melba

I don't remember exactly when I first became aware of Jodi Huis-entruit as an on-air personality at KIMT-TV3 in Mason City, Iowa. She was beginning her career in broadcast journalism as a morning news anchor as I was reaching the end of my nearly twenty-year career as an evening news anchor at KAAL-TV6 in the neighboring southern Minnesota town of Austin.

The television news business is a small, somewhat intimate world. People know people. They're aware of who's doing what, which station has openings, who might be let go, who's changing jobs, and who's looking to move up. It has its own industry publications and professional groups, and word travels fast. In many ways, it's not much different than any other industry.

So it was second nature for those in the business to keep an eye on the competing news stations' shows and personalities, no matter the size of the market. I suspect that is still the case. It certainly was a way of life in our television market, which was made up of the

three major network affiliates: KAAL in Austin, Minnesota (Channel 6—ABC), KTTC in Rochester, Minnesota (Channel 10—NBC), and KIMT (Channel 3—CBS) in Mason City, Iowa. The viewing area of those three stations is made up of a large part of southeastern Minnesota and northeastern Iowa.

At the time, that region clung to its agricultural roots and it still does. But it is home to small and medium-sized cities boasting diverse industries, a largely well-educated work force, and a relatively stable job market. *Fortune* 500 companies, including Hormel Foods Corporation, and the huge Mayo Clinic medical complex are anchored in the region, and the three television stations still serve a valuable local news niche. Minneapolis and St. Paul, the Twin Cities of Minnesota, lie about a hundred miles to the north, and Des Moines, Iowa, is about a hundred miles to the south. A glance at a map of Minnesota or the United States will easily identify the intersection of two major U.S. interstates, I-35 on its north–south route, and I-90, on its east–west traverse across the country. That's where we were.

I anchored the six and ten o'clock evening newscasts on TV6, and while going about my daily duties, I would see glimpses of Jodi and her colleagues, both on their live shows and taped spots for other programs they promoted. Back in those pre-cable days, in the years when three major networks battled it out for dominance in the ratings, our newsroom kept a bank of TV monitors running perhaps twenty hours a day, keeping tabs, as it were, on our own and our network-affiliated competitors' broadcasts day and night. It made up the ubiquitous background chatter in the usually chaotic newsroom environment.

So I know I remember seeing Jodi and her news cohorts on the air, much as I was aware of the broadcast efforts of KTTC, the NBC affiliate in nearby Rochester, Minnesota. Jodi was young, relatively new in the business, eager in the way all neophyte reporters are, anxious to get a big break and make it to stardom in the competitive world of television news.

From my perspective, as an established evening anchorwoman, I had seen perhaps a hundred or more young men and women fresh out of college or internships, and some from yet-smaller market TV and radio stations, parade into and out of our television market with a turnaround time that many of us old-timers referred to as the "revolving door." I was older and decidedly more seasoned (okay, perhaps more cynical), having been on the air for close to twenty years.

Although I'd grown up in the Twin Cities, I had come to know and love that little corner of the world in southern Minnesota and northern Iowa. My husband, Joe, and I, along with our kids, had by then considered the area home for years. You might say we were the "big fish in a small pond." Joe operated his own business, and we owned some real estate. So we made the decision to stay, and I (for the most part) chose to ignore other TV opportunities when they came along. Delivering the news every weekday evening certainly made me a local celebrity, and I was a fixture on television.

Like many, I had from time to time toyed with the idea of going on to a larger market, but life sometimes has a way of interfering with some of our best-laid plans. I was happy there—reasonably content. I watched, managed, and helped to train the steady stream of youthful television hopefuls with mixed emotions. Working with them, I was by turns the grand old dame (well, I was older than most of them, at least!), a news junkie, and a sometimes-tough taskmaster, cracking the whip over them to finish their work and meet their deadlines. I was part mentor, part exhorter, and part boss. I was a concerned, sometimes bemused parent. To be truthful, I also was a bit amazed (and envious) at times at the career trajectory of a few after they left our station.

At the time, Jodi Huisentruit did not stand out in my mind as much different from the rest. Sure, she was young, pretty, perky, and enthusiastic in her on-air job, but those traits were basic requirements for such a position. Youth and beauty has always had a special province on television. I remember thinking the name

"Huisentruit" was an unwieldy one for her profession. Dutch roots, I supposed, if I thought about it at all.

I didn't know her personally and had met her perhaps once or twice in the course of our professional lives. Jodi was charming, chatty, and relaxed on the air, a good fit for an early morning show, her voice a bit thick with the long vowels of a native-born Minnesotan. Speaking as someone who knew, I thought at the time that she would likely benefit from some vocal coaching aimed at diminishing some of that uniquely Minnesota sound.

On a particular, unforgettable day in June of 1995, however, I felt nothing but concern and kinship for this charming young woman and the nightmare that was evolving.

By June 1995, I was no longer working on the air, having left my longtime job the previous December. Nineteen ninety-four had been a tumultuous year for the kids and me. My husband—their dad—had passed away in March of that year. A couple of months after his death, I took a leave of absence, mostly to focus on the kids and the business Joe had left behind. I also needed the time to "find my feet" again. And when that six-month leave was up in December of 1994, I decided to call it a career. I have no regrets about those decisions, which spurred me into new directions.

Several months later, in June of 1995, my family was busy preparing for the wedding of my youngest sister, who was to be married that weekend in a St. Paul suburb. She had come to Austin for a short visit the week of her wedding, and she and I were having coffee in the kitchen while we watched the morning news.

The chilling reports were all over the airwaves that Tuesday morning, June 27, 1995. Jodi Huisentruit had not shown up for her job as morning anchorwoman at KIMT. She was supposed to have arrived at the station between three and three fifteen to begin preparations for the six o'clock morning broadcast. About four o'clock that morning, Amy Kuns, her behind-the-scenes producer on *Daybreak*, called Jodi's apartment, apparently waking her. After mumbling a quick apology and giving an assurance that she'd be

there as soon as possible, Jodi hung up the phone. That was the last time the two women spoke.

Kuns later admitted one of her first impulses was frustration with Jodi. It wasn't the first time Jodi had been late, and the two had an agreement that they would call the other if one overslept. Jodi was usually the recipient of that call, according to Kuns, who went ahead and filled the gaps for her colleague, never suspecting that something unthinkable had happened. Jodi's absence required Kuns to work doubly hard, not only to write and produce the show, but to solo anchor it as well. Kuns was understandably under pressure to meet a deadline, and as a result, she naturally pushed aside any immediate concern about Jodi's whereabouts in her rush to get the show on the air.

The first call to police concerning Jodi's disappearance was made by a KIMT staffer just after seven o'clock, when *Daybreak* was over. The staffer requested that a police officer stop by Jodi's apartment to check on her. Kuns later commented that she sometimes carried a burden of guilt, being the last person to have talked to Jodi, even though, in hindsight, she no doubt realized that she would have been powerless to change the course of events that unfolded.

When police arrived at the apartment complex, it was very clear very quickly that something had indeed gone wrong for Jodi. Apparently she had been intercepted as she hurriedly left her home for the TV station, a short five-minute drive away. She had run out of her apartment building, but had not made it into her car, which was parked only a few steps away from the building's exit.

Police found some of her personal effects, including makeup, a hair dryer, a can of hairspray, earrings, and red shoes, scattered in a wide area of the parking lot near her little red Mazda Miata convertible, which she had just purchased earlier that month. A key that appeared to have been bent in the car's locking mechanism was also found at the scene. Witnesses reported seeing evidence of blood and drag marks. Clearly a confrontation had taken place, and the personal items strewn across the lot seemed to indicate that Jodi

had attempted to resist her assailant or assailants. The normally mundane parking lot had become a crime scene.

It had rained on and off for several hours the previous day and night. That Tuesday morning, the air was heavy with moisture, fog having settled along the river behind the complex. The morning sun was beginning to burn off the fog by the time search parties began their operations in the area near the apartment building. Initially, they searched dumpsters and a nearby park and an especially intense effort was focused in the water and on the banks of northern Iowa's Winnebago River, which flows past the apartment complex.

The search quickly expanded to include rural areas and farm fields near Mason City. The Mason City Police Department recruited help from other police personnel and search dogs from around the region, and helicopters conducted aerial searches. Within hours, the state's DCI (Division of Criminal Investigation) was called in, and within days the FBI was involved. The ebullient young anchorwoman had become the object of the largest manhunt in Iowa history.

Shock and panic reverberated across northern Iowa and the surrounding area. In the KIMT newsroom, and no doubt in many others as well, the fear was palpable. At least two of Jodi's female colleagues dared to voice the fear: Was it going to happen again? Was one of them the next target? Other early morning and late-evening anchors in the region and beyond likely felt similar tremors of apprehension.

In the hours and days following her disappearance, airwaves across the Midwest were alive with news of the search efforts. Across Mason City and northern Iowa, tree branches and windows displayed yellow ribbons, and signs proclaimed "Pray for Jodi" or simply, "Jodi." Similar symbols sprouted up in Jodi's Minnesota hometown and elsewhere. People held vigils in her honor.

As hours turned into days, I remember thinking that a break *had* to come soon, and then I slowly realized that she could not still be alive. No person, and decidedly not one with some celebrity stature,

just vanishes into thin air. At the time, I expressed to friends that I didn't think her body would be found for a number of years. I believed then that she had almost certainly died the day—even perhaps the very hour—of her disappearance. Now I am not so sure. More than one person thinks she may have been alive up to thirty-six hours or more after the initial confrontation.

I am not alone in remembering Jodi. There are many others who have not forgotten the events of that fateful June day, and for those who knew and loved her—her family and friends and colleagues—the wounds remain deep. The incident also left scars on those who investigated the crime, and the loss haunts many past and present TV anchormen and women.

The Internet was in its infancy at the time of her disappearance, but today the name of Jodi Huisentruit gets thousands of hits in computer search engines. Some of the sites are informational and well meaning, devoted to finding out what happened. Some still offer rewards, over fifteen years after the fact. Others simply offer a place for interested observers to share their opinions and feelings about Jodi's case. Sadly, others have absolutely no altruistic motive; some pornographic sites somehow insert her name into copy as a way to draw in unsuspecting viewers.

Jodi's story remains an enduring, frustrating mystery, a source of gruesome fascination to some, and a hole in the hearts of family and friends who grieve her loss. It is both a tragedy and a cautionary tale. Although she was not a personal friend, her disappearance affected me deeply, and it reminded me and others of the dangers of working in the high-profile profession of television news. And of course, her disappearance shattered a community's sense of safety. In particular, much of rural northern Iowa lost its innocence that day.

The television industry has had to adapt to changing technology in the ensuing years. Cable and satellite television and the Internet have profoundly changed American's ways of learning the latest news. But young men and women like Jodi still are—and will

be—drawn to the opportunities and the limelight television airwaves offer. In an age when being on television can confer instant celebrity status, there's no more certain a route to recognition than anchoring the local news. Local news anchors are some of the most visible people in any community. With few regrets, I have left that profession behind. One thing remains the same: I still want to know what happened to Jodi.

CHAPTER TWO

MORE QUESTIONS THAN ANSWERS

> "Let all the poisons in the mud lurk
> and hatch out."
>
> —Robert Graves, *I, Claudius*

Every police department in every city across this country has boxes of files filled with investigative notes and evidence from cold cases. The boxes may be relegated to a basement storage room or stacked precariously on shelving units in a closet or back office, but they all gather dust, silently mocking investigators. They are not a source of pride for any department; instead, they represent failure.

Jodi Huisentruit's is one such case, and it has stumped northern Iowa authorities. It haunts a family. It grips an entire industry. Her disappearance remains an all-too-present frustration in the law enforcement community because of its ongoing sensational nature. Let's face it: a story becomes a media mainstay when the format involves the perfect triad of sex, violence, and celebrity.

The story of this now-cold case in Mason City might have been long lost in obscurity had not a public figure—and a pretty, young blonde one at that—been involved in such a violent way. At the time

of the crime, news outlets and media across the country picked up coverage. Jodi's disappearance became the subject of news magazines and television shows. The case became the focal point for discussions on nationally syndicated talk shows, including those of Oprah Winfrey and Sally Jessy Raphael, among others. A young television anchorwoman who yearned for national fame and recognition in the broadcasting business got that fame not because of her work, but through the way she disappeared.

It's revisited often—every year on the anniversary—and any time unidentified remains are found, sometimes even several states away. A new clue or tip sets off a flurry of publicity. People still talk about it and wonder what happened, and Jodi's name has become a household word in a way that might not have been possible had she lived and not become a victim.

Investigators agree that at this point, so many years after the fact, if they find her remains it will probably be by default—that is, they'll find them accidently or in the course of some other investigation. Hundreds of thousands of acres of northern Iowa and southern Minnesota wetlands, woodlands, park preserves, and farms—not to mention thousands of lakes and ponds, rivers, and streams—provide vast and relatively unpopulated areas in which an assailant could have secreted away a body and hidden evidence.

In a few cases, so-called "default finds" have proven to blow cold cases wide open again. A hiker, a hunter, a farmer, or a boy scout, even an overly zealous dog, will stumble across a suspicious spot, inadvertently uncovering something otherwise thought to be well hidden by an assailant.

Criminal profiler Pat Brown, author of *The Profiler: My Life Hunting Serial Killers and Psychopaths,* identifies the three usual ways to link someone with a crime when a case has gone cold:

- newly discovered DNA evidence (processed with rapidly evolving technology) links a perpetrator with a victim

- a body found on a suspect's property

- an outright confession by a suspect.

A more recent case has proven that another approach can be fruitful, one using new interrogation techniques. In June 2010, WTVN-TV in Columbus, Georgia, reported on a retraining session attended by officials from several area police departments. After having learned just such a new interrogation technique, the attendees assessed an old taped interview connected with an unsolved double homicide in the area around Phenix City, Alabama.

The training session leader, Glenn Foster, said the approach the trainees learned that day can be key to cracking any case. When interviewing a particular witness or suspect, he said, "Don't judge them. Pay attention inside the room because they saw things. . . . " He went on, referring to a specific case. "I wish I could go into detail, because we actually brought someone in here and this particular person lit up like a Christmas tree when he was approached correctly. He never [previously] talked about some things that he talked about [today]."

Foster, who has been called the "father of forensic interviewing," specializes in interrogation techniques, including how to read human behavior, examine hand-written statements, and determine whether a suspect is lying. It is not unheard of for years-old mysteries to be solved by careful attention to these things, according to Foster. Cases gone cold over many years have been cracked wide open again by things like new technology, a different pair of eyes, or a fresh set of ears listening in new ways. We can only hope that will yet happen in the Huisentruit case.

Jodi Huisentruit vanished, seemingly into thin air, on June 27, 1995. She disappeared that day at the hands of another, and somebody literally got away with what we have to assume was murder.

Murder is a strong assertion, of course, but we are forced to recognize it as one of the only answers we can reach. Some might argue that, as an adult, she could have staged her disappearance alone or with the help of another; she could have chosen to walk away. Others might argue that she may still be held against her will. As we will discover, though, all the signs point to homicidal violence

as the only realistic conclusion to her story.

I do not know exactly what happened to Jodi or how it happened. I claim neither investigative talent nor expertise, nor can I boast psychic capabilities. I assume, like most others, that she is deceased, because the likelihood that she is still alive is exceedingly small. I do know that her body has never been found, and that the court system declared her legally dead six years after her abduction.

My recounting of Jodi's story is based on equal parts truth and speculation. The names, places, and dates that I mention are part of the public record. Some of the information I write about was, by necessity, given to me off the record. Simply put, several of the players in this story would agree to talk with others and me only if they remained unnamed. I cite sources when possible, but I've also respected the anonymity of those who requested it. I am simply the reporter.

Over the years, hundreds, perhaps even thousands, of people have shared ideas, tips, and suspicions regarding the case. Police and other investigators surely followed up on many of these, quickly discounting some for a variety of reasons and simply ignoring others. Nevertheless, authorities are apparently no closer to resolving the Huisentruit case than they were on day one.

Some of the speculation in what follows is based on hundreds of conversations, and it comes from many sources. So many people offered observations, facts, and theories; the questions about what was true and what was not became very tricky to answer.

Although it is thought that Jodi was likely unconscious or dead before her body was loaded into an assailant's vehicle, we don't know how or exactly when she died, because her body has never been found. Suffocation or blunt force trauma may have killed her. Her death may have involved a knife or another weapon. She may have been kept alive for some time after her capture. We don't know. She simply disappeared. So many theories exist, and each one leads down yet another baffling trail, a trail that eventually becomes obscured by yet more thorny questions. I've found that fingers point

in many directions.

After a murder, a body reveals a host of clues, not only about the manner and circumstances of the death, but about a multitude of tiny evidentiary details that can lead investigators to a suspect. Those minutiae can be admitted into court during a trial, and they may sway a jury. Without the body, it is decidedly difficult to arrest and prosecute a suspect.

Gary Peterson, a former television colleague who fanned the flames of my interest in the case and encouraged me to write about it, generously shared not only facts pulled from his extensive investigation files, but also his interpretations, theories, and scenarios.

Gary's interest in the case began some five years after Jodi's disappearance, while he was working as a news director in the newsroom at my former employer, KAAL-TV in Austin, Minnesota. At the time, he wanted to air a series of special news reports to mark an anniversary of Jodi's disappearance. What he and his staff began to discover in the process fueled his desire and commitment to find out what really happened.

Now retired, Gary and his wife, Gladys, lend their expertise to the coroner's office in southeastern Minnesota's Fillmore County, as death scene investigators for natural deaths, accidents, suicides, and homicides—those deaths that occur outside of hospitals and nursing homes. Gary and Gladys (an observant investigator in her own right) are two of only a few hundred accredited medico-legal death investigators in the United States. It is as a natural extension of that work that he continues to pursue this troubling case, as well as a number of other high-profile cases nationwide.

This book necessarily contains some amount of speculation and conjecture, Gary's as well as my own. That conjecture has also been colored and shaped by dozens of others, witnesses to Jodi's life before that awful day. My own interpretations and relevant experiences are included, too. Through sometimes rambling hours of conversation, Gary and many others forced me to rethink and re-analyze many preconceived notions about the case.

Josh Benson, currently of WFTV/WRDQ-TV in Orlando, Florida, has contributed hundreds of hours of manpower, legwork, and ongoing interest in the case. He initially became involved in the story in 2002 while working as an anchorman in Gary Peterson's newsroom at KAAL. In the process of developing stories for broadcast and interviewing people for substantive information, Josh and Gary discovered a mutual passion to learn more and dig deeper. The two founded, funded, and continue to operate a website called Find-Jodi.com. Josh, a Minnesota native, is the reporter and the voice of the video narratives contained on the site. Those narratives were originally produced and aired for news broadcasts on KAAL, and they netted him several prestigious television awards.

FindJodi.com, perhaps surprisingly, still receives hundreds of annual visitors and continues to serve as a credible source for up-to-date information and tips. It has helped to keep the case open years after the fact.

In a 2006 posting, Josh responded to criticism of the media's handling of a tip in Jodi's case:

> Gary and I have followed the case for years. We've spent hundreds of hours of our personal time digging through gross basements, interviewing nut-jobs, losing sleep, spending our own money (this site), following up leads, interviewing more nut-jobs, flying to other states, driving hundreds of miles, the list is long and not too pleasant. For what? Well, at first I realized it was a very intriguing story. But after sitting there in the parking lot where Jodi was taken staring at a tired Lieutenant and an exhausted and depressed sister (Jodi's) . . . I realized there was a job to do. For months, we've uncovered leads in the case . . . for months, other TV stations have taken our information for their benefit . . . I don't care. I want to see this case solved. So you can bet every lead that's there, we're going to follow. I feel we owe it to that family. And we owe it to ourselves.

14

Other private investigators have also spent time on the case. Shortly after Jodi's disappearance, Jodi's family hired a private investigator with a long and impressive background in police work. Now retired, Jerry Koerber spent nearly twenty-five years with Iowa's Cerro Gordo County Sheriff's Department. Starting in 1959, one of his early assignments as a rookie deputy took him to the scene of the now-infamous small plane crash in Clear Lake, Iowa, one that killed music legends Buddy Holly, J. P. "The Big Bopper" Richardson, and Richie Valens.

After leaving the Sheriff's department in the early 1980s, Koerber returned to school, earning his bachelor of science degree in criminal justice and psychology from Minnesota State University at Mankato, and his masters in public administration from Iowa State University. He also served two separate stints as police chief in the Iowa towns of Oelwein and Fort Madison and is a certified private investigator in Iowa. After the September 11, 2001, terrorist attacks on the World Trade Center, he began service as a federal contract investigator for the Department of Defense and the U.S. Treasury, among others.

Koerber, a credible and highly competent detective, often cites quirks that he says are common to law enforcement. For example, Iowa is made up of ninety-nine counties, and in his opinion, only ten to twenty investigators employed by police and sheriff's offices across the entire state of Iowa are up to snuff. He claims a good investigator is "born, not made," and says it's impossible to teach curiosity and other necessary skills to those not naturally blessed with the traits.

He's cited another problem he's often seen: polygraphs, along with the "experts" who administer them, are often faulty. Koerber told me the story of accompanying an extortion suspect who had just submitted to, and passed, a lie-detector test. In the car after the test, the suspect admitted his guilt to Koerber and laughed about acing the polygraph.

Koerber spent a considerable amount of time developing his

sources and reporting his findings to the Huisentruit family before he was asked to stop by then-Mason city police chief Jack Schlieper, who told Koerber that his work was interfering with the police department's "official" work on the case. After conferring with Jodi's sister JoAnn Nathe, Koerber agreed to end his official investigation and sent his entire file of voluminous notes to the family.

Koerber has strong suspicions about who is responsible for Jodi's disappearance. He is not alone. South Dakota's Jim Feldhaus, who has also immersed himself into the case for years, has convictions of his own. Like others who claim they "know" who did it, they will not cite the suspected perpetrator's name, saying they have no proof that can convict the person.

I found that the conversations with those who knew Jodi were also critical to this story. Jodi's former boss, Doug Merbach, shared valuable insight into Jodi the professional, while Jodi's sister JoAnn and a few childhood friends gave me a perspective on Jodi that I never would have learned from sources in Mason City. They helped me understand the Jodi they knew on a personal level.

Solving a crime is a collaborative effort, of course. Though officers spent years and countless man-hours on this case, some have charged the Mason City Police Department with outright incompetence, saying that it bungled the investigation. For its part, the department says investigators interviewed hundreds of people, and followed innumerable tips; a room deep in the bowels of police headquarters in Mason City houses volumes upon volumes of information gathered in connection with the case. Nevertheless, this book contains observations that likely never became part of the police files.

Some observers have charged the police department with treating the case as a random tragic event. Others say the department unwisely focused on the crime as the action of an obsessive stalker. Yet others think police focused on only one obvious suspect. Some think the department performed as well as it could, given the available resources. And still others claim the department simply dropped the ball, failing to follow through on many diverse tips and

leads, dismissing a number of them outright.

Of course, it's likely that many sources deliberately withheld information from law enforcement, either thinking it to be irrelevant or in an effort to protect or otherwise insulate themselves. And any police department is always stretched beyond the confines of time, money, resources, and available people. Further, it is arguably the mindset and convention among authorities not to talk freely, except to other authorities. Few police officers have loose lips with an outside audience.

In addition, internal department politics likely played a part into how the investigation was carried out. The chief of police at the time, Jack Schlieper, was said to be "extremely territorial" in his handling of the case, reluctant to let any other department or agency involve itself in the investigation. Despite those allegations, a couple of Mason City officers worked tirelessly and did a credible job, given the available resources. In fact, it's safe to say very few days go by that Jodi is not on the minds of Frank Stearns and Ron Vandeweerd, two officers who handled the case from the very beginning.

From the beginning, law enforcement spent a considerable amount of time questioning and administering polygraph exams to one primary person of interest, namely Jodi's closest male friend at the time, John Vansice. No surprise there; for obvious reasons, it is common and usually fruitful methodology for murder investigators to focus on the victim's closest friends and relatives.

I explore Jodi's connection and relationship with Vansice in this book, although, of course, no one on the outside, including me, really knows what happens behind the closed doors of any relationship between two people. No one truly knows (and Vansice isn't telling) whether he was a "father figure" to Jodi; if their relationship was one of close friends; if he wanted a deeper relationship that Jodi resisted; or if they were indeed lovers.

We know they were close on many levels. Despite the fact that he was more than twenty years older than she, they spent a considerable amount of time together, in public and in private. Whether or

not their relationship was sexual, it was ongoing, and she apparently consented to spend time with him. Although she claimed to some that she wanted to distance herself from him, she made no known attempt to overtly end the relationship. When one of her friends asked Jodi directly if she and Vansice were "an item," Jodi responded, "Absolutely not." She said she wanted to play the field, and not commit to any one man.

We know she and Vansice spent time in each other's company on many occasions. We know Vansice spent money on her; bought her drinks, meals, and flowers; took her on boating and waterskiing expeditions; hosted a lavish surprise birthday party for her just two weeks before her disappearance; and doted on her, flattered her, and showed her off. Some have speculated that he may have even helped her buy the car parked at the scene of her attack. He was known to be one of her closest friends, male or female, at the time of her disappearance; she spent more time with Vansice than with any other friend.

But there may have been a darker side to the attention Vansice showered on Jodi. He was what most people viewed as obsessive about her and obsessed with her, so much so that he named his boat "Jodi." He admitted that he named the craft after her, as he put it, "just because she's Jodi. She's been such a big part of my life lately and she just makes me feel so good." He was quoted as saying, "You can't help but love the woman . . . you just can't help it."

Jodi mentioned Vansice in her journal. They went out often, drinking and dancing together. By several accounts, he was observed getting publicly angry with another man for dancing with Jodi. One of Jodi's neighbors reported that it was not uncommon to see Vansice sitting in his car in the parking lot outside Jodi's apartment building in the middle of the night. For what reason, one has to wonder. As close as they were, she might have shared with him her concerns about a stalker. Was he trying to keep her safe, to prove himself to be her "knight in shining armor"? Many in their circle of acquaintances insist that he wanted more from the relationship than she was

willing to give.

Or was he jealous? Did he suspect another suitor? If he was not her assailant on the morning of June 27, does he know who was? It is very obvious why police initially took fast action to detain and question Vansice, to quickly name him "a person of interest." However, he was never arrested in connection with the case, polygraph testing proved inconclusive, and some time after the flurry of interest died down, he left his home state of Iowa for good.

Some have surmised that Jodi's disappearance may be related to a death of someone else she knew, a death that happened not long before she vanished. In the weeks and months before her disappearance, Jodi was said to have expressed frustration over the recent death of a close acquaintance, Bill Pruin. The manner of his death by a gunshot from his own gun was originally labeled a suicide; the death certificate later stated that the cause of death was undetermined. Pruin's death, not even three months before Jodi disappeared, remains a mystery, unsolved to this day. It seems relevant to ask about the real nature of their relationship and whether his case and her case are connected.

Jodi's disappearance is believed by most to be the work of no more than two people. Perhaps only one carried out the heinous act. The silence surrounding the case would have almost certainly been broken by now had more people been involved in the incident. Offenders are no exception to the rule that people enjoy talking about themselves and the work they do.

Psychologists confirm that it is relatively easy to get offenders to talk, especially in general descriptive terms, as long as those doing the questioning avoid specific queries about crimes. All human beings crave validation for their work, and criminals do, too, as we will explore later. They have the need for recognition, and that need sometimes becomes their downfall, especially when private comments become public. Someone knows exactly how events played out that morning, and it is still possible that he or she will talk.

So what happened? Random attacks can and do occur. Maybe

Jodi was targeted and "taken out" because somebody thought that her position as a television reporter made her privy to damaging information. Other television anchorwomen around the country who have been attacked and murdered are a sorry testament to the danger of stalkers, so we can't rule out stalking in this high-profile case.

But crime statistics don't lie, and most homicides, statistically speaking, happen at the hand of someone known to the victim, someone whom the victim perhaps even loved and trusted. In a recent study of prosecuted murder cases, the Bureau of Justice Statistics revealed that about 80 percent of murder victims knew their killers—either intimately (as a family member, friend, or lover) or casually (as a neighborhood acquaintance or a drug supplier, for example).

The study further revealed that more than half of those victims had a romantic or social relationship with their murderers. Finally, females are far more likely than males to be violently victimized by a friend, an acquaintance, or an intimate. That's the reason that, when a woman is killed, police are most likely to immediately zero in on a spouse, domestic partner, or boyfriend. So did Jodi know her attacker? According to the statistics, probably.

And what about a motive? Why would someone—friend, acquaintance, or stranger—want to attack Jodi Huisentruit? Think of the classic myriad human motives for murder one finds in any mystery, fictional or otherwise. What comes to mind? Money, love, sex, greed, drugs, obsession, jealousy, revenge, clandestine damaging knowledge, or keeping somebody's mouth shut.

The late quintessential mystery writer Agatha Christie, in her prosaic wisdom, might have boiled the list of reasons for murder down even further to the only three that encompass all of the above: love, money, or to cover up another crime. The more research we do into the Huisentruit case, the more compelling those three reasons become. Any one or all of these motives could have been a factor in what happened to Jodi.

During my research into this case, an old adage often came to mind, one we hear a lot: it's a small world. There are said to be only "six degrees of separation" between one person and any other on earth. It's fair to say that in this case, in northern Iowa in 1995, there were only one or two degrees of separation—at most. In a community like Mason City, people knew people. As a result, the lines easily became crossed, and the possibilities became seemingly endless. Too many variables existed: who, how, why? When one person points to one motive, it invariably leads to yet more questions. I often found myself thinking—ad infinitum—things like this:

- "If that's true, then this isn't."

- "But there's a hole in that theory, if what I just learned is true."

- "Given what others say, that doesn't make sense."

- "Yes, but. . . . "

- "Why would it happen like that? Am I missing something?"

- "For what reason?"

- "Think of it this way. . . . "

As I spoke with people and looked into sources of information, I quickly found that one idea led to another, and was contradicted by yet another. Because the case remains unsolved, so many fingers still point in so many different directions, and each story holds the seed of a plausible hypothesis. This case had—and has—no simple answers.

Even the police said as much. The complexity of the case flummoxed Mason City police and other investigators. At one time, Sergeant Frank Stearns of the MCPD said, "In a normal homicide, you can narrow it down . . . and count them [the suspects] on one hand." In this case, that was not easy to do. In June 2010, the fifteenth anniversary of Jodi's disappearance, Stearns said, "When I got the case, I had no idea how big it was going to grow. I thought we'd find

her quickly."

When I set out to dig deeper into this story, with the possibility of writing a book in mind, I had some very simplistic notions about Jodi's disappearance. Had you asked me then what I thought, I would have given you three scenarios:

1. She was attacked by someone she knew well, for one of the classic human motives listed above. This, I thought, was highly likely.

2. An obsessive stalker who had been tracking her movements successfully zeroed in on his target. I considered this scenario statistically less likely but nevertheless a real possibility, because Jodi was a public figure.

3. It was a tragic random act, a "wrong place at the wrong time" kind of situation. Even at the time, I considered this the least likely description of what happened to Jodi.

Each of these early notions still contains some merit, and as I pursued them, I quickly became fascinated and frankly astounded by the highly complex nature of this story. What I continued to learn in my research regularly challenged and stretched those ideas.

Family and friends paint a picture of a lovely and ambitious young woman with high ideals, a charismatic charmer who valued her relationships. It may be trite to say that she lit up the room when she walked in, but that's what they say she did. She was well loved by a close circle of family and friends, and she was professionally well regarded, too.

However, we can assume she had imperfections, like any other person. In saying so, I wish neither to malign Jodi nor to tarnish her memory. My aim is not exploitation. I simply want to find the truth. As her sister put it, perhaps her biggest failing was the fact that Jodi was somewhat naïve about the darker side of human nature, too trusting of others' intentions, friendly to a fault.

Jodi was said to be uncomfortable with confrontation and perhaps was a bit gullible: too quick to accept and believe others'

words as truth. Some say she was innocent in the ways of the world, but others said that she could be a world-class flirt. The former reporter in me strives to be as realistic and objective as possible when considering what happened on that long-ago June day. Considering all aspects of her personality and how they may have played into her disappearance is part of that aim.

Though we may never get real closure, I hope that my account will re-open interest in this old case, perhaps even lead to a much-awaited resolution. People move on, as they must. Time marches on, hearts begin to heal, and other, newer crises draw our time and attention elsewhere. But there is moral to this story, a lesson for the ages.

A few words before moving on. The Mason City community has changed considerably in the years since Jodi appeared on TV. As you read, keep in mind that 1995 technology was not what it is now. Cell phones were not yet widely in use. Text messaging had not yet been developed. And although the World Wide Web was in existence at the time, people did not yet routinely communicate via email. "Google" was just another silly word—not the verb it is now. Were she alive, Jodi would not likely recognize the computers, software, tools, and equipment routinely used today by television reporters and anchors.

Another rapidly evolving technique is DNA analysis. In 1995, such analysis was not terribly sophisticated. For example, DNA could not then be gathered from a victim's possessions as it can now. Actual human tissue (including blood, bone sample, hair, etc.) was needed for definitive DNA analysis.

Finally, a note about this book's title. In the world of television, "dead air" is a dirty term. It is most often used when a TV program comes to an unexpected stop, either through operator error or for technical reasons. Among professional broadcasters, dead air is considered one of the worst things that can happen, since it results in a blank screen or, in digital television, a frozen image. Dead air is the lack of audio or video on the screen at any time, and it is to be

avoided at all costs. Valuable viewers are lost during periods of dead air.

Jodi's disappearance created dead air of a different kind: a moment frozen in time. Someone, perhaps more than one person, knows exactly what happened to Jodi Huisentruit in the fateful predawn hours of June 27, 1995. None of us yet know how this particular episode will end.

CHAPTER THREE

A DREADFUL DAY

> " Facts are stony things that refuse
> to melt away . . . "

—Agnes Repplier

The questions nag at investigators, even today. Why Tuesday? Was it simple happenstance that Jodi was attacked on that particular Tuesday morning? What made that morning different from any other morning in any other week? Did something happen some time during the previous twenty-four hours that made the Tuesday attack likely or even inevitable? Did the attack have something to do with Jodi's attendance at a golf outing and banquet the previous day?

She had played in the annual Chamber of Commerce golf event at the Mason City Country Club in the afternoon and early evening of Monday, June 26. Had she met someone at the golf club, someone with whom she perhaps flirted and with whom she made later plans? Had a stalker come face to face with her during that or another very public event?

She may not have headed straight home after leaving the golf club. Though no one else attests to seeing her there, John Vansice told police that she had stopped by his home that night, and that

they viewed a video of the surprise birthday bash he had hosted for her earlier that month. The last time he saw her, he said, she was leaving his home.

Did something happen as a result of her visit to his home, if indeed she went there? Did he or someone else visit her later that evening at her apartment? Was this visitor the one who attacked, or was it someone else, someone waiting in the dark for her, someone who may have thought that he *had* to attack as she headed for work that Tuesday morning, the morning she also happened to oversleep. Although any attacker would have assumed that she had to exit her apartment building sooner or later, was the person waiting for her surprised by how late she actually was?

If Jodi had known for a fact that she was being followed or stalked, wouldn't she have been especially cautious that morning? Perhaps she never saw the attack coming. Had she lowered her guard? Had something about that morning—or the evening or day before—made her especially vulnerable? Was it just that she over-slept and was distracted because she was late for work?

Perhaps she had seen a late-night visitor; if so, she probably wouldn't have gotten much sleep and would have been especially groggy that morning. Maybe she had taken some type of drug (a sleep aid, for example) the previous night, leading her to oversleep and to remain off-balance that morning.

Had Jodi seen a white or light-colored van with its running lights on in front of the building that morning? A witness attested to seeing it. Did she see it and ignore it in her hurry to get to work? If she saw a vehicle such as the van and viewed it as a threat, why didn't she run back inside or yell for help?

Most importantly, how did her attacker maintain the element of surprise needed to carry out his successful attack that morning?

Four noteworthy events may have made the day before Jodi's disappearance different from other routine workdays:

1) She attended the golf event at the Mason City Country Club, which had been called on account of rain and lightning. She

stayed for the social hour and dinner that evening.

2) She may have stopped by Vansice's home after leaving the club to relive another recent event. He claimed she was with him the night before she disappeared to watch the video of her recent big birthday party—a surprise party that had "thrilled" her. He told police that he was the last person to see her alive. As he tells it, the evening before her abduction, she descended an outside stair-case from his second-story duplex apartment, smiling and laughing as she made her way to her car.

Although this is the story Vansice told police, some question his assertions, claiming that the timeline just doesn't fit. While the neighbors living in the ground-floor unit of his duplex were out of town that evening, they said that they had seen her enter and exit his apartment at least two or three times in the recent past; they said that she had not stayed long on any of those visits. Had she made another such visit the night before her disappearance?

3) An unidentified male knocked on Jodi's apartment door sometime that evening, demanding her to "open up." Jodi's female neighbor across the hall reportedly told police that she over-heard a man pound on the door and yell, "Jodi, open up. I know you're in there!" He apparently gave up and left after a few minutes. Given that the man called her by name and said that he knew she was home, he probably knew her, either well or casually. The fact that he acted as though Jodi would recognize his voice and open the door to him supports this assumption. We do not know exactly what time he stopped by, so we do not know if she was at home at the time he knocked on the door. Whether her car was in the parking lot at that time is another unknown.

If her car was in the lot, it would have indicated to this man that Jodi was probably at home, having returned from the golfing party. And perhaps she was. Perhaps the man saw the car, assumed she was in her apartment, and banged on her door. Perhaps she chose not to answer the summons, staying quietly inside her locked apart-ment until he gave up and went away. Perhaps she was unwilling to

face the man that evening. Or perhaps, when the unidentified man knocked at the door, she had another visitor inside her apartment, a person she didn't want her new caller to see.

But, since we don't know the timeline, we have to consider that maybe Jodi was still away and that her car was not even in the lot at the time of his visit. This possibility raises another troubling question. Why would the man have said that he "knew" that she was at home if her car was not in the lot? Surely he would have noticed whether her car was there, and it is reasonable to assume that any man who "knew" her would know what kind of car she drove. If her car was not there, why didn't he assume that she wasn't, either?

4) She is believed to have had another visitor—likely male— later that evening. During a press conference, police spokesman Ron Vandeweerd commented that police had reason to believe "it all started in her apartment," and this reason was related to the belief that Jodi had a man in her apartment the night before her disappearance. Reliable sources confirm that police had made a startling discovery in Jodi's apartment the morning she disappeared, although the department had kept the finding quiet, choosing not to reveal what might have been a critical clue to the media and the public. What did officers see? *The toilet seat in Jodi's bathroom was raised.*

Let's be realistic: a woman who lives alone *always* keeps a toilet seat down. There are not many reasons to raise it, except perhaps to clean it. Further, it's highly unlikely she would have thought about cleaning the toilet on a morning she was running very late for work. Had a man visited her later Monday evening, perhaps spending the night in her apartment?

By the time police arrived at the Key Apartments complex around quarter past seven that morning, it was clearly a crime scene. The attacker was believed to have accosted Jodi as she attempted to insert the key into the door of her car. The police found her car key and it was bent, indicating that some heavy pressure, either from Jodi's hand or the hand of her attacker, had been applied while it was in the locking mechanism.

After processing the car that day, police noted that the heavy morning moisture had been rubbed off the door and that an outline of her head was on the car's black fabric roof. Presumably, Jodi's attacker had pushed her back against the car. It appeared as if her attacker grabbed Jodi from behind and twisted her around, pushing her small frame back against the driver's door and forcing her head back onto the convertible's ragtop.

The forensic team also found a partial bloody palm print on the car, and witnesses reported seeing blood or tissue evidence on the driver's side rearview mirror, which indicated Jodi may have been injured and that she may have fought for her life. In an effort to fend off the attacker, Jodi may have flung out her arms or struck back with some kind of satchel, purse, or briefcase, dropping some of her belongings, including a hair dryer, a can of hair spray, and earrings; police found these, as well as a pair of her red high-heeled shoes, scattered over a significantly wide area of the parking lot.

Jodi was said to carry notebooks in her purse or briefcase, but police did not find any such evidence at the scene, leaving us to presume that whoever took Jodi also took any notebooks she may have had. Police noted partial drag marks on the pavement, indicating an attacker had overcome Jodi and dragged or yanked her into another vehicle. We can assume that she would have been dazed, unconscious, or dead immediately after the attack.

As we already know, Jodi's failure to show up at the television station caused some anxiety for her behind-the-scenes producer, Amy Kuns, as early as four o'clock. Normally, Jodi was scheduled to arrive for work well before that time, at three or three thirty. But it was not unusual for Jodi to race in considerably later, full of apologies for her tardiness. After her initial call, Kuns followed up with another, made after Jodi had apparently left her apartment. We know the second call went unanswered, when Kuns said the phone "just rang and rang."

The women had talked in the past about covering for each other, arranging to make phone calls as back-up alarms should one of them

oversleep. Most times it was Jodi who received those wakeup calls. Kuns and others often protected her, making no mention of her frequent late arrivals to her boss, Doug Merbach.

But those phone calls also served another unspoken purpose, according to Kuns, who said that, since both needed to be at work unusually early every morning, the two "kind of took care of each other." The two women shared an underlying concern, one far more serious than simply being late for work. They each left their homes every day in the small hours of the morning, and that made them feel vulnerable. They were well aware of the prospective danger inherent in venturing out alone in the dark, and they had frequently shared "what if" scenarios. How would anybody actually know if something serious happened to one of them in the wee, dark hours?

Kuns recalled her final phone conversation with Jodi:

> Everything sounded normal, like I had just woke her up. "What time is it?" She asked the question, so I told her, "Jodi, it's about ten to four; you need to come in to work." [Then she asked] "How much time is left to produce on the show?" I mean, she was obviously thinking, she was aware, she just knew she had overslept and she had to get in to work. I didn't hear anything out of the ordinary. Nothing.

Kuns admits to being frustrated with Jodi when she made that first phone call. She was probably still frustrated when she made her second call, placed after Jodi apparently left her apartment. Maybe Kuns was fed up by having to continually cover for Jodi's frequent tardiness. Maybe she thought it was about time for the boss to become aware of the situation. But by five thirty, Kuns surely sensed that something was amiss.

That morning, Kuns was under huge pressure to meet her deadline: the looming sixty-minute six o'clock morning newscast. She had to finish writing and editing enough material to fill the hour and pull together the elements of the show—all by herself. At the small

television station, Kuns was one of only a few people in the building at that time of morning. In addition, she had to pull herself together to solo anchor the show. She did not have a moment to waste.

In an interview with CNN's Nancy Grace years after Jodi's disappearance, Amy Kuns shared how she felt that morning. According to the show's transcript, she said she simply didn't have time to call police or anyone else.

[At 5:30] I was just concerned about getting the show on the air. We couldn't put in black. I went on the air for her. And then one of our creative services guys walked through the studio at . . . somewhere between 6:00 and 6:30. And I told him, "Dave, Jodi's not here. Go to her apartment. Call the police, whatever you need to do, but she's not here and I'm really worried." And that's when we kind of got the ball rolling.

Though she was worried about her coworker's safety, Kuns said she never visualized an actual attack on Jodi. Instead, she said that, on reflection, she had been more concerned that something might have happened to Jodi inside her apartment that made her unable to get to work. Kuns thought that perhaps Jodi had fallen, hit her head, and lay unconscious or unable to call for help.

From all appearances, Jodi shared a reasonably good relationship with Kuns; after all, they looked out for each other. Although there may have been some elements of competition or jealousy between the two—Kuns admitted to wanting Jodi's position—they worked well together.

Jodi had also developed a level of camaraderie with her other newsroom colleagues, including the evening anchorwoman, Robin Wolfram. The two sometimes chatted about their common goals: to anchor the news in a larger-market television station. Even better, they both wanted to see their names and faces prominently displayed in a national television context.

All the newsroom staffers who worked with Jodi have since moved on in their careers. Some still work in television news and some do not, but they all have their own poignant and personal memories of the day she disappeared. Brian Mastre, KIMT's evening coanchor with Wolfram at the time, had the unpleasant job of breaking the devastating news to viewers. He recalled, "I remember getting a call in the morning and breaking in during programming and telling people that somebody who sits two desks away from where I was right there was missing."

He said it is as clear to him now as it was that day. Facing the camera, he sat on the edge of a desk in the newsroom, struggling to convey a calm demeanor while reporting what had happened. He didn't want to reveal panic on the air; he had typed out the script as a crutch in case his emotions welled up. The announcement lasted a little over a minute, and Mastre doesn't remember taking a breath while reading it. "Everything and everyone in the newsroom stopped that morning. No matter how many disturbing indicators we had up to that point, several people expected Jodi to walk back into the station that day." He said the gravity of the evidence revealed at the crime scene had not fully sunk in for most of Jodi's newsroom colleagues. "Once we broke into programming," Mastre said, "I think it sealed the story as the real thing for any doubters."

Former KIMT staff meteorologist Don Harman said, "[That day] the world fell apart for a lot of us." Another meteorologist who worked the morning show with Jodi said that he "knew it was more than Jodi [just] oversleeping that morning." Kevin Skarupa remembered the day this way: "The police started to show up at the station, and we knew it was a . . . different day than our normal morning wakeup show at that point."

Mastre, who served as executive producer in addition to his anchor work, remembers the FBI questioning him and others in the newsroom. In fact, he said the agents on the scene viewed virtually everyone in the newsroom as a suspect. He told the story of sitting across from the two agents in a conference room. As he put it, "They

were trying to figure out if I was a threat. I was trying to figure out what they knew that we could report. They did the standard good cop-bad cop routine, tried to figure out if I had a relationship with Jodi, and then started to ask detailed and obscure questions about [things like] on which shoulder she used to carry her purse. I remember being torn, knowing their fishing expedition was going nowhere—while at the same time, we still had to cover the biggest story of our lives up to that point."

Mastre said he didn't cross paths too much with Jodi at work, since they essentially worked opposite shifts—she in the early morning, and he late at night. They rarely saw each other outside the newsroom, either. Mastre was married, while Jodi was single, so it is not surprising that he says they didn't frequent the same circles.

Newsroom boss, KIMT news director Doug Merbach, first heard about the situation about the same time that police were notified. When Amy Kuns called him to break the news, he recalled that he had said goodnight to Jodi less than twelve hours earlier at the country club. Given this, his initial reaction was not one of panic. He simply thought that the sociable Jodi had stayed up too late, perhaps drank too much, and hadn't gotten up. It didn't take long, however, before he realized the full impact of the situation. He described himself that day as facing a four-headed monster.

The first was personal. He thought to himself, "Where is my employee, and is she okay?" He desperately hoped that Jodi had just taken off, and that it was all just a big misunderstanding.

The second was professional. He knew that he'd have to get somebody to fill the anchor chair for the noon newscast. Merbach had to juggle the schedule to fit someone into that spot, and he had a shell-shocked staff to draw on and think about.

The third related to law enforcement. After discovery of the scene of the crime, he recognized that it would be natural for police to ask questions at Jodi's workplace. As Jodi's boss, Merbach was the point man.

The fourth was the media. Merbach knew that the media circus

would be relentlessly multiplying outside the television station throughout the day. He was right. Reporters from print, radio, and television outlets all over the country were descending on Mason City, clamoring for information, video, and sound bites. Merbach had to walk a fine line to meet their needs (Jodi's disappearance *was* news, after all), all the while wanting to remain cognizant of what he called the "exploitation factor."

KIMT's evening anchorwoman, Robin Wolfram, in an interview later aired on ABC's *20/20*, recalled a surreal moment of clarity when she looked up at a newsroom monitor on one of the first days following her colleague's disappearance. She recalled seeing an on-air promotion for an upcoming story on the case and thinking, "This is not what Jodi meant when she said she wanted to be on national television."

Sometime after Jodi disappeared, Amy Kuns admitted to a reporter that she sometimes felt badly about taking over the work that Jodi had done. She said, "I felt guilty . . . doing her job. It [the job] was something I always wanted, but I didn't want to get it that way."

At the television station on that Tuesday morning, the broadcast day began as always, and *Daybreak* aired in its usual time slot, despite Jodi's absence. In live television, as in live theater, the show must go on. And the show did go on before, during, and after the discovery of the crime. On that dreadful day, Jodi's shocked and fearful coworkers displayed their professionalism by continuing to do their jobs.

Today, many years later, a tree planted in honor of the missing anchorwoman still stands near the entrance to the KIMT building, a large Quonset hut-type structure on Pennsylvania Avenue in downtown Mason City. A tattered and stained yellow ribbon still hangs in limp tribute on a portion of the perimeter fence around the property. On the ground nearby lies a gravestone etched with her name and the image of a television camera and a microphone. It reads, simply, "Always remembered."

CHAPTER FOUR

THE BLUE HOUR

> " May God curse the night that's grown uneasy
> near the dawn. "

—W. B. Yeats, *The Hour Before Dawn*

It sounds reflective, wistful, longing. Springing from the French expression *l'heure bleue,* the "blue hour" is a romantic term that refers to the period of twilight just before sunrise and just after sunset, when there is neither full daylight nor complete darkness. In the morning, the blue hour occurs when the sky perceptibly brightens; the sun is still below the horizon, but some of its light already reflects in the atmosphere back to earth.

During that time, creatures begin to stir after their night's slumber, and birds begin their insistent wakeup calls. It is the time when the smell of flowers is considered to be the strongest in the summertime. It is also the time when most car accidents are said to occur and when other unpredictable human behaviors can be at their peak. Perhaps it is not surprising that Jodi was attacked during the blue hour, on a morning just a few days after the summer solstice, the longest daylight period of the year.

Early on June 27, 1995, the sky was beginning to show signs of

clearing in Mason City, Iowa, and it had rained off and on for much of the previous forty-eight hours. That morning, some cloud cover may have dimmed both the brilliance of the blue hour and the visibility it might otherwise have afforded.

We simply don't know if the plan to strike at Jodi at that particular time on that particular day was premeditated. Her assailant may have found what he considered to be the perfect conditions that morning to zero in on his target. It was a time when her attacker most likely knew she would be exiting her apartment building and heading to work, though she was running at least an hour late that day.

Because her job demanded such unusual hours, her attacker may have thought that the very early morning would be the prime time to carry out an attack. And, because many apartment windows faced the parking lot of her building, the attacker may have considered the predawn hours to be prime time for another reason: the fewer the possible witnesses, the better. Naturally, many people would not be up and about in the predawn hours.

But whether or not one has a crime in mind, plenty of people have plenty of reasons to be alert during the blue hour. Early risers, night owls, insomniacs, and shift workers are only a few who could have seen or heard something during that time. Enough people were up and around at that time, enough to make it curious that few claimed to see something amiss that morning. Several people still alive today may have something to offer to shed some light on Jodi's final minutes in the parking lot. Specific observations made about that time point to the fact that people were in the immediate area, despite the early hour.

THE CAMPERS

Around the hour of Jodi's assault, campers were beginning to stir in the campground adjoining the Key Apartment complex. An

annual event catering to history lovers had been held in Mason City the weekend before Jodi's disappearance. History buffs from around the country had participated in an annual Civil War re-enactment that last weekend in June. The event, called the Civil War Battle and Encampment, now in its seventeenth year, is like a number of such summertime events around the country. As it does now, the 1995 gathering featured live entertainment, such as battle re-enactments, cannon and mounted cavalry demonstrations, and soldier encampments.

Although the event was winding down by June 27, some campers had stayed on; campers, trailers, and tents were still present in the campground that morning. Then, as now, a rustic wooden fence and vegetation, which serves more as a visual divider than any real barrier, separated the riverside camp from the parking lot where Jodi's car was parked.

TWO MEN

Before dawn on the morning of June 27, a female resident of an apartment that overlooked the entrance into the parking lot from Kentucky Avenue remembers some interesting facts. She overheard two men talking in a grassy area outside her open window, which faced Kentucky Avenue. She was unable to discern details of their conversation, but thought it odd they would be there that early. Shortly after that, the resident also recalls two cars, one of which had a loud muffler, leaving the parking lot within minutes of each other. One of the cars turned left on Kentucky to go north. Within minutes, the second car pulled out in a hurry, grinding gears while heading south.

THE FAN

A self-professed fan of the morning anchorwoman garnered some attention from police and the media that day, when he claimed to have witnessed a white van in the parking lot outside Jodi's building. The eyewitness, Randy Linderman of Mason City, said that he noticed a white or light-colored van pulled up by the curb in front of Jodi's building. While driving by, supposedly on his way to work, he described slowing down, because the van's parking lights were on and he figured the vehicle might have been used by a police officer.

Linderman, who at the time lived just up the street on Kentucky Avenue, claimed the van was a mid-'80s Ford Econoline cargo model. That oft-mentioned van, frequently cited in media accounts of the story, has never been found.

It is noteworthy to mention that Linderman, because of his eyewitness account, was also said by police to have been a "person of interest" in Jodi's disappearance. Linderman was interviewed extensively following his offering of the eyewitness claims and also submitted to polygraph testing. As he put it, the police "had to see if I seen what I saw," because he was one named person to identify a vehicle that has not been found.

That simple fact leads some to speculate about whether the van was actually in the parking lot at all or if his statement was made for an entirely different reason—one that focused on deliberately distorting facts or pointing police in the wrong direction. Was the white van in reality "a red herring"?

But these speculations may be too hasty. There were at least two other mentions of a mysterious white van. In a news conference the day of Jodi's disappearance, police spokesman Ron Vandeweerd acknowledged police reports from the previous night. Those reports centered around mention of the presence of a white van in the neighborhood.

Linderman's eyewitness account of that white van, as valid as it

may have been, has led some to focus on other, more puzzling questions. Linderman, who by his own admission was an admirer of Jodi, may have been unduly interested in or enamored with her himself, well before the time he went to police as an eyewitness.

It is also relevant to note that he admitted to being the owner of a dark truck in the mid-1990s. Might he have been the unidentified driver of a dark truck with darkened windows, which was noted on previous occasions to have distressed Jodi? As we'll explore later, some of Jodi's friends and relatives recall her concerns about being stalked by the driver of a dark truck. Another woman, an early morning runner who prefers to remain unidentified, also expressed concern about similar events that happened to her.

And just why was Linderman driving past the Key Apartments that early in the morning? He was said to usually report to work about eight o'clock each day at Capital Industries in Forest City, Iowa, his employer at the time. Linderman and a coworker would often carpool to work in Forest City, a distance of about thirty-five miles (or approximately a forty-five-minute drive) from Mason City. That one simple fact has not escaped notice. It is noteworthy that he claimed to be "on his way to work" nearly three hours earlier than he needed to be, given his place of employment. Several people have raised suspicion about his precise activities in the neighborhood near the time Jodi disappeared and why he was there so early.

THE JOGGER

Another person may be a key witness to the events of that specific time period on the morning of Jodi's disappearance. A female runner, who refuses to be identified, has exceptionally vivid observations of the time immediately following the incident. In the following chapter, we'll explore the observations of this woman who daily traced a running route past the Key Apartments.

THE NEIGHBOR

In the high-profile days after Jodi vanished from the Key Apartments, police fanned out across the apartment complex in an effort to contact and gain information from her neighbors. They went door to door in her building and in the other buildings whose apartments had windows facing the parking lot. Officers were seeking out someone—anyone—who could shed some light on what had happened. But the process yielded only a few teasing glimpses into the events of that morning. One involved a woman who lived across the hall from Jodi during the time in question; she reported a couple of troubling observations, both made before the morning in question.

That woman, who prefers to remain anonymous, tells of seeing a white van occupied by two men whom she didn't recognize in the parking lot of the building about a week before the abduction. In 1995, she said she worked for a company that required her to arrive relatively early on weekend mornings (about five thirty). On that weekend day, she was on her way to her workplace when she realized she had left something she needed back at the apartment. Retracing her route and returning to the apartment building, she was puzzled to see two men, one white and one black, sitting in a van outside her building. Naturally, she was suspicious of their motives for being in the building's parking lot at that time of day. She was suspicious enough that she didn't feel safe getting out of her car. So she made an instantaneous decision to do without the forgotten item and turned around to go back to work.

In a postcrime interview, that same neighbor also told police of the unknown male visitor to Jodi's apartment the evening before the crime. She overheard the man pound on Jodi's door across the hallway. As he banged the door, he announced, "Open the door, Jodi! I know you're in there!" Jodi failed to answer, of course—as we already know—and her visitor gave a final exasperated rap before he left the building.

Another of the neighbor's observations is notable. The morning of the crime, she said she was awakened by a scream. She claims to have heard a slamming sound and a thump, followed by a frightened woman's voice crying out, "NO . . . John. . . . " Or perhaps it was Don, Ron, Lon, or Shawn. ". . . DON'T!" The sounds were brief and she heard no more.

THE OTHERS

On that fateful June day, a few other building residents at the Key Apartments told police after the fact that they had heard a scream or a call for help around the time of Jodi's disappearance. "'Just 'help, help.' That's basically all I heard," said neighbor Keith Walsh. According to police records, at least five neighbors heard those cries for help. Two people described the cry not as a horrified scream, but one of surprise. "I just thought it was somebody playing in the park," said Betty Walsh.

THE POSSIBLE WITNESS AT THE WINDOW

As with similar crimes, psychics contributed their insights into Jodi's disappearance. While we will explore some of these later, one is worth mentioning here. One medium insisted she has strong feelings that an elderly resident of a ground-floor apartment near Jodi's may have actually witnessed the attack in the parking lot. The medium, who visited the site of the crime several years after it happened, claimed that strong energy fields remained at the scene, as is thought to be common in areas where violence has occurred.

Her inklings were persistent; an elderly resident on the ground level may have peered out from behind curtains as the assault was in progress. Although police extensively interviewed building residents, especially those whose windows fronted the parking lot, that

person never came forward. If there was such a witness, we can only assume that what he or she saw that morning was frightening enough to keep him or her silent. He or she may have been very fearful of exposure or retribution. We have no way of knowing if the medium's opinion is correct, nor, if true, do we know if that person has since moved away or is no longer alive.

All of the above-mentioned people had specific observations about specific elements of the happenings that took place on the morning of June 27. At the times described by these people, Jodi's absence had already been noted at the television station, and it was unusual enough to warrant real concern. Her absence mattered, given the pressing need to write, produce, and anchor the fast-approaching news hour, not an easy challenge for just one person.

Each separate observation, in and of itself, probably didn't seem to justify an emergency report. As a result, no one called 911, and police received no word of trouble until shortly after seven o'clock. That's when the call came from KIMT requesting authorities to make a welfare check at Jodi's apartment building. It is both remarkable and very puzzling that police received absolutely no word of this incident earlier than seven o'clock.

Jodi's new Mazda Miata convertible had been parked near the exit door and within sight of the building, and her personal items were found scattered across a wide area of the parking lot. Surely other residents of the building exited that same door between four thirty and seven. During that time, residents of the Key buildings across the parking lot almost certainly had accessed their cars in that lot, too. Why did that scene of disarray in the wet parking lot fail to arouse any curiosity for over two and a half hours?

Perhaps we can think of the blue hour on June 27, 1995 as what those in emergency medicine refer to as the "golden hour." That's the time period after a traumatic injury during which there is a high likelihood that prompt and appropriate medical treatment will prevent death. It's well established that a victim's chances of survival are greatest if the victim receives care within that golden hour, the

relatively short period of time after a serious injury.

If police had received earlier notification of trouble at the Key Apartments, might Jodi's chances of retrieval or survival been enhanced? Might the chances of the successful identification of a suspect been increased? These are critical questions.

When evidence of the crime became public knowledge, the blue hour had yielded to dawn, and dawn became just a memory. A significant amount of valuable time had elapsed—time that was critical from an investigation standpoint. For two and a half hours, Jodi's presence had been needed, and thus missed, at KIMT. For two and a half hours, her personal items lay presumably unnoticed in a large parking lot. Two and a half hours of advantageous lead time was granted to her attacker, allowing him to get away with Jodi. From four thirty until seven o'clock, one hundred fifty precious minutes were lost before the search for Jodi even got underway.

CHAPTER FIVE

THE SPRINTER'S STORY

> "One event is an anomaly, two is a coincidence, and three a pattern."
>
> —Long-forgotten high school science teacher

Rising very early in the morning dark, a runner would lace up her running shoes and take off. Covering seven miles every day and cutting her course along the same route, she'd fly by the Key Apartments at about four thirty. The predictable timing and familiar route allowed her to turn inward, focus on her pacing and her breathing. On some days, just for fun, she'd shake it up a bit, add to her mileage, sprint to improve her lung function.

The lone female runner valued her time afoot, spending it dreaming and planning. Her runs were as much mental release as they were physical exercise. Heading out in the dark, she wasn't reckless—she had learned to be aware of her safety and her surroundings. Throughout many of her runs, the warnings from friends who were concerned about her nutty running habits echoed in her head.

There were certain areas of town that made her nervous, especially at that time of day, and she'd be on high alert when approaching the problem spots. In areas with heavy foliage, for example, where

someone might hide, she'd pick up the pace, run in the center of the road if possible, and stay alert.

She'd often notice lights underneath the bridge near Kentucky Avenue and presume there were drug deals going on down there. On both sides of the river, she knew that well-worn paths through the summer overgrowth led to private and covered areas invisible from above. In retrospect, the runner reflected that, during the time immediately before Jodi Huisentruit's abduction, she had been on especially high alert.

KIMT's morning news anchor was not normally at the top of the list of things on the runner's mind at any time of day, and she certainly did not think of Jodi during her cherished morning outings. Her schedule full, the runner rarely watched local television newscasts at all, and she was not well acquainted with Jodi. In fact, prior to hearing the shocking news of the disappearance, the runner had met the KIMT anchorwoman only once at a community event and did not know where she lived.

Following the scary abduction news, however, the runner thought a lot about the newscaster and about the dangers inherent in venturing out so early. She became hypervigilant, not only about her own safety, but also about keeping an eye on the drivers who shared the road with her.

Not to say she wasn't already wary enough. A longtime runner, she had learned to be. She'd heard too many stories from and about other runners and had plenty of unnerving experiences of her own while on the road. In a general sense, it seemed to her that some drivers really enjoyed harassing joggers. In particular, the driver of one small car presented a consistent problem, and she'd constantly kept an eye out for that one. In fact, she always meant to get the car's license plate number and report it to police.

One time, the driver of that vehicle had really frightened her. That day, seemingly out of nowhere, the car suddenly appeared next to her, keeping pace with her on the left. Dawn was still an hour away, but the car's headlights were turned off. With a runner's

wariness, she refused to make eye contact with the driver and kept on moving, purposely pretending to ignore the vehicle. She'd logged a lot of road hours and had learned what worked to deter a driver's interest. Trying a little test to assess the problem, she slowed up. So did the car. Then she ran faster. The car kept up.

The driver, whoever he was, was obviously pacing her, and she was terrified of being cornered. After a few moments, she felt she had little choice but to get off the road and disappear into the darkness. Scanning the landscape ahead, she scoped out a spot where trees and shrubbery would shield her getaway.

But the driver apparently had other plans: he suddenly sped up and moved way ahead of her. The momentary surge of relief she experienced in that moment gave way to new horror when the driver made an unexpected U-turn in the middle of the street, blinding her with his headlights and coming right back at her. She didn't know what he was trying to do: did he want to size her up, identify her, kill her?

Her limbic brain screaming, "Danger! Danger!," she made an abrupt about-face and scrambled from the pavement. As fast as she could, she made a helter-skelter route change, zigzagging across lawns and roads as she headed for home. Perhaps the driver gave up and realized the runner was lost to him that morning. Maybe he saw the runner was not the person he thought she was, someone he wanted to intercept. Whatever the reason, he lost interest and drove away at normal speed.

On Monday, June 26, the day before Jodi's disappearance, the runner experienced another unusual and frightening event. As she approached the Keys in the day's predawn, she noticed an adult white male talking to a preteen black boy, perhaps eleven to thirteen years old. She remembers the boy as gangly, with legs that were skinny and too long for the bike he was straddling. She thought that the man was about thirty and particularly noted his appearance; she initially thought he bore some resemblance to another man she knew.

She might not have paid any further attention to the pair, but

when the man saw her, he suddenly stopped his conversation with the boy and gave her a cold stare. As she passed, the boy began to pedal after her, fell in pace beside her, and maintained the unlikely alliance for several blocks.

Although they didn't speak to each other, she recalls being amazed at the child's aggressiveness and odd behavior. She admits to feeling fearful at first, but after a while she became more curious than scared. Despite her curiosity, she wanted him gone. In an all-out effort to shake him off, the runner broke into a hard sprint, and the kid finally seemed to tire of the game. She got her reprieve when she angled off onto a side street, and the boy lost interest, scooting off in another direction and leaving her behind.

Upon reflection, the runner thinks she probably interrupted an illegal transaction between the man and the boy that day. Because the boy's reaction was so immediate, she felt sure that the man told the boy to follow her. Whether her observation that Monday morning had anything to do with what happened the following morning remains unclear.

Even today, that predawn runner who logged part of her daily miles on Kentucky Avenue retains extraordinarily vivid recall of the morning Jodi Huisentruit disappeared. The memories do not spring from any emotional connection she had with Jodi, but instead from deeply imbedded responses she experienced that day, as well as an intense sense of distress she experienced during the days after the disappearance.

One element contributing to this distress was the fact that, on the morning of June 27, the runner overslept by five minutes, something she says she'd never done before. And to this day, she remains convinced that the five-minute delay was due to an angel protecting her from witnessing something and perhaps becoming a victim herself.

She describes the morning of Tuesday, June 27 as unusually quiet. Every morning along her route she would see cars, other early rising runners, and the general activity of people as they

headed off to work. But that day was pretty peaceful. Nothing seemed out of the ordinary when she emerged from her home, and the first couple of miles were uneventful. Putting one foot in front of the other, her body's muscle memory readily adapted to its regular routine, and her breathing became deep and rhythmic, as it always did. She had learned to cherish this peaceful early morning routine, a quiet and reflective time to prepare for an otherwise busy professional and academic day.

Then, one after the other, two seemingly random events made the otherwise gutsy jogger take notice. Heading north on Kentucky at a four-way stop sign, she halted momentarily to jog in place, waiting for a small car that was approaching her from the opposite direction to pull through the intersection. Instead of routinely moving forward, the car's driver hesitated, confusing the runner. Its driver simply waited, apparently patiently, for a few moments.

In those stalled few seconds, she and the driver seemed to reach an unspoken impasse: each one studied the other, waiting for the other to make a move. The encounter struck the runner as odd and unexpected, and it made her antennae rise. She had another reason to be wary: the car looked similar to the one she feared. After a few vigilant seconds, moments that seemed to drag, the driver broke the standoff and made his move into another direction. More guarded than relieved, the northbound jogger nevertheless moved ahead on her route, the route that always took her right by the Key Apartments.

That's one reason that the following few moments remain forever etched in her brain. As she approached the Key Apartments, crossing the Kentucky Avenue bridge, a car without headlights suddenly barreled out of the parking lot, its driver clearly out of control as he attempted to veer south on Kentucky. He was apparently agitated and in a big hurry, and he appeared to be headed straight for the runner.

The runner's daily workouts were not in vain. Her muscles, agile and taut, sprang into action as she instinctively leapt onto the

pedestrian sidewalk that abutted the bridge rails to avoid being hit. At the same moment, the driver swerved as well, seemingly seeing her just in time. Frightened, angry, with reflexes wailing and eyes focused only on her feet as she negotiated the jump, she was flooded with adrenaline, her entire body rattling in response to the close call.

It was over in a matter of seconds. The car already gone, she doubled over, gasping for air, grasping for control.

In that moment of silence, she knew that she had been lucky. Then, with the danger past, she did the only thing she knew to do in that moment: after catching her breath, she stood up straight, put one foot in front of the other, and fell back into a comfortable, comforting pace.

After a while, the adrenaline stopped its relentless pulse and her heart rate steadied. Her sense of disquiet eased and the route became quiet and peaceful again. Moving easily and covering familiar ground, she had the time to more calmly reflect on what had happened. Her first impression, of course, had been sheer panic. Anyone (or anything) else in her position would have reacted similarly. Humans and animals alike share a fight or flight response in the face of imminent danger.

But her second impression of that speeding car was a bit more thoughtful. The car was not like the usual pieces of junk that harassed runners. It was a nice vehicle, deep in color (maybe dark blue or crimson red—she couldn't tell in the dark); it was a medium-sized, very clean, very shiny sedan. The driver had regained control after the near miss and then switched on the headlights.

It seemed like just one of those things, the kind of thing that could happen to any runner, especially in the dark. She didn't attach much overall importance to it. Maybe the driver was late for work, or maybe he or she had just had a quarrel with a girlfriend or boyfriend at the apartments. It wasn't until later, after she learned about what had happened to Jodi, that the event took on much more significance. For some time afterward, she felt haunted by what she came to think of as a failure on her part. To this day, she says she

wishes she had turned as the car sped by, and she wishes she had the presence of mind at the time to remember the vehicle and memorize its license plate number.

And yet, her ignorance must also be a source of some comfort. If the runner had gathered and reported the car's make and license plate number, publicly became an eyewitness, and if the driver had indeed been carrying human cargo that morning, he'd have been a danger to her. And if this car and driver had been involved in Jodi's disappearance, the account I relate here could still put her in danger. That's why the runner insists that I keep her anonymous, even after these many years.

On reflection, she says she's mystified that much of the publicity about the case still centers around the report of an elusive white van. For what it's worth, the runner says she never saw a white van that morning. If it was at the Key Apartments at all, she figures it was already gone by the time she passed by, five minutes later than her usual time.

As it was, on the otherwise quiet and unremarkable morning, she saw only three people during her run that day: the mysterious person at the four-way stop, the agitated and aggressive driver screeching out of the Key parking lot, and a friendly, middle-aged jogger who smiled and said hello to her at the end of her route. She links the first two events together in her mind, and strongly feels that the last person was just a congenial fellow runner.

The morning after Jodi's abduction, the runner woke at her regular time and set off on foot, as usual. But this time, as she approached the entrance to the Key Apartments, she was surprised to see police cars, roadblocks, and people stopped on the side of the road. An officer stopped her that day, too, and asked where she was going. When she told him she ran by there every morning at around four thirty, he looked both astonished and wary. He told her that she'd be wise to change her running route.

Then the officer broke the news of the previous day's events. It was the first time the runner had heard anything about the local

anchorwoman's disappearance. She remembers feeling surprised to learn that the anchorwoman lived in the Key Apartments, property that the runner considered to be run-down.

After this initial surprise, the significance of the event, as well as her possible role in it, hit her like a bombshell. Her brain in overdrive, the shocked runner couldn't help but think of the events of the previous morning. She felt sick and consequently did something quite against the grain, something she normally wouldn't have considered: she cut her usual seven-mile run short.

Later in the week, she voluntarily went to the police department and met with an investigator assigned to the case. She told him about the speeding car and other events of that morning. He said her information could be a break in the case, but she couldn't describe the car well enough or provide the license plate number to make the break significant. Nevertheless, the next morning, police set up a roadblock again near the Key Apartments.

When recounting the interview, she remembers another thing: her surprise that the police never asked for her name so they could follow up with her.

The female runner who felt threatened by cars and unidentified drivers tracking her movements had something in common with the abducted anchorwoman, although she may not have known it at the time. Jodi had reported similar stalking concerns to police in the months before her disappearance. These concerns left her shaken and on alert, with the feeling that she was being followed. And they had another thing in common: the slim blonde who liked to run in the cool predawn could easily have been mistaken for Jodi.

Today, the runner no longer lives in Mason City. She resides in another state and lives a life far removed from her days in northern Iowa. Yet she still follows the investigation and wants some closure, not only for herself, but also for Jodi's family. She maintains a strong hunch that the perpetrator, wherever he is, still occasionally logs on to the FindJodi.com website and others, just to see what people are saying.

The runner says her nerves were tested by one entry made some time ago. The reference line reads "Re: Psychic visions, Dreams and Impressions," and is attributed to "Patty" in California. At the end, the message says, "There is a feeling that there WAS a witness out by that bridge. They either didn't realize what they were seeing or fear has kept them silent. Running . . . Jogging . . . Faster . . . See me . . . Please see me . . . YOU KNOW I read this." Perhaps the abductor himself wrote this contribution to the site.

They are chilling words, indeed.

CHAPTER SIX

"Some questions *don't* have answers, which is a terribly difficult lesson to learn."

—Katharine Graham

A trip to a northern Minnesota casino was on the agenda for JoAnn Nathe and her mother on June 27, 1995, the day their sister and daughter disappeared. JoAnn Nathe, Jane Huisentruit, and one of JoAnn and Jodi's aunts had taken a bus trip to Walker, Minnesota. JoAnn, normally not much of a gambler, was on summer vacation from her first-grade teaching job, and she had been trying to spend more time with her aging mother. When they boarded the bus for a day trip to the casino in Walker, they looked forward to spending a day of diversion and fun with a group that included JoAnn's aunt, as well as some friends and neighbors.

JoAnn vividly remembers a casino staff member approaching her group to tell them of a long-distance emergency phone call. Not knowing the source or the reason for the call, JoAnn felt a momentary frisson of panic, but Jodi was not first in her thoughts. When she picked up the phone in the private room where they had been escorted, JoAnn heard the voice of an officer identify himself as

from the Mason City Police Department. He asked her if she was sitting down.

"Oh no," she thought. "Jodi." She knew that her little sister had something of a lead foot on the road, and she immediately thought the worst: Jodi had been in a car accident. So when the officer informed her that Jodi was missing, JoAnn says she actually felt a small measure of relief. "Oh, she's missing. Well, then we'll find her," she thought. Unfortunately, that initial sense of relief did not last.

JoAnn and her family were bundled into a van provided by the casino, and a staff person was dispatched to drive them back to her mother's place in Long Prairie. The details are still clear in her mind. JoAnn remembers her mother sitting in a daze in the front passenger seat, while she and her aunt fought off waves of nausea in the back seat. She was distressed over the possibility that Jodi had been kidnapped and agonized over what her captors might do to her.

As soon as possible, they set out on the more-than-four-hour drive from Long Prairie, Minnesota, to Mason City, Iowa, where KIMT-provided accommodations awaited them. The family had been plunged into a nightmare, and JoAnn, put on the offensive, got to work before and after they arrived in Mason City. She phoned several of her sister's friends, asking if they could shed light on Jodi's whereabouts.

Childhood friend Staci Wagner Steinman vividly recalls that phone call from JoAnn, a call that marred what would have been an otherwise wonderful week: Staci was to be married that weekend. The horrifying news of Jodi's disappearance hurtled Staci onto an unwanted roller-coaster ride of emotion: the anguish of an awful loss replaced her prewedding euphoria. Her pal Jodi was scheduled to serve in the wedding party.

While Jodi's family members were still making their way south, a horrified public tuned into radio and television stations and picked up newspapers to learn more about events as they transpired. Jodi's coworkers, meanwhile, grappled to make sense of what was happening. Some in the KIMT newsroom wondered what her

disappearance meant for their own safety. As the news spread, other male and female reporters and anchors, in many other television newsrooms across the country, no doubt felt similar anxiety.

In the KAAL newsroom, just across the Minnesota border, the reporters who were working hard to tell the story were keenly aware of just how close to home it struck. Jodi was a colleague, and her story could just as easily have been theirs. What had happened to her could have happened to any one of them.

They had all experienced callers and pieces of mail that made them uncomfortable; it was part of the business. What kept them off balance was not knowing *why* Jodi in particular had been targeted. Overt fear gnawed already frayed nerves. Was the abductor someone who was after news anchors in general, or was it someone who was just after Jodi?

Former KAAL-TV anchor and reporter Erin Connors shared her perspective:

> People think they know you and want to share their opinions. They want to stop and talk with you when they see you at the grocery store. In my case, some people just wanted to hug me or touch me. They didn't understand that I didn't know them. It may be a part of the business, but that part changed for me on the day she [Jodi] went missing. I was very careful about this stuff after that. You could say I grew up a little—became more suspicious of people's intentions in some cases.

Erin, who anchored the weekend newscasts in the summer of 1995, admitted that she became very afraid for her personal safety in the wake of Jodi's disappearance. She had always worked odd hours, and routinely didn't get home until after dark. She appreciated that KAAL-TV management had taken some new precautions at the time: putting new locks on the doors, providing personal-safety classes, monitoring the anchors' mail and calls. She appreciated, too,

that her landlord had installed motion-sensitive lights outside of her building because she was worried about her tenant.

Looking back at some of the lessons she learned that summer, Erin said, "I did things differently. I was much more aware of my surroundings and still am to this day. I am careful to watch where I go alone and change the path of my daily walks often. I will never look at a white van the same way."

Erin's KAAL colleague Carla (Johnson) Conradt, who worked as a news reporter at the time, was another broadcast professional shaken to the core after the incident. Carla, an attractive brown-eyed blonde like Jodi, lived in Austin's Key Apartments, a property owned by the same company that controlled the Mason City complex of the same name. Though Carla and Jodi were not acquainted and did not share the same kind of job (at the time, Carla was a pavement-pounding news hound and a well-regarded reporter), Carla found herself uniquely and oddly connected with the missing anchor for another reason.

Newly married, Carla took extra safety measures that year. Reflecting back on that time, she didn't link the safety measures directly to Jodi's disappearance, though. Carla was troubled by another problem: an apparently schizophrenic neighbor who made life difficult for her with stalking behavior and by making nonsense calls to the police about her. Carla's husband, Dan Conradt, then a KAUS radio reporter (he works at KAAL today) in Austin, recalled being highly vigilant about safety that year, and he says they kept up that pattern for months.

Those who shared Jodi's social life in Mason City were left to deal with their own sets of demons that Tuesday. Early Tuesday morning, before police received the call to check on Jodi at the Key Apartments, John Vansice had called another female friend to inform her that he would be unable to meet her for their usual early morning walk. He offered no explanation.

Then, at about seven o'clock that morning, just before the police received their initial summons, Vansice reportedly ran into another

friend at a local convenience store and informed him, "Jodi is gone." When asked what he meant by that cryptic remark, Vansice said, "She didn't show up for work this morning. We gotta get over to her apartment." It's not clear how he knew Jodi was gone and had never arrived at work. Police were just beginning to amass at the scene of the crime—word of Jodi's disappearance was not yet common knowledge.

Vansice and his friend showed up at the Key Apartments a little later that morning, while police were assessing the evidence in the parking lot. Those present described him as pale with shock and said that he rambled, nearly incoherently, in his conversation. When asked by officers to identify himself, he couldn't immediately remember his last name. And when one officer asked him what he was doing there, he purportedly said that he wanted to find out when he and Jodi were going waterskiing next. It was an unusual comment from a man who would know Jodi would usually be at work that time of the morning.

Then he reportedly began to volunteer more information, perhaps out of nervousness or fear, perhaps because he was rattled by what was happening, or perhaps as a way to justify his presence at the scene. Vansice told officers that he had a personal connection with the missing anchorwoman and that he could prove it. He boldly proclaimed to the police that he had been the last person to see her.

As a matter of fact, he claimed she had just been at his home the previous evening, when he said that they watched a video of her recent birthday party. All was well at that time, according to Vansice, and the last he saw of her, she was smiling back up at him as she descended the outside staircase from his second-story duplex apartment.

When asked what time she left, he was confused, at first blurting out "Midnight," then saying that it had been at eleven, and after thinking about it, ceding maybe she left closer to nine o'clock.

At the time, the police didn't fully interrogate Vansice. Later, they and others would question him in-depth. The assumption

based on his statement that she had been at his home Monday night was readily accepted. As the investigation developed, investigators learned that Monday had been a long day for Jodi. She had spent much of that day at the country club playing golf and socializing over drinks and dinner. She had still been there when her boss, Doug Merbach, left the club shortly after dinner.

When Jodi got home, she made a phone call from her home phone to a friend in Mississippi, Kelly Torguson. Kelly's husband noted that he answered the phone that evening around eight o'clock central time. He told Jodi that he'd have his wife return the call if she arrived home before nine thirty or ten. Given this timeline, how could Jodi have squeezed in even an hour-long visit to Vansice's place?

And on that Tuesday morning when he first encountered the police at what was by then an obvious crime scene, why did Vansice freely offer up statements that put him physically close to Jodi within the previous twenty-four hours, thus setting himself up as an object of closer police scrutiny? Perhaps he wasn't thinking clearly. But some speculate that those statements were, in fact, a clever ruse on Vansice's part. Perhaps they were his way of saying, "Hey, I'm as surprised as you are by this turn of events! Everything was great between us when I last saw her."

When an officer asked Vansice that day to define the nature of his relationship with Jodi, Vansice reportedly claimed a father–daughter connection with her. Those who knew Jodi and Vansice do not corroborate this description. When he left the scene that day, he agreed with officers that he would make the birthday video available to police.

Meanwhile, news was spreading fast. Another close acquaintance was horrified by Jodi's disappearance. On that Tuesday, Lanee Good was shocked to hear about the news while she was at work serving and tending bar at the Other Place. Good knew Jodi and her friends well; they were regulars at the downtown Mason City sports bar, a popular lunchtime and after-hours gathering spot. Close in age to Jodi, Good was friendly with many of her customers at the

Other Place, the establishment of choice for what she called many of "the suits" who worked downtown.

When questioned, Good identified Jodi as a regular at the bar and said that she usually saw the anchorwoman two or three times a week on average. Outgoing, friendly, and warm, Good was uniquely suited for her work and had developed a rapport with many of her customers, including both Jodi and Vansice. She had been at the big birthday bash, too. She said it was common knowledge to her and others that Vansice wanted a deeper relationship with Jodi, and that Jodi resisted.

On the day of Jodi's disappearance, the news hit Good hard. As soon as her shift ended at six o'clock that evening, Good and her mother drove to the Key Apartments, near where searchers in boats were dragging the Winnebago River in the search for Jodi. She found Vansice in the parking lot, dejectedly sitting in his van. Telling her mom she needed to spend some time with Vansice to see how he was doing, Good left her mom and joined him in his vehicle.

She later described Vansice as looking "horrible" that day, his normally ruddy skin tone ashen. She clearly recalled his apparent state of mind, too. While she described herself as saddened and grief stricken by the turn of events, she said that Vansice, in her estimation, sounded in turns beaten, angry, and agitated, repeatedly asking, "Why did they do this to me?" Clearly the two were processing their shock and grief differently.

Feeling restless and ill at ease at the crime scene, Good didn't want to stay in that spot, didn't want to see if authorities pulled something or someone from the river, so she and Vansice left the scene. They drove around town and talked for a while. Remembering that evening, Good said that Vansice simply didn't want to be left alone that night. She agreed to keep him company at his place.

Good never directly accused Vansice of being involved in Jodi's disappearance, and she refuses to do so today. But she clearly had some misgivings, as illustrated by a phone call she recalls making to her mother that night. When she told her mother she would be out

for the night, she said, "If something happens to me, I want you to know I am at John Vansice's place." According to Good, the two spent the evening watching the video of Jodi's recent birthday party, and she slept on the sofa that night.

But the following morning, Good revealed that Vansice awoke her very early and insisted she rise in a hurry so he could take her home. She described him as intent on going to work that Wednesday morning, but they took his personal vehicle, not his work van. When she asked him why he wasn't driving his work vehicle, he rebuffed her, telling her "Never mind." She thought it unusual that a man going to work wouldn't take his work van. Though she hesitated to speculate any further, she had the sense that something was not quite right and wondered why the work van was off-limits only twenty-four hours after Jodi had gone missing.

But Vansice apparently didn't go to work that morning after he dropped Good back at her home, at least not right away. Jodi's sister JoAnn had arrived in town by that time, and JoAnn Nathe and John Vansice met face to face for the first time that Wednesday morning. Despite the difficult circumstances leading to their meeting, JoAnn said she had a pretty good first impression of her sister's friend as they became acquainted over breakfast. In fact, she thought him to be a fairly attractive and fit forty-something.

That initial good impression, however, was tempered somewhat by one comment he made toward the end of the meal. JoAnn says she was surprised by Vansice's reaction when she asked him if Jodi had ever talked to him about her father and how he had died. Vansice was pretty brusque in his reaction, according to JoAnn. She said he stood up and coldly responded, "She never mentioned her dad to me," and shoved at his chair.

JoAnn admits she was probably a bit overprotective about Jodi. As her much older sister, she understandably harbored maternal instincts for Jodi. JoAnn also admits that she sometimes preached to her baby sister about safety much as a mother would, and she said that Jodi at least once bristled at the implication that she couldn't

take care of herself.

Jodi had been open about being "on guard" about her safety, mentioning her concerns to her family, friends, coworkers, and the police. She told them that she had been unnerved by a stalker or stalkers in the weeks before her disappearance, and one time JoAnn said that Jodi cried on the phone when telling her mother about her fears of being followed. Jodi had requested a police escort to work on some mornings, but refused the offer of a regular ride.

Some people close to her have suggested that Jodi was noticeably uneasy in the weeks before her disappearance, and may have felt something was about to happen. Amy Kuns, her coworker, commented that Jodi seemed unusually exhausted in the preceding two weeks, and seemed to have a lot on her mind. One of Jodi's childhood friends recalls feeling a sense of unease about Jodi's welfare in what turned out to be her final conversation with her friend. In retrospect, she remembers hearing "utter exhaustion" in Jodi's voice.

For her part, Jodi's sister JoAnn now knows only one reality. Forced into a role she did not want, JoAnn served as the front-person for the Huisentruit family during the aftermath of Jodi's disappearance, a role she still fulfills today. She took charge, conferred with police and the television station, talked with private investigators, and submitted herself to unrelenting media interviewers.

She took on yet more painful tasks: combing through, packing, and later clearing out her sister's apartment and tending to necessary paperwork and legal formalities. She carried on with her work and her family responsibilities in Minnesota, all the while maintaining a vigil for her beloved sister. To this day, she continues the delicate dance between the present and the past.

Now she wants for the only payback that really matters. She wants closure for herself, her family, and Jodi. She wants to know where Jodi's body was laid to rest. She remains nostalgic in her memories of and her love for her baby sister and would like to have a proper funeral for her. Most of all, she wants answers to the two

biggest questions of all: who was responsible for the crime, and what really happened on that summer day in 1995.

CHAPTER SEVEN

ANCHOR AWAY

> **"**Constant use had not worn ragged the fabric
> of their friendship.**"**
>
> —Dorothy Parker

Jodi had been on the move on the final weekend of her life. The highly sociable anchorwoman spent much of the weekend in the company of friends, who corroborated her whereabouts and her activities. On Saturday, June 24, a sunny weekend beckoned Jodi and her friends to one of her favorite places: the water. They set out on a one-hundred-fifty-mile road trip to eastern Iowa. Their destination was the beautiful Coralville Reservoir, an area extensively developed for recreational use and a popular waterskiing destination. That's where Jodi and two friends, Tammy Baker and Aunie Kruse, spent the day with John Vansice and his son, Trent, on Vansice's boat.

Jodi was in her element as everyone took turns on skis behind the boat. An avid waterskier, Jodi later noted in her journal that Trent offered her some great advice that day. Trent, just a few years younger than Jodi, suggested that she pay attention to her stance and the angle of her body while on the water. He also advised her to keep her ski tips higher. She was excited about putting his words of

wisdom to further good use.

The group spent the evening on the town in Iowa City, just south of Coralville, where they had some dinner and did some barhopping. While making the rounds, Jodi was pleased to run into a few of her former colleagues from her internship-reporting days at Cedar Rapids KGAN-TV. As she had previously described her surprise birthday party, in her journal she referred to the Iowa City jaunt as a "wild time."

Their original plan was to stay the night and cruise the water on skis again on Sunday. The group did spend the night at Trent's Iowa City area apartment, where the women shared a bed, according to Tammy. But on Sunday, rain thwarted their plans to get back out on the water, so Jodi, Vansice, and Kruse were forced to make an earlier return to Mason City.

That afternoon, the three stopped in Clear Lake to visit another mutual friend whose wife had apparently shot the video of Jodi's big birthday party two weeks earlier. They asked for a copy of the tape, but had to go to another location in Mason City to retrieve it. The friend described Jodi and Vansice as affectionate and "lovey-dovey" that afternoon.

We are left to our assumptions after that. Quite likely, Jodi and Kruse spent some time viewing the birthday videotape with Vansice at his home that rainy afternoon or evening. After all, they had just acquired the tape, and they all were understandably eager to see it.

We can only assume that Jodi spent some quiet time alone later at home, where we know she made what was to be her final entry into her journal and connected with a friend or two. She talked on the phone to one of her Minnesota pals, who said she was struck by how "worn out" Jodi sounded.

And Jodi penned a note to her mom in Long Prairie. JoAnn read the following final words Jodi jotted to her: "Mom, Looking forward to seeing you this weekend—Will be fun! Went to Iowa City and did some waterskiing. Saw Tammy Baker. Drove down with friends. Think about you all the time. Love you, Jodi."

After the frenetic weekend, it's probably safe to say that Jodi retired early that evening in preparation for a demanding Monday.

Jodi's movements are also fairly well accounted for that Monday, the day before her disappearance, and it appears to have been one very long day, with precious little down time. June 26 began with Jodi rising very early in preparation for her approximate three o'clock arrival in the KIMT newsroom, where she prepared to anchor what we now know was her last newscast.

She worked her usual morning shift, but did not anchor the noon show, instead heading to the Mason City Country Club. Along with her boss, Doug Merbach, she was to be a player in the annual Chamber of Commerce golf event, and the two played in separate foursomes. That was not a tough assignment for Jodi, an accomplished golfer.

But it was a wet day on the course. A downpour drenched the golfers, and lightning sidelined the event. Not to be deterred, most of the players simply brought the party indoors. Many of the participants that day must have espoused the philosophy of fair-weather golfers who invariably look forward to the "nineteenth hole" in the club. A social hour and dinner followed, rounding out the evening.

In her element, Jodi socialized at the club and stayed for the banquet, as did her boss, Doug Merbach, though Merbach says they did little more than share pleasantries before joining groups at separate tables. He recalls saying a few words to Jodi before he left the club shortly after dinner. Merbach teased her a bit, telling her not to stay too late and miss the early newscast. Then, he simply said, "See you tomorrow." That was not to be.

We don't know exactly when she left the club. As noted, John Vansice asserted that Jodi headed directly for his place. And as we know, that assertion was accepted as fact for some time, but several people later questioned Vansice's statement, saying the timeline just didn't make sense.

Upon her return to her home, Jodi made the aforementioned phone call, which rang in Kelly Torguson's Mississippi home about

eight o'clock central time. Torguson was out that night, but her husband spoke briefly to Jodi; he said that his wife's friend sounded like her usual upbeat self. He said she sounded happy, even giddy, when telling him about her weekend. Jodi asked him to have Torguson return her call if she returned within a reasonable time. Torguson arrived home later than expected, and did not return the call.

That's the last anecdotal evidence we have about Jodi's activities that Monday. We simply don't know if she delayed her bedtime because of a visitor, and we don't know if she spent the entire night alone. The account of the upright toilet seat leads us to consider some other scenarios and creates a new and dizzyingly abundant set of questions, such as the following:

- Was her sleep interrupted or delayed because she received an unidentified male visitor that night?

- Was the man someone she had met at the golf club earlier that evening?

- Was he the one who pounded on her door? Or was he there when another man was heard pounding on the door?

- Did her visitor stay the night?

- Was he there at four o'clock in the morning when Jodi received Amy Kuns's wakeup call?

- Did Jodi hurriedly leave that person behind in her apartment, so she could make the mad rush to work?

- Was that person the last one to use the bathroom that morning?

- Could he have been a possible witness to the attack in the parking lot?

- If that was the case, why didn't he come forward?

- Or, the most obvious question of all: could that man, in fact, have been Jodi's attacker?

CHAPTER EIGHT

MISS BUBBLY

> "Shakespeare speaks of 'lean and hungry men,'
> but he never seemed to notice that a lot of women
> are lean and hungry, too . . . "
>
> —Taylor Caldwell

It might truthfully be said that, from the beginning, Jodi Sue Huisentruit was destined for the spotlight. The cherished baby of her family, she was open, extroverted, and a bit of a "ham," an outgoing child who made friends easily. Her sister described her as an adorable toddler who got a lot of attention, with white-blonde hair and saucer-shaped chocolate-brown eyes. Even as a kindergartener, she was admired for her warmth and wisecracking ways.

One of her earliest childhood friends said that that was her first impression of Jodi when they met in kindergarten. The friend, who readily admitted that she was the shy child who clung to her mother and cried the whole first week of school, admired and wanted to be friends with Jodi, whom she described as the "girl in the corner cracking jokes." The two were best friends by the time second grade rolled around, and since then she's insisted that Jodi was born with her own uniquely bubbly personality.

Jodi carried those trademark outgoing traits and goofy sense of humor from childhood into adulthood, and her family and friends were probably far from surprised when she landed on her feet in the broadcasting business. However, her open, trusting, and guileless nature may not have served her very well as an adult, especially in her chosen profession.

Broadcasting, which can sometimes be cutthroat and competitive, is an industry perhaps better suited to people with a more measured and cynical view of the world, those who do not readily accept people and their stories at face value. In the summer of 1995, Jodi's otherwise admirable characteristics may have made the young anchorwoman a vulnerable target for others wishing to take advantage of her sincerity.

While still a little girl, vivacious Jodi, who seemed destined to have fun, discovered an early affinity for golf. And when her parents indulged her with a set of her own clubs, they did not waste money on a childish whim. John Stefanich, a Long Prairie golf coach, said he can still remember Jodi starting the game as a third grader and developing a real passion and talent for the game.

In the sixth grade, Jodi declared her intention to win the state championship golf tournament in high school, and she did just that. As a member of Long Prairie High School's Class A State Championship Golf Team in 1985, she ranked fourth individually in her junior year of high school, and a close friend ranked fifth. The team captured the coveted championship title in 1986, the girls' senior year.

The Long Prairie Country Club, where Jodi nurtured her talent, still honors Jodi's memory today. Ten years after her disappearance, family and friends dedicated a memorial bench at the tenth hole of the golf course. It still stands today as a testament to the avid hometown golfer.

While Jodi became remarkable by the manner of her disappearance, she was raised in relatively unremarkable surroundings. The youngest of three girls, she grew up in the obscurity of the small central Minnesota town of Long Prairie, which claims a population

of about three thousand. Jodi's father, Maurice, who worked in plant security at the nearby Melrose, Minnesota, Kraft plant, passed away from colon cancer when Jodi was only fourteen and in junior high school. Morrie Huisentruit had apparently been ill for some time, and his death undoubtedly dealt quite a blow to "daddy's little girl."

The young teenager's loss of her father must have affected Jodi's emotional development. Some theorize that it may have led her to search for father figures in her adult life. If anyone could have served in that role, friends say it was John Stefanich, simply known as "Coach" to many in town at the time.

Jodi's golf coach, Stefanich was also her sixth-grade teacher who later admitted that, when Jodi first became a student in his class, he was initially concerned about the time and effort it would likely take to keep the witty and chatty girl focused and on track. But the two became fast friends and he was important to Jodi not only as a teacher and coach; Jodi came to admire him as a mentor and a father figure of sorts, and was said by friends to have stayed in touch with him long after her days in primary school were over.

Jodi was lucky in that she was not alone in having to navigate the early life storm caused by her father's death. She had the backing of extended family and friends. One of Jodi's longtime friends, Staci Wagner, remembers her youthful efforts to keep Jodi busy the summer of her father's death. She recalls Jodi as being strong, remarking that Jodi did not show her grief easily or openly during the time. But her sister recalls the strain of her father's illness on her younger sibling, saying Jodi became "too thin" during the ordeal.

Jodi's oldest sister, JoAnn, was already grown and no longer lived at home when their father died. In fact, eighteen years separated Jodi and JoAnn, who said, "When Jodi was in kindergarten, I was teaching kindergarten." Her middle sister, Jill, five years older than Jodi, was out of high school at the time, so Jodi essentially spent much of her teenage years as the only child at home with her mother, Jane. Jane and her later-in-life daughter were close, sharing a special bond, and JoAnn called her baby sister the family's "pride and joy."

As Jodi became a young woman and left her childhood home, she remained devoted to her mom. In the fall of 1994, about a year after she was hired at KIMT, Jodi and her mom took a vacation cruise to Mexico together. Later, Jodi recorded an anecdote in her journal about the onboard safety briefing on that cruise. Following the briefing, Jodi was amused when her mother asked if she was expected to wear her life vest for the entire cruise.

As close as she was to her mother when she lived at home, the highly social Jodi also reached out for more family togetherness. Two of Jodi's closest girlhood friends both say Jodi spent a great deal of time at their respective homes and grew close to both of their families, relishing the noisy family atmosphere she did not experience at home. Jodi also developed a close relationship with an older cousin, Maureen (Jude) Seliski, who says she and her parents, Ruth Ann (Huisentruit) and Victor Jude, had many special times with Jodi. Despite a ten-year age difference, the cousins indulged in their shared love for horseback riding at the Jude family farm in Maple Lake.

As a teenager, Jodi was a good student, and was involved in lots of extracurricular activities in addition to golf. She participated in volleyball and basketball, played the clarinet in the Long Prairie High School Band, and served as rifle commander in the band auxiliary. According to friends, she "gave her all" to whatever activity she pursued.

Following high school, Jodi attended Minnesota's St. Cloud State University, where she studied TV broadcasting and speech communication, and earned her bachelor's degree in 1990. Attending college also gave her the opportunity to study abroad, and she spent a semester in England as part of her curriculum. While there and during a visit from her Aunt Ruth and Uncle Vic, she even had the chance to golf at Scotland's legendary St. Andrew's course with her uncle. On the back of a photo taken of her at the Scottish golf course in September of 1987, Jodi penned these remarks:

We went to Scotland for the weekend and stayed in St. Andrew's Friday night. We golfed the Jubilee course on Saturday and had a great time. It was like a dream to be golfing in St. Andrews. There was a golf tournament on the Old Course so we saw Sean Connery (James Bond). I won a few Scotch/lemonades and was declared SCSU's champ by my competition.

Like many other students studying abroad, she took advantage of the opportunity to visit other parts of Europe, as well as North Africa. Jodi spent some time trekking across the continent, too, seeing Rome and other cities, and crossing the Strait of Gibraltar. Photos from North Africa reveal a grinning Jodi atop a camel and setting sail with friends on the Mediterranean Sea.

One of her university college instructors believed Jodi showed promise as a future broadcaster, saying her work in the broadcasting program stood out among that of her fellow students. In an interview aired on *20/20* in 2005, Jodi's professor Gretchen Tiberghien told ABC's Elizabeth Vargas that, unlike some of her other students, she thought Jodi's aspirations in the television news business were "realistic for her capabilities." Perhaps it was her on-camera work, in which she revealed a carefree, yet somewhat crafted persona.

Videotapes that Jodi kept from her college career show a smiling young woman as confident and bubbly on camera as she was in person. In a taped vignette with a male college reporter, *she* was the one who called the shots, determining which "take" would be used. Like many other television personalities, she was highly self-critical and revealed the same demand for perfection that she had previously shown on the golf course.

She expected a lot from herself and from her friends, which apparently gave ammunition to some early enemies. As a former high school boyfriend put it, she demanded as much from others as she did of herself. Tom Kintop, now a Wisconsin chiropractor, spoke openly about their relationship when questioned by a reporter some

time after her disappearance, describing how Jodi wore his ring with yarn tied around it to fit her finger. He went steady with Jodi for almost six years through high school and for a short time afterward, and got to know her and her family very well.

When asked to describe his high school girlfriend, Kintop remarked about Jodi's effervescent personality, but also said that, at the time, "Jodi had some enemies." Questioned further about that curious comment, he said that the younger Jodi tended to push people to be more than what they were. He referred to the rounds of golf she used to play with friends as an example. Jodi would make comments like, "You can do better than that," and "You've got to strive to do better." She would say, "Here, let me show you how I do it."

Kintop said some people tired of that attitude, and some actually grew to actively dislike her. Recognizing, however, that the green-eyed monster may also have been a factor, he said that a lot of people were just plain jealous of Jodi, her winning personality, and what she proved to do with her life after high school. There is no question that Jodi had a tendency to set herself apart from others with her perfectionism, but perhaps it was the sheer force of her vibrant personality that separated her from the rest.

According to friends, Kintop might have been one of the only men Jodi dated long-term and exclusively. Although she'd had another boyfriend or two along the way, as well as many casual dates during college and beyond, friends say most of her other dating relationships didn't last beyond a few months.

During a couple of summer breaks from college, Jodi worked as a bar-cart girl and cocktail waitress at a well-known northern Minnesota resort, Madden's, located on Gull Lake. During one of those summers, Jodi and her childhood friend Staci Wagner worked together at Madden's, a place that the girls viewed as a virtual summertime paradise. After all, as employees at the resort they could play golf, live on the lake, and enjoy access to people with boats.

Wagner recalled their frequent evenings out: "Our goal was . . . to

go out but not bring any money," she said and laughed. The two attractive coeds managed to save their summer earnings *and* met lots of people who would buy them drinks and invite them on boat rides. At the time, Wagner and Jodi viewed it as harmless fun, and the always outgoing Jodi would often remind Wagner of the valuable networking opportunities those outings provided.

Wagner recalled one such evening out that summer. The two young women were invited to a party attended by mostly older men. Wagner described herself as being reluctant to stay at the party, thinking of it as a boring way to spend the evening. Jodi, on the other hand, wanted to stay, and told her friend to think of the networking possibilities and good prospects for future job-hunting. This recollection provided Wagner with one reason not to consider Jodi's later befriending of the much-older John Vansice in Mason City as unusual behavior.

When recalling her friend's relationship with Vansice, Wagner said that she had never met him. She first heard of him in a phone conversation with Jodi. Jodi told her, "I met this guy . . . he's a good friend . . . he's got a boat." Wagner said that, at the time, Jodi didn't think it at all unusual that Vansice named the boat after her. Referring to her friend's frequent weekend waterskiing expeditions with the man and his boat, Wagner shrugged and said, "That's how she was," pointing out that the lively Jodi was always quick to make new friends with whom she shared common interests.

Although Jodi was known to play hard, she certainly worked equally as hard. Between college graduation and her position in Mason City, Jodi proved to be a hungry and ambitious young woman, holding a handful of professional jobs. She earned her "wings" in one of her first work stints after graduation, becoming a flight attendant with Northwest Airlines, an experience that gave her the opportunity for more travel abroad. But aviation was apparently not part of her long-term ambition. She joked with a friend that she felt like a glorified waitress in her airline work, and she apparently felt her vocation was *on* the air, not *in* the air.

She entered the broadcasting business by snagging a reporting internship job at KGAN-TV in Cedar Rapids, Iowa, and served as a general assignment reporter for the station's Iowa City bureau. Her coworkers there called her a fast learner, and remember her as a hardworking, energetic, and friendly young woman. But much to Jodi's disappointment, KGAN management apparently chose not to renew her employment contract, and Jodi returned to her home turf in central Minnesota for a year and a half, working as a news reporter at KSAX-TV in Alexandria.

Those early jobs were just baby steps, however. To begin her ascent to the position that she ultimately wanted, namely that of a major market television anchor, it was necessary for her to pay her dues and put in the time in a smaller-market network-affiliated television station. So when she landed the job in Mason City in the autumn of 1993, she immediately saw a rise in her stature in the television news business.

Of course, Mason City's KIMT was still small-market TV, but it was bigger than tiny KSAX. KIMT also had the advantage of being a CBS network affiliate, and her position there gave Jodi the long-awaited chance to anchor the news. Jodi jumped at the opportunity, and clearly viewed her new position as morning and noon news anchor as a necessary step to reach the TV stardom she longed for. Her boss, former KIMT news director Doug Merbach, called her "a natural fit" for the station's morning newscast. "People could relate to her as the girl next door," he said, and "she just had a natural kind of Midwestern personality that people around here really loved."

Emphasizing how Jodi quickly became part of the Mason City community, Jodi's cousin and friend Maureen Seliski commented that Jodi liked to be a participant in the community events that she reported on. That, and her love for golf, for example, were two of the reasons Jodi readily agreed to be a team member in the Mason City golf event the day before she disappeared.

Cousins Jodi and Maureen carried their friendship into adulthood, and it continued after Seliski married. Jodi, with her infectious

laugh and positive attitude, would often join Seliski and her husband, Joe, for occasional resort vacations and other outings. Just a few weeks before Jodi disappeared, she spent the weekend with her cousin and family at Seliski's home in the Minneapolis area. Seliski chuckled as she recalled Jodi's constant sleep deficit—no doubt a common problem for early news anchors everywhere, and especially so for one with such an active social life. She said Jodi would get comfortable on the sofa and nod off very quickly, unable to stay awake long enough to watch a movie with them that weekend.

During that last weekend visit with her cousin, Seliski said Jodi was her usual bubbly self when talking about a number of her male friends and what they did together. She did not appear troubled, and told Seliski there was no one special in her life at that time. The two women shared a standing, humorous agreement that Seliski and Joe would have to "vet" and approve any future husband for Jodi.

But the anchorwoman was apparently *not* on the lookout for husband material during her tenure in Mason City. Though she met and casually dated a number of men, she apparently did not seek romantic entanglements, choosing instead to focus on her career. Two girlhood friends remember a trip they made to visit Jodi during the time she worked in Iowa City. One of them remarked on Jodi's virtual "interrogation" of them, both of whom were in serious relationships at the time. "Jodi really wanted to know, 'How do you *know* that's the right person?'" She further remarked that Jodi was a great friend for "girl talk," because she was very curious about relationships and life choices.

Though it appears that the very career-driven Jodi did not want to settle for just any man or be tied down while she pursued her television goals, she loved to flirt. Some of her Mason City friends said she had pretty high standards, not only for herself but for a potential romantic or sexual partner as well. According to her Iowa friends, she wouldn't even consider a serious relationship unless the man met at least two standards: he had to be educated and he had to be well connected in the community. She also valued a man with some

element of stature in his professional life, a man respected for his work.

Because of her stringent requirements, or perhaps because she valued the financial security they might offer, many of the men she met, such as John Vansice, tended to be older than she. Although Vansice was her friend, friends say it appeared he didn't meet her level of criteria for a romantic interest, much to his apparent dismay.

Although reluctant to commit to a serious romantic relationship at the time, she dated often, like a lot of other twenty-something year old women. She remained a loyal pal to her many friends, too, through phone calls and frequent visits. One friend recalls what proved to be the last phone conversation she ever had with Jodi. It was on Sunday evening, June 25, and was the casual and common-place chat of longtime friends catching up with each other. They talked of the familiar and the ordinary: about how Jodi spent the out-of town weekend with Tammy Baker, Aunie Kruse, John Vansice, and Trent, Vansice's son.

That "was a new one" to Jodi's pal—it was the first time she had heard of Vansice's son, Trent. She said she hadn't previously known that Vansice was that much older than Jodi, and that he had a son almost their age.

The two women talked in anticipation, too, of the upcoming wedding of their close girlhood friend Staci Wagner, in which they were to serve as bridesmaids. Jodi joked about needing to lose a few fast pounds on a "cabbage-soup diet" so she could fit into the brides-maid gown she was planning to wear that upcoming weekend.

There was one significant part to that final conversation between the two old pals, although Jodi's friend says she didn't attach much importance to it at the time. In retrospect, knowing what she couldn't have known then, she distinctly recalls how she got the sense that Jodi was "worn down," and that she sounded "drained" and emotionally exhausted on the phone.

At the time, her friend dismissed the thought, thinking that anyone would be beat after the kind of weekend Jodi had just

experienced. She said that during the conversation, she thought that Jodi just needed some rest and a couple of good nights' sleep. Jodi was not one to complain, according to her pal, who now wishes she had asked if something was weighing on her friend in those final days.

As noted by her sister and others, Jodi was often naïve and many times remarkably unsuspicious about other peoples' motives. Her open and uncontrived ways were apparently a genuine part of her character. As one close friend described it, Jodi sometimes seemed to lack the instinct or intuition that many of us feel around certain people, the uncomfortable feeling that "this is creepy." But that was part of what made her so much fun—Jodi was inclusive, open to meeting anybody, and was naturally flirtatious. Her humor, laughter, goofy playfulness, and party-girl persona was often misinterpreted—by both men and women—to be a sexual come-on.

Her closest long-term friends, however, insisted that Jodi was not promiscuous, and said that the Jodi they knew was sexually less experienced—more naive, even—than most women her age. They said that Jodi would engage in conversations with, and show genuine fascination in, just about anyone. She was great at "virtually interviewing" others, and was a good listener. The interest she showed in others, they said, "wasn't fake—it was just her."

As generous as she might have been with her time and attention, Jodi was notoriously frugal with her money. One friend remembers as a child being fascinated when visiting Jodi's home by conversations between Jodi's mom and her aunt, conversations she never heard between the adults in her own home. She recalled the two women, whom she laughingly dubbed "colorful characters," sitting at the kitchen table, going through the newspaper ads, yakking at length about the prices of groceries, clipping coupons, and then driving all around town in the search for the lowest prices on tomatoes or ground beef.

Jodi apparently grew up to internalize some of those penny-pinching characteristics. The young anchorwoman was quirky

about clipping coupons, and would think nothing of riffling through her wallet at happy hour to find one for free appetizers. She looked for bargains, shopped for her on-air suits at the sale racks, and bought only items that were marked down. One pal remembers Jodi modeling a suit she had purchased, delightedly crowing that she paid "only ten bucks" for it. She apparently didn't care about name brands or designer labels, but she did want to look good.

Although Jodi did not want for a lot of things, she apparently liked what money could buy, and had the tendency to be drawn to, and impressed by, people with money. During her time in Mason City, several who knew Jodi remembered her habits of befriending older, well-placed members of the community. Friends remarked on it as an interesting dichotomy. Some found it curious that, although Jodi was not terribly materialistic, she was fascinated by and interested in people who lived flashier lifestyles.

Jodi would see no harm in openly enjoying the company of those who would offer to buy her drinks, dinner, or flowers, host her at other events, or offer her outings in their boats. Though she could not reciprocate in kind, she did not hesitate to accept generous offers from others.

Although shunning debt for herself and although frugal in many ways, Jodi was nevertheless devoted to her nearest and dearest, and didn't let her reluctance to spend money get in the way of showing her love for those close to her. She would constantly pen notes and never missed a friend's birthday. Jodi's friends would laugh good-naturedly about another one of her penny-pinching ways: Jodi would buy cards in bulk, and make whatever adjustments were needed. She would write a warm note on a happy anniversary greeting card, for example, then cross out the word "anniversary" and add the word "birthday" or whatever was needed to suit the occasion at hand.

When asked about how their thrifty friend afforded the new 1995 Mazda Miata convertible on her paltry television salary, two friends said that they got the impression that Jodi had received

financial help from her mother. And her sister JoAnn thinks that that was likely the case.

She said that although Jodi may have sought a small loan, her frugal sister wouldn't have wanted to carry a heavy debt load. JoAnn remembers her mother helping Jodi to buy a new Honda (a car she named "Precious") when she first went off to college. Jodi drove that car for years, trading it in to splurge on the new Mazda, the vehicle by which she met her attacker.

To such longtime friends who knew her well, Jodi's life just before her disappearance seemed as happy and carefree as she was, with social engagements and celebrations, such as her own birthday party and her close friend's upcoming wedding.

At least two of Jodi's Minnesota girlhood buddies remembered receiving invitations to Jodi's final surprise birthday party, hosted by John Vansice, and attended by many of her newer friends in Iowa. Many years later, they expressed regret that they were both unable to make it down to Mason City that early June weekend. In hindsight, they rued the fact that they didn't have a better feel for what was going on in Jodi's life just a couple of weeks before her disappearance. Neither one had ever met her Mason City friends, something they dearly wished they had the chance to do after Jodi's disappearance.

And sadly, Jodi never served in her role as anticipated bridesmaid at Staci (Wagner) Steinman's wedding. That wedding, on July 1, 1995, went ahead without Jodi. Wagner shared her painful recollections of that final week before her wedding, which she had taken off from work. She said she had received a phone call from JoAnn that Tuesday, asking if she had heard from Jodi, who had been reported missing. Wagner said that through an ensuing series of urgent phone conversations with her fiancé and her friends and family, her panic and fear grew.

She recalled crying a lot that week, a week that should have been happy and anticipatory for the bride-to-be. She felt guilty and wondered, "Do I get married? Do I cancel it?" Their priest counseled

the couple, telling them that they needed prayers and that it was important for the people who loved Jodi to be together during such a difficult time. So the wedding went on as planned, and the groomsman who was to have walked the aisle with Jodi served in another role that day.

Remembering her wedding day just four days after Jodi went missing, Wagner said that although hearts were grieving, she, as the bride and center of attention, hadn't yet absorbed the full reality of her friend's disappearance. In fact, she said most people that day still harbored a sense of hope for Jodi's return. Fifteen years later, Wagner recalled her nuptials, saying, "I still was thinking she was going to be found."

When asked what she thought happened to Jodi, Wagner did not want to point a finger at anyone specific. But in her heart of hearts, to this day she still feels strongly that Jodi was abducted by someone she knew or had at least met. She said that she has ruled out her friend's disappearance as a random event, believing that Jodi very likely had come face to face, even in a chance encounter, with her attacker before that Tuesday morning.

As loyal as ever to her old friends during her time in Mason City, Jodi collected more of them, beginning upon her arrival there. Although she appears not to have dated anyone seriously during her time at KIMT, she surely got a lot of attention from men. With her good looks, athletic lifestyle, and gregarious personality, she had any number of frequent, casual dates. However, her close friends say they don't know if she had been sexually active at the time; one of them, in fact, said she would be very surprised to hear if Jodi had been. Although men often interpreted her interest in them as sexual, those who knew her from childhood have insisted that Jodi was not promiscuous.

Unlike a lot of media personalities, she continued to be friendly, sometimes too friendly, with everyone she met. More than one of her close friends mentioned incidents in which Jodi showed some lack of discernment, often involving herself in long conversations

and beginning companionships with relative strangers. In social situations in which she, as a local celebrity, naturally drew a lot of attention, she had trouble establishing boundaries.

In public gatherings, many media types find it useful to work the crowd by keeping moving, offering quick smiles and words of thanks. This tact helps to discourage long, monopolizing conversations with over-eager viewers, many of whom are otherwise virtual strangers. Jodi apparently had trouble doing this, however; she didn't like to turn her back on anyone. Given her tendency to do what she liked to call "networking"—what others might call hypersociability or simply having an open and friendly nature—it's clear Jodi loved the attention and camaraderie that came from spending time with others, both men and women.

While working in Mason City, she became part of a large group of singles who congregated on Fridays and other nights at the Other Place, a downtown Mason City pub near both the television station and the Law Enforcement Center, as well as other area watering holes. From there, some from the group would barhop further, or make plans for the weekend, including plans to go boating and waterskiing in the warmer months. Jodi made mention in her journal of her newfound Mason City friends and her passion for waterskiing. Both factored into how she spent her time only three days before her disappearance.

As we know, Lanee Good, one of the servers at the Other Place, was friendly with a number of people in the loosely organized and constantly changing group of Mason City friends of which Jodi became a part, and she identified some of the "regulars." John Vansice had been drawn into that group when, following a 1994 divorce, he temporarily moved into the Key Apartments and befriended his new neighbor, Jodi. Bill Pruin, a good-looking Mason City area farmer who died an untimely death barely three months before Jodi's disappearance, was also seen often at the Other Place.

Jodi's friendships with both Vansice and Pruin apparently created some jealous posturing between the two men. Good has

offered interesting insights into the dynamics of the relationship between these men at the time. She mentioned Vansice's blustery personality and his tendency to display one-upmanship behavior toward the more restrained Pruin.

When Pruin would relate a story, for example, Vansice would often have a longer, better, louder account of a similar story. Good likened the men's behavior around each other to that of some animal species where the males "puff up" to display dominance over the other. As Good noted, it is common mate-attracting behavior among some members of the animal kingdom, and apparently often manifests itself in human males, too.

Jodi surely proved to be a magnet for new friends such as Vansice and Pruin. Despite the early setback of her father's death, Jodi was by all accounts a natural optimist, a person who chose to see the best in life and in others. As an adult, she maintained an almost tangible zest for living, and loved the opportunities she'd had to travel. At one point she told her mother, "I am so lucky. I have such a wonderful life. I've been to so many places, and known so many people. I get to do so many interesting things."

Bolstering her naturally positive attitude, Jodi listened to motivational and self-improvement tapes, most notably an Anthony Robbins success course. Purposely choosing to minimize the negative aspects of her life, she remained upbeat, gravitating toward the good she saw in people. She would likely have agreed with Winston Churchill, who was once quoted as saying, "I am an optimist. It does not seem to be too much use being anything else!"

Jodi inked her goals in a journal, and apparently took inspiration from Christian Larson's "The Optimist's Creed." It reads:

> I promise myself To be so strong that nothing can disturb my peace of mind. To talk health, happiness, and prosperity to every person I meet. To make all my friends feel that there is something worthwhile in them. To look at the sunny side of everything and make my optimism come true. To think

only of the best, to work only for the best, and to expect only the best. To be just as enthusiastic about the success of others as I am about my own. To forget the mistakes of the past and press on to the greater achievements of the future. To wear a cheerful expression at all times and give a smile to every living creature I meet. To give so much time to improving myself that I have no time to criticize others. To be too large for worry, too noble for anger, too strong for fear, and too happy to permit the presence of trouble. To think well of myself and to proclaim this fact to the world, not in loud word, but in great deeds. To live in the faith that the whole world is on my side, so long as I am true to the best that is in me.

Some time after her disappearance, a California psychic shared with a reporter a phrase that he said emerged from what he referred to as the "unconscious collective" (a phrase famously attributed to psychotherapist Carl Jung as the "collective unconscience"). The phrase that emerged, he said, was a communication from Jodi— from beyond the grave. This psychic credits Jodi's spirit for citing the phrase "to thine own self be true" in an effort to open up the lines of extrasensory communication and to validate herself. The psychic suggested that, while she was alive, perhaps Jodi would have had these words framed somewhere in her apartment.

After the attack, a KAAL-TV news videographer was shooting footage as Jodi's sister JoAnn and cousin Maureen shared the somber duty of removing some of Jodi's personal effects from her apartment. One scene captured that day showed a framed print of "The Optimist's Creed" sitting atop other items in a box of Jodi's belongings. That line, "so long as I am true to the best that is in me" was clearly visible in the image. Strikingly, those words immediately bring to mind the words of another similar adage: to thine own self be true.

"Those who know the joys and miseries of celebrity know it is a sort of octopus with innumerable tentacles. It throws out its clammy arms on the right and on the left, in front and behind, and gathers into its thousand little inhaling organs all the gossip and slander and praise afloat to spit it out again . . ."

—Sarah Bernhardt

CHAPTER NINE

THE MIRROR HAS TWO FACES

> " He who answers a matter before he hears the
> facts—it is folly and shame to him. "
>
> — Proverbs 18:13

Truth always tends to lie somewhere between two extremes, and I'd be crazy to expect it to be any different in my investigation into Jodi's story. In my research, I encountered continual resistance from nearly every source I contacted. Maybe it's not surprising. For what may be obvious reasons, those close to Jodi—her family and friends—have been naturally hesitant to talk to outsiders. Understandably, they fear exploitation—Jodi's and their own.

As I initially tried to earn the trust of those who could tell me more about a woman I never really knew, I was surprised that they didn't necessarily want to cooperate with me. Although many, of course, currently wish to keep the case alive in hopes of getting some answers to their questions, they've often been approached by people with less than stellar motives, including those who want to find the "dirt." And as far as they were concerned, I was just one more muckraker.

Some of those who worked with Jodi in the broadcasting

business were also initially reluctant to talk to me. For them, too, her disappearance was personal—a painful chapter in their professional lives. Doug Merbach, her former boss, was one person who admitted to dealing with a great sense of loss after his employee's abduction. He said that he stayed awake for "weeks, months and years" wondering and worrying about Jodi.

And he freely talked about the emotional impact the case had on him. He felt guilty and depressed; he stopped working out and stopped playing golf. He didn't want to go out in public and didn't want to take calls, even from friends. In fact, he began to retreat from those well-meaning friends. It was his way of avoiding the constant questions and gossipy chatter about the case.

Investigators and others who could fill in the blanks often had their own reasons for withholding their support of my efforts. They didn't necessarily want to see the information they could offer me printed in black and white, especially alongside their names. It's easy to understand why police officials to this day remain extremely reluctant to go on the record with their observations about this high-profile case that has been cold for so long.

And it's fair to say that others may simply fear retribution or retaliation from whoever perpetrated the crime. Indeed, I've found that those who have strong private convictions about who was responsible for Jodi's disappearance fear naming names in the public arena. They remain reluctant to make private suspicions public. Because of this, many of the observations they shared with me were offered on the condition that I consider them "off the record."

Finding and telling the truth about Jodi's life and her disappearance became my ultimate goal, but it wasn't always easy. Because I heard several conflicting stories, I found it difficult to differentiate between fact and fiction. It may sound clichéd, but things aren't always what they seem, and people aren't always who they seem to be.

Gossip is one perfect example. Simply said, I've heard much

gossip about Jodi. Some of it was salacious and raunchy and downright cruel. Many of the stories were wildly untrue, and many others probably harbored kernels of truth. But much of it was simply and obviously trash.

For that reason alone, I'm not willing to take claims about Jodi at face value. But I also have some personal experience with gossip. During my tenure in television, I was confused and mystified by the repetition of blatantly untrue stories about me and my private life. I'm thus hesitant to accept many of the stories about Jodi as blanket truth because I know what it's like to be the subject of so many untrue rumors.

In trying to balance the stories about the public Jodi and the private Jodi, chances are we will never know the truth. That has likely gone to the grave with Jodi. A few stories about Jodi that I learned as I researched her disappearance highlight the challenges we face when trying to accurately put together the pieces of the bigger picture.

One woman remembers meeting KIMT's Robin Wolfram and Jodi Huisentruit at a talent show in Ventura, Iowa. The two anchors were there to emcee the event, and in between their stage appearances they stayed in the backstage area to direct people to go on when their turns were up. The visitor, there to provide piano backup for a contestant, says she sensed some tension and competitive jealousy between the taller Wolfram, who seemed to be doing all the talking and directing, and the smaller Jodi, who smiled but said little.

Did that perception detect something true about the relationship between the two women, or did the observer just pick up on something about the circumstances at the time? Was the perception accurate at all? The woman remembers another aspect of that long-ago event. While waiting for the judges to make their decisions about the winners, Wolfram emceed and Jodi entertained the audience with a kind of marching or baton twirling routine. It looked to the witness as if Robin was calling the shots for Jodi to be silly and

that Jodi resented it. But the audience apparently lapped up the crazy antics—the two women had them laughing. Was *this* observation accurate? Does it validate the witness's earlier observation?

A server at one of the Mason City and Clear Lake bars frequented by Jodi and her colleagues tells another story that was passed from one server to another to yet another; it's one that the bar workers thought was pretty "juicy." Apparently, John Vansice and Billy Pruin nearly came to blows in a bar one night when Vansice spotted Pruin and Jodi dancing together. Vansice became extremely jealous and angry, striding up to Pruin, shoving him in the chest, and yelling, "Jodi's *my* girl! *Nobody* dances with her but me! If you do that again, I'll kill you!" Then he turned to Jodi, held out his arms and said, "Let's show him how *we* do it." In response, they say Jodi leapt up into Vansice's arms, wrapped her legs around his torso, and ground up against him.

Is this story true? Was it embellished in the retelling? Told this way, the story raises any number of questions and much fodder for gossip and speculation. Was Jodi at all embarrassed or made angry by the macho display and intimidating stance? If not, why not? Did the possessive behavior excite Jodi? Was her response her way of placating Vansice, an attempt to defuse a display of impulsive anger? Or is the whole story just an exaggerated tale?

In my research, I've heard a lot of stories like these. Some are likely true, and no doubt many are not. I feel as if I've heard them all. I've definitely heard just about everything negative that anyone can say about Jodi: She was hated by her coworkers at KIMT, especially the females who were threatened by her. She had a tense and competitive relationship with other female anchors at her station. She was high maintenance, not a "real" journalist, showed little interest in reporting, and just wanted to get her pretty face on television.

Furthermore, some say, she thought she could charm herself out of doing the work of reporting. She wantonly flirted with older and wealthier men. She flaunted her sexuality and her attractive, petite

figure by prancing around in suggestive clothing. She was a show-off, a gold-digger, and a "tease." She used hard drugs in public places. Whether they were stories of sexual misbehavior or drug usage, the rumor mill worked overtime.

So I've heard the stories, and I don't buy them—certainly not all of them.

Consider the other side. Many of her former television colleagues spoke highly of her; they noted her willingness to learn and work hard, and remarked on her genuine interest and involvement in the northern Iowa community. She showed real warmth and friendliness to people whom others often avoided. Her sister JoAnn called Jodi a woman with high ideals—"the cream of the crop"—and said she was "clean," not interested in using hard drugs. Longtime friends staunchly defended their late friend's honor, insisting that Jodi was not promiscuous, that she had high standards in her personal life. The Jodi they knew simply did not "sleep around."

Others describe her as a wholesome Midwestern girl; a "ray of sunshine"; and a loyal and caring friend, sister, and daughter. Several former colleagues called her a quick study, smart yet humble in her willingness to learn from others. Many of her acquaintances and friends recalled her optimistic nature, her sharp wit, a down-to-earth sense of humor, and her distinctive and ready laugh. They say Jodi was not one to listen to naysayers, either; she was ambitious and driven to succeed.

Was Jodi Huisentruit a Miss Goody Two-Shoes? Probably not, and these positive portrayals don't claim that she was. But since I didn't know her well and she's not here to defend herself or to set the record straight, I choose to err on the side of belief in those who did; those who knew her well had more positive than negative things to say.

This is a more realistic portrait of Jodi that emerges from the descriptions of those who knew her well:

- She was not a "news junkie," but she really liked the public exposure her job afforded. She wanted to be a television star,

not a hard-nosed reporter. In wanting this, she wasn't the first or the last television reporter to think that way.

- She was ambitious, driven to work hard and play hard.

- She put her career first, chose to play the field socially, dated a lot, and didn't want to be tied down.

- She was compassionate and loyal to her friends and family.

- She enjoyed the party life, and liked to drink, especially beer.

- She liked to dress in attractive, well-fitting clothing and wanted to look good, as do many women.

- She was active and athletic: She jumped at the chance to play a round of golf, or don a bikini, hang out at the lake, waterski with friends, and tip a few glasses afterward.

- She loved to laugh, socialize, and be friendly and inclusive with everyone, men and women.

During their investigation, police and private investigators alike tended to agree on one issue: Jodi was an all-American girl who frankly didn't have a lot of "dirt" in her background. Although they tried to find fault in her as a way to identify a potential motive for murder, they simply couldn't pinpoint hard-and-fast reasons for someone to be driven to eliminate her.

Although he was never apparently hired in connection with Jodi's disappearance, one private investigator who has immersed himself in the case, Jim Feldhaus of South Dakota, apparently spent years trying to learn new information. He opines that Jodi apparently didn't have any real enemies, so it's nearly impossible to conjure up a motive for why she was targeted. Feldhaus recently said that he still works the phones occasionally trying to get information. He said, "We simply clear one possible suspect after another, until we are left with a suspect that we can't clear."

He's speculated that Jodi was in the wrong place at the wrong time, or stayed too long in the company of the wrong people, perhaps overhearing something she shouldn't have. Like others, Feldhaus

has deep-seated convictions about the case and about who is responsible, but he can't prove it. He is, however, sure of one thing: "The world is out to get people who do things like this. Whoever did this—he has no friends."

Iowa Private Investigator Jerry Koerber said that everything he dug up in his work has convinced him that Jodi was a fun-loving woman and a natural flirt, but that she was not promiscuous. In the course of his work, he developed a network of unidentified informants, those who could provide insight into the crime. He probed her social life, too, and remains convinced that she wasn't necessarily out-of-bounds in her personal behavior.

A lot of conjecture and hearsay does not add up to a motive. Jodi's actions simply cannot explain what happened to her. Nothing she did can be reasonably seen as "asking for it." Chances are, the truth can be found somewhere in between the pictures of Jodi the saint and Jodi the sinner. If we are honest, that can be said for most of us.

CHAPTER TEN

JODI'S JOURNAL

> ❝All writers have concealed more
> than they revealed.❞
>
> —Anaïs Nin

Journalists learn very early to write under pressure, whether they like it or not, because deadlines are part and parcel of life in the newsroom. No matter how the deadline manifests itself—a newspaper editor cracking the whip, a book publisher pressing for the latest pages, or the clock ticking down the seconds to the airing of a television newscast—"the show must go on." While not everyone finds it fun to crank out a story under deadline, some people claim to work better under pressure. And most professional writers find some enjoyment in and get a feeling of accomplishment in having to "deliver the goods" on time.

Fingers to keyboard or pen to paper, many like to write outside the confines of a deadline, too. Observations, poetry, stories, record keeping, and goal setting are all forms of private release. Jodi apparently found pleasure in keeping a journal, and although much of what she wrote was unremarkable and even somewhat prosaic, the discovery of the existence of that journal came as a surprise long

after her death. It is safe to say she never realized her private musings would become public.

In 2008, thirteen years after her disappearance, Jodi's private diary was made public for the first time in a surprising way. In the aftermath of the 1995 crime, the eighty-four-page journal was one of the items taken by police from her apartment as evidence. Surely investigators at the time scoured the notebook for clues into what happened and who was involved in her life, but its existence was never revealed to the media or the public. So when it finally surfaced, that diary set off a storm of controversy.

On an otherwise routine day in June 2008, a reporter on staff at the Mason City *Globe Gazette* newspaper, Bob Link, picked up his mail and discovered what he probably thought was "manna from heaven." A front-page story, the perfect highlight for an anticipated upcoming anniversary observance, dropped right into his lap. Not every story is destined to be on the front page. This one was, and Link knew he had something.

As a longtime newsman, Link knew that sometimes finding a story to write about is easy. After all, news happens every day. Some of it is fascinating; some of it interesting and thought provoking, but very often much of it is downright mundane. Link knew his business and was familiar with the mundane, and he was used to getting on the phone or going out to beat the bushes for something—anything—to write about. In this case, the packet he received in the mail proved to be new information about an old story, and Link recognized that it was almost immediately exploitable as lead news.

Whether we like to admit it or not, bad news sells. "If it bleeds, it leads" tends to be a common mantra repeated in television news-rooms. In fact, sensational, violent, or blood-soaked news often appears right at the start of a TV newscast. As evidenced by the way auto traffic slows as individual drivers pass by an accident site, human beings tend to be fascinated by others' misfortunes.

Television news admittedly exploits that tendency for a very simple reason: there is a direct correlation between more viewers

and more advertising dollars. More viewers mean higher ratings, which translates into higher advertising rates for air time. Like their television colleagues, many print journalists exploit sensational news in the same way.

Scanning through his mail that day, Link found a sheaf of papers inside an oversized envelope bearing a June 4 postmark from Waterloo, Iowa, but no return address. The contents proved to be quite a scoop. A journal reputedly penned by the longtime missing anchorwoman Jodi Huisentruit would make great front-page copy. We can only imagine the thoughts and questions running through Link's mind and the emotions he felt when he identified the package as containing the copy of Jodi's journal: Who sent this? Is this what I think it is? Is it the real thing? Why me? Is there more to it? Why was it sent here instead of the TV station?

As any self-respecting newspaper reporter would do, Link took advantage of the information by publishing a story about the as-yet-unknown journal on the front page of the June 23, 2008, edition of the *Globe Gazette*. The move was anything but impulsive: Link let nineteen days lapse between the time he received the journal and the day he published the story.

Reflecting on the events of that early summer, Bob Link said that the package was not sent with his prior knowledge or permission, and that he initially wasn't sure what to think when he first received the journal in the mail. In fact, he said he "sat on it" for three or four days, and as might be expected, he pored over it, intensely curious to see if its contents matched up with other facts he had heard and knew to be true about the case.

Furthermore, he had not been an original insider on this story, because he had not been part of Mason City's journalism community at the time of the crime. A North Dakota native who came to Iowa after a number of years at the *Bismarck Tribune*, Link said he had formed few preconceived notions about Jodi and the crime.

Link became convinced he was holding a bona fide copy of a journal originally penned by Jodi and eventually revealed his

possession to the city editor and the managing editor of the *Globe Gazette*. Both he and the paper's editors showed a good deal of journalistic integrity in choosing not to rush to publication with such a highly sensitive piece of information. The big concern became how to substantiate the document, and it took some work to do so.

After conferring with police, Link learned that, indeed, a diary or journal had been taken as evidence at the time of the crime, something not then widely known. The fact that a copy of the journal surfaced in that summer of 2008 posed a different kind of dilemma in police quarters: the department now had mud on its face. Why had the information been leaked in this way to the public? Who had possession of the notebook besides police?

Link later said that the police and the Iowa DCI (Department of Criminal Investigation) tried to dissuade him and the newspaper from publishing any part of the journal, arguing that it might compromise the case by providing as yet unknown details to the public (and perhaps the perpetrator as well). Just why police thought that the publication would hinder an already-cold investigation is not clear.

It did not take long for an internal police department probe to discover that the wife of a former police chief was responsible for sending the copy. After nine years at the helm, former Chief David Ellingson resigned from the Mason City Police Department in the summer of 2006. Link says Ellingson resigned under pressure, and he described the chief as a victim of "political posturing" within the department.

Officials would only say that when Chief Ellingson vacated his office, he "inadvertently" took a copy of the diary with him. His wife reportedly found it later in their home as they were preparing to move, and it was her decision to share it with the newspaper. As a result of the probe, the Mason City police department determined that Ellingson had broken no laws and the department did not file any charges in connection with the leaked document.

So why did Bob Link receive the journal in the first place? When

considering this question, Link said that during his newspaper days at the *Globe Gazette,* he had developed a good working relationship with the police chief and thought highly of Ellingson. Link knew Ellingson's wife, Cheryl, only casually at the time, but he thought that she had chosen him to receive the journal because of his trust and belief in her husband. It may be that Ellingson's wife also desired to make the police department look bad, after what she viewed as the department's poor treatment of her husband. Furthermore, the *Globe Gazette* had employed Cheryl Ellingson in the past, which may be another reason she chose to send it to the newspaper instead of another media outlet.

According to Link, the eighty-four pages he received was the whole of Jodi's journal, representing roughly a year and a half of Jodi's life before her disappearance. He now claims that he no longer has a copy of the document, having ceded it to the newspaper and the police after publication of the story.

As for the diary itself, Jodi started it in early 1994, although she apparently kept journals like it throughout her life. Her sister JoAnn, although she never read the diary, was not surprised to learn of its existence, since she knew that Jodi was interested in self-improvement. It made sense that Jodi would write about it and use a journal as a means of self-reflection.

She was clearly not content with complacency. From her youth, ambition and drive defined Jodi's nature, and her childhood environment and experiences apparently enhanced it. She wanted it all: fame, notoriety, stardom, and money. She worked hard to move up in the television business, and, given what she says in her journal, apparently found a good deal of inspiration and motivation in the work of Anthony Robbins.

Robbins, the author of *Awaken the Giant Within* and *Unlimited Power: The New Science of Personal Achievement* exhorts his readers and followers to write specific, measurable, timely and action-oriented goals toward what they want. Jodi took Robbins' advice seriously, internalized it, and was committed to living Robbins' words:

The truth of the matter is that there's nothing you can't accomplish if 1) you clearly decide what it is that you're absolutely committed to achieving, 2) you're willing to take massive action, 3) you notice what's working or not, and 4) you continue to change your approach until you achieve what you want, using whatever life gives you along the way.

Robbins also helped to popularize this old adage: if you do what you've always done, you'll get what you've always gotten. Some prefer Will Rogers's more homespun version of the same advice: "If you always do what you always did, you'll always get what you always got."

Quotes like that resonated with Jodi, who saw no bounds to what she could achieve if she committed herself to it. In her journal, she continually reminded herself to "focus" on her goals, something preached by Robbins and other well-known motivational speakers. Did her ambition to be a major player in the world of television news blind her to the reality of the downside to such notoriety? Did she become so intent on her career that she made foolish choices and ignored her personal safety?

During the time the diary became public, an unidentified woman was critical of the way Jodi expressed herself in writing. The woman, in an online chat room, expressed her opinion that Jodi's writing was atypical for a single woman. She claimed when women keep diaries, they seem to be more romantic in a "Bridget Jones kind of way," writing about personal and relationship issues. But Jodi placed much value on her career development at the time, so that's what she thought and wrote about.

A line from the book of Matthew (6:21) illustrates this basic truth: "...for where your treasure is, there will your heart be also." Jodi poured much of her heart and soul into writing about the importance of her career, and her desires for the future were all centered on that—more money, TV fame, and a bigger TV market. Sadly, she did not live long enough to make those idyllic dreams come true.

The selected parts of the journal that were made public revealed nothing terribly notable or shocking. Most of the entries were fairly commonplace observations about daily activities and lists in which Jodi reminded herself about how to channel her energy. Jodi's loopy, girlish handwriting provided little real insight. But, despite the lack of depth, the notes proved she was especially concerned about her professional life in the months before her disappearance. Like many young television anchors, she wanted to be able to move up in the broadcast industry and get a job in a top-thirty U.S. television market.

We will never know whether she would have reached that lofty goal. Talent, like beauty, lies in the eye of the beholder. Television news has been called the most subjective business on the planet where news talent is concerned.

The journal highlighted her intense desire to succeed, but also revealed some of the fears and doubts she had about her ability to do so. It showed the insecure side of the young woman who made her living out of appearing so confident. She was confused about how to get an agent to represent her, and apparently was concerned about her voice development, and how her distinctive vocal inflections would affect her chances of relocating.

Colleague Brian Mastre recalls Jodi asking some of her newsroom cohorts for constructive critiques of her work during that time. He suspected that, in addition to her voice, she was told she needed more reporting samples and live shots reflected on her demo tape, the tape she used to showcase her work to other TV stations. He said he saw her a bit more around the newsroom in the spring of 1995, while she was actively preparing new audition tapes, and he remembers her working hard to soften her uniquely Minnesota sound.

Voice consultants with whom she had worked had apparently commented on Jodi's "thick" and somewhat nasal Minnesota accent. Former KIMT news director Doug Merbach, who hired Jodi, good-naturedly joked about the way she pronounced the long vowels in

her name ("Jo-dee Hoosentroot") and thought she could benefit from some vocal coaching. He also joked about having to remind her to keep her chatty tendencies at bay on the air. Some casual time-filling chat was fine in the early morning show, but it was less appropriate for the business-as-usual noon newscast.

Even today, one can happen upon a clip of one of her television appearances online and hear that unique sound. It's hard not to laugh at one of Jodi's off-the-cuff comments made way back when. Waving her hands and chatting with a coanchor about the weather, she blurted, "It's gonna be a doozy, let me tell ya!"

In the pages of her journal, she cited two nationally known television personalities of the time, Paula Zahn and Kathie Lee Gifford, as role models. The central Minnesota native also revealed a longing to work in a warmer climate, perhaps Arizona, and Jodi wrote that she'd like "to see what they think about my accent." She wrote she might even consider producing the news in an Arizona market.

In one of her earliest entries, written in late January 1994, she wrote,

> I love news, improve my career, make more money, communicate, have more impact on a larger audience. Get the Huisentruit name out. Make mom proud. I need to give myself five years in business. I'm not where I want to be.

In the spring of 1994, about a month before her twenty-sixth birthday, Jodi made her goals more specific. This entry itemized her ambitions in television news:

$100,000 (salary) by the time I'm 28. Main anchor, top 30 market

How will I get there?
1. Stay committed
2. Look and feel my best:

- exercise
- 110 lbs.

3. Practice voice daily for half an hour
 - Read about voice—review notes from pros/consultants
 - 15 minutes—read aloud and practice what I'm working on!
4. Picture myself being Paula Zahn
 - Model after her
 - Watch anchors who I want to be
 - Invest $ for consultant
5. Act like who I want to be daily!
6. Stay on media line

But Jodi didn't live in a vacuum—daily life took some time away from her pursuit of these professional goals. We know she was not an "all-work-and-no-play" kind of girl. A highly social creature, she liked her free time, too, and valued her personal relationships with others. In an undated entry, she stressed her personal life (we can assume the entry was pre-John Vansice, who appeared in her life later). Work and friends filled her days, and she expressed appreciation for her many friends and for her life, but she longed for more.

Even in this entry, she addressed her personal relationships and then firmly turned it right back to her professional ambitions:

Now I can honestly say, I think, from all the guys I've dated, I'm ready to find Mr. Right. I'm kind of fed up with the dating scene. Just like to find someone special. I'm set to get refocused on my goals. It's funny how I've got into certain routines and out of them. I must stay focused!!!

Though John Vansice was apparently not "Mr. Right," the last three entries in the journal included his name (and that of his son, Trent) and their activities. A paragraph written Sunday, June 11,

1995 reveals some details about what proved to be her last birthday bash:

> What a weekend, Surprise. My Mason City/Clear Lake friends thru [threw] a big party for me! At a lounge, wild. It was in Clear Lake. They had a 16 gal keg—huge cake (with a skier) so much left. John Vansice grilled 150 pork burgers, we were dancing on tables . . . dancing everywhere . . . Everyone had a ball. Video camera was rolling, cameras were clicking—oh what fun! Life is so good. The party made me feel so good.

Then, Tuesday, June 13, 1995:

> Last night, John . . . and I went to the Glen Miller Orchestra in Belmond. I have so many great viewers. People are so kind. This nice weather has me wild. I bought a new Mazda Miata, simply love it.

Jodi's final journal musings, neither particularly deep nor poignant, referred to the last weekend of her life spent with Vansice. These words were written less than two days before her disappearance:

Sunday, June 25, 1995

> Got home from a weekend road trip to Iowa City—oh we had fun! It was wild, partying and waterskiing. We skied at the Coralville Res (Reservoir). I'm improving on the skis—hips up, lean, etc. John's son Trent gave me some great ski tip advice.
> Today, Sunday, it was raining in Mason City, so didn't get any skiing in. I love it, it's addicting.

Great friends but professionally, I'm fed up. It's difficult finding a new job and I'm confused about agent and what to do.

This is where the diary ends. Right through the last page, it's apparent that Jodi loved her life, and was excited about the future, even though she expressed normal human doubts.

The journal is notable in that she did not reveal herself as being troubled, as behaving in a troubling way, or expressing overt concern over her relationship with Vansice or anyone else. Nothing in the parts of the journal made public would point the finger toward a suspect or motive, and there is no proof of her concern about a possible stalker or stalkers, concern she was said to have expressed verbally to her mother and others. She appeared to be a typical twenty-something-year-old woman, albeit one with a consistent need for attention and with particularly high career ambitions.

The diary excerpts give us a fascinating glimpse into parts of Jodi's life. But right down to the final passage, it fails to provide further insight into what happened to her less than forty-eight hours after her final entry.

CHAPTER ELEVEN

OBSESSION

> " The thought had taken root in his
> imagination . . . until it crowded out all
> other thoughts in his mind. "
>
> —Frances Marion

It's the paradox of notoriety: one who seeks stardom generally comes to resent the intrusion it makes into private life. It's impossible to separate the two. An anchorwoman becomes fair game for public scrutiny because of her fame. She keeps a schedule that essentially becomes part of the "public record."

It certainly does not take a genius to observe her on-air schedule or to determine where she lives. It is not a stretch for an interested party to learn of her comings and goings, the people with whom she spends her time, what she likes to do away from work, where she shops, and her favorite restaurants and watering holes. Perhaps it is even easier in a Midwestern town like Mason City, Iowa, with a population of about thirty thousand.

Let's face it: attractive newscasters are the norm. Because television is a medium that values youth and beauty, station managers tend to hire newscasters who are reasonably attractive. Network affiliates and today's cable channels still tend to recruit the brightest

and prettiest women they can find to anchor their popular news shows, providing what some call "intelligent eye candy." Ratings-driven newscasts demand viewers who want to watch for any reason. The most accurate weather forecast, the most local news, the cutest anchorwoman...it doesn't matter *why* viewers watch...it only matters *that* they watch.

Television stations want the general public to make the daily decision to invite reporters and anchors into their homes (or their kitchens, living rooms, or bedrooms) and to identify with them as friends, family members, and trusted advisors. When a celebrity appears in public, either on station business or personal business, it only deepens the connection for the viewer. So it becomes easy to see why some in the audience can regard a public appearance as an invitation and take it a little too far. Fans and potential stalkers alike seek out the presence of a favorite broadcaster.

So it is not always a point of pride that virtually every on-air personality (male or female) in any television market is the subject of fascination to someone in the viewing audience—someone perhaps inordinately concerned with her schedule, her face, her personality and on-air appearance. According to nationally known California forensic psychiatrist Dr. Park Dietz, the question is not *if* a celebrity has any stalkers, but *how many* he or she has.

Dietz, a pioneering researcher and leading consultant on stalking, violence prevention, and threat assessment, has spent years investigating and testifying against serial killers and stalkers, including extremely high-profile ones like Jeffrey Dahmer and John Hinckley. He has said that the stalking of television news personalities is an occupational hazard that few in the broadcasting industry like to recognize or discuss. Nobody knows how many anchors on the news get stalked each year, but Dietz puts the likelihood for good-looking females on the nightly news at close to one hundred percent.

It's sometimes risky business to be a celebrity, although most television anchors and reporters tend to diminish the hazards. But local television reporting is increasingly becoming a dangerous

occupation. Experts say a confluence of factors has made the job more perilous, even as the industry has been reluctant to confront the issue in any meaningful way.

That's not to say that station managers don't deal with the problem once someone is targeted. In fact, many stations have far better security systems now than they did a decade ago. But the safety problems in the business—a business that is dominated by crime coverage and one that packages its journalists as personalities and even commodities—aren't addressed by professional organizations or academia.

Stalking, sometimes also called psychological terrorism, is not a joking matter, nor is it something to be desired. Having a stalker is nothing to be proud of. When stalkers step over the line, their fascination becomes a dangerous obsession.

Television personalities are hard pressed to escape such attention. Being in the public eye brings unwarranted attention both when it is wanted and when it is least wanted, because of the illusion of intimacy inherent in the act of watching television. It's what stations bank on to keep their ratings high ... that elusive and hard-to-define connection between broadcaster and viewer. And it's inevitable that some viewers, the mentally unstable included, are pulled in because of it. Donna McNeely, author of *Stuck in the Box: A Life in Local TV News,* describes it this way:

> Television creates a false intimacy for the viewer. As a local TV reporter, and especially as a local anchor, you're in the viewer's home everyday, looking at them, smiling at them. You're not an actress playing a role; you are being you ... at least the TV version of you. Viewers know this and therefore begin to believe that they *know* you. Why shouldn't they feel this way? You're speaking directly to them ... As a news anchor, you're just one more attractive female commodity to be consumed in daily doses—but the viewer also comes to believe that you are their *friend.*

While men on television aren't immune to obsessed fans, stalkers more frequently target women. Dr. Dietz identifies the ideal victim as a gentle, pretty, approachable virgin-type, a profile that allows many males in the audience to think, "She's meant for me."

If Jodi Huisentruit was the victim of a stalker, her situation was not unprecedented. Other young television newswomen around the country have been victims before and since Jodi's disappearance. Some of the stories from small towns and big cities provide unnerving accounts of how assailants come to view their prey as objects of desire.

In 1998, a twenty-one-year-old stalker in Temple, Texas, was convicted of the murder of Kathryn Dettman. Dettman, a thirty-six-year-old reporter, was on the verge of an important career move, and she was excited about her impending relocation to Dallas, where she had accepted a new job at a much larger TV station. Stepping out of the shower on the morning of January 22, 1998, she met her stalker face to face and died after an extremely violent attack: she was viciously stabbed multiple times.

It did not take long for police to make an arrest. When police arrived on the scene, the later-convicted murderer, Anthony Silvestri, was found hiding in Dettman's bedroom, his clothes soaked with her blood. Silvestri lived in the same apartment complex, and had been following Dettman, flattering her, asking her out. On the morning of the attack, he had apparently entered her apartment through a door she had left open for her pets to use.

Dettman, described by her best friend as a trusting person (as Jodi has been called), didn't recognize Silvestri's interest as potentially dangerous, although it's hard to say what would have happened even if she had. Many on-air personalities aren't even aware they're being stalked, and there's little protection that can be legally afforded a stalking victim, at least in the early stages of a dangerous obsession.

Could Dettman have prevented the attack? Even her attacker, interviewed in jail, admits he doesn't know. "I've never blown up

like that before, went off on anybody like that," said Anthony Silvestri. "Maybe she could've left the door closed. Maybe she could've screamed at me. She could've hit me. She could've done something but she didn't." It's interesting to note that while his disclaimer acknowledges the deed, he doesn't take direct responsibility for it, instead placing the onus of the attack on the victim.

A more recent case, the heinous beating death of a Little Rock, Arkansas, anchorwoman, was also brought to a close when her stalker was arrested. Anne Pressly, a lovely and popular twenty-six-year-old morning anchor like Jodi, apparently was awakened when an attacker entered her home in the wee hours of October 20, 2008. Pressly's mother found her daughter later after the younger woman failed to pick up a customary early morning wake-up call. Pressly's nose was broken, her jaw pulverized, and she had suffered facial and skull fractures serious enough to cause a stroke.

She clung to life for another five days, her family by her side, and died without ever regaining consciousness. Not long after her death, a man from Marianna, Arkansas, a town about a hundred miles away from Little Rock, was arrested in connection with the brutal attack. Though her family insists that Pressly was targeted, Little Rock police still believe it was a random home invasion, with robbery as the motive.

As heartbreaking and difficult as these cases are, Dettman's and Pressly's families were able to see some minimal justice prevail in the arrests of the perpetrators. This is not always the case, as another deadly attack illustrates.

This still-unsolved mystery is the case of Jennifer Lynn Olson-Servo, a twenty-two-year-old Montana native who had barely begun her broadcasting career at KSXC-TV in Abilene, Texas. She was found bludgeoned and strangled in her Abilene apartment in September of 2002. An active U.S. Army reservist, Jennifer Servo (as she was known on the air) had worked for only two months as a news reporter. Although investigators focused much of their attention on her military boyfriend, Ralph Sepulveda, who had moved

with her to Texas, an arrest has never been made.

When we talk about attacks on attractive young television newscasters, we often lump them together, and we often take for granted that their predators were (potential) sexual offenders driven by just that—sexual impulse. However, suspending that judgment is critical. What if sex, or control via sex, is not the intent? A sex offender seeks control and power through his actions, and killing the victim is thought to be the way the predator achieves ultimate bonding with and control of his victim. But another equally dangerous motive is simply the desire to eliminate a person, for whatever reason.

Despite this kind of danger, most TV personalities don't take the warnings of stalking seriously enough. Bob Papper, professor of journalism, media studies, and public relations at Long Island's Hofstra University (and a former Minnesota television journalist), warns otherwise:

> This is a widespread problem that people in the business don't like to talk about. Take this stuff very seriously because you can't distinguish between the harmless crackpots and the dangerous ones. And television stations are magnets for crackpots—harmless or otherwise.

Jodi was aware of the risks, at least to a certain extent. Not long after she got to Mason City, she discovered a terrifying side to the fame she so desperately desired. She feared at least one viewer was taking that sense of intimacy too far. In fact, according to her sister JoAnn Nathe, Jodi was on guard about her personal safety.

In the fall of 1994, Jodi apparently became convinced that the driver of a "suspicious" dark truck was following her to work in the morning. She reported her fears to police officers, and according to police records, even got early-morning escorts to work a few times. Remembering this time, JoAnn said that Jodi "got very, very nervous and was even crying when she called my mom on the phone. So after that, she was taking even more precautions."

Jodi was proactive to mention her concern of one or more stalkers to police, and she was specific in identifying one dark truck that followed her several times. She told police she was unable to see who was behind the wheel because of the truck's darkened windows. She found it very unnerving that she could not identify who was following her or why.

In addition to going to the police, she mentioned her concerns to friends and family, and even wrote a letter to her friend Kelly Torguson in Mississippi, in which she said that she was "concerned for [her] safety" and that she was "being stalked." Torguson turned the letter over to Mason City Police right after her friend's disappearance. Ironically, Torguson said she received the letter in the mail on June 27, the day Jodi was abducted.

Jodi had even sought information about a self-defense course at one time. One Mason City martial arts instructor, Sonny Onoo, said Jodi had attended a self-defense class he taught in March of 1995. Onoo said that, at the time, Jodi told him that "she'd had an incident a few months back that she wasn't comfortable with."

While a stalking victim can report incidents and be proactive about safety, there's little police can legally do to protect someone against a determined stalker. It's not until a stalker crosses the line that the full force of the law can be brought to bear. Usually by then, however, it's too late.

I personally recall several people (not all men—there are obsessive females out there, too) who caused me some concern during my television career. Over the years, I occasionally would receive a disturbing phone call or a letter in the mail . . . some leeringly suggestive, others outright propositions. Although I sometimes felt I was being watched, I consider myself fortunate to have received few overt threats.

However, my concerns were significant enough. At one time I reported to postal authorities that I thought my mail was being tampered with, and at another time I received a handwritten, threatening note in my home mailbox. Although I found the note

upsetting, I suspect that it had less to do with me and more to do with hot tempers and divisive opinions concerning a developing Local P-9 Labor Union strike at the Austin, Minnesota, headquarters of Hormel Foods.

At another time during the Hormel strike, a pickup truck driver made a point of deliberately driving through the trees of my home's heavily wooded front lawn, leaving tire tracks in the muddy spring soil. Though my station and I strove to be objective in our reporting during the strike, it sometimes seemed like we couldn't please either labor or management. In looking back, I can say that whole situation had very little to do with me personally, and much more to do with high emotions that were running during a very difficult time.

But at other times, it *was* personal. One time, a developmentally disabled young man apparently developed a crush on me, one that lasted for the better part of a year. Although annoying, he was, I still believe, relatively harmless. He sought me out and approached me regularly during public appearances. If he saw me around town doing errands or just living my private life—in a restaurant for example—he would think nothing of interrupting whatever I was doing to talk to me.

Even more disturbingly, for some time he developed the habit of calling the newsroom every evening, immediately after the six o'clock newscast was finished. "Hi Beth, this is Kevin [not his real name]," he would say in a high-pitched and whiny tone, invariably causing me to shudder. Then he'd say something like, "I watched you on the news tonight, and you sure looked pretty. Can you come over to my house [his group home] for dinner tonight?"

When I would tell him no, he'd follow up with "Why not?" I couldn't easily answer that question for someone of limited intelligence who clearly thought he was doing nothing wrong.

Ultimately, his calls became so predictably creepy that I would sometimes have another newsroom staffer pick up the phone to tell him I simply was not available.

That year, when I hosted the local telecast of the annual Jerry

Lewis Labor Day Telethon (for the Muscular Dystrophy Association), our staging area was set up in an area mall, and the event drew lots of fans and curious onlookers. Sure enough, "Kevin" was there, clinging to and climbing on the barriers set up around the staging area, taking every available opportunity to call out to me, grab at me, wave at me, and do whatever he could to distract my attention away from the work at hand and toward him.

I found it tough to keep my mind on the business of the moment—the off-the-cuff commentary and ad-lib interviews required by a live show of that nature. I remember that particular telethon as one of the most difficult I had ever hosted, and I served as local host of the MDA show for at least fifteen years.

In many of the other years, the telethon broadcast originated from the station premises, and even though the public was also invited to telethon-related events on the property outside the station, the people allowed inside were limited in number and well monitored. But live shots, whenever and wherever we did them, always had a degree of uncertainty, not only about the technical aspects of being on location but the people as well. Live shots invariably draw crowds, and crowds by their very nature tend to be unpredictable. "Kevin" was one good example.

Another person who gave me reason to be concerned was an apparently older gentleman from a nearby town. I'll call him Herb. I concluded that Herb was elderly given his style of handwriting, as well as comments he made about what doctors were saying about his physical "condition." For example, he'd write things like "We may not have much time left in which to meet."

Early on, Herb would send me warm, handwritten letters, often accompanied by flowers from his garden that he'd press, place on cards, cover in plastic, and frame. While it may sound innocent enough, he wrote as though we were already well acquainted and had previously discussed plans to get together. The friendly invitations to his home often were extended for an upcoming weekend.

He'd write, "Saturday about six would be a good time to visit,

and be sure to bring the kids along . . ." He would ask me to call and tell him when I planned to come. Of course, even though the notes seemed relatively harmless at the time, I never responded, and gave little real thought to them for quite some time.

Following my husband's death, however, his letters became especially fervent and more troublesome. (Since I was a local celebrity, the news of the death became a matter of public interest.) Herb continued to send frequent letters, at first declaring his condolences, but soon turning up the heat considerably. He declared his feelings: "I might as well come out with it—I love you . . ."

I could have dismissed those words as the fantasy of a silly old man. But fantasy and obsession—are they really that far apart? Soon, the letters crossed the line into expressions of mental illness. He wrote that he was convinced I felt the same way about him: "and I can tell by the way you look at me and the things you say to me when you're on TV. I know those looks are just for me."

I wasn't the only one in my professional circle who was troubled by people like Kevin and Herb. One of my former television colleagues at KAAL still shudders at memories of threatening calls she received from the so-called "Weepy Voiced Killer." Now-deceased, Paul Stephani of Austin, Minnesota, was said to sound much like a woman on the phone, and would become very teary and emotional during his calls. Recordings of his voice were posted on the Internet for some time, before they were removed for "terms of use" violations.

On reflection, it is very plausible that someone with a sexual or romantic obsession for Jodi went too far. As attractive and engaging as she was, we know Jodi had scores of admirers, the majority of whom meant well and were simply interested in connecting with a public person. She made mention of her great viewers and their warmth in at least one journal entry. But while some may have had genuine interest and warmth toward her, it is quite possible that others developed emotional fixations.

After her disappearance, authorities spent a lot of time

investigating those who were more than moderately interested in Jodi in an effort to see if hers was a stalker case. But the police were also hindered in their efforts, because high-profile cases like this one tend to draw more than a few deluded people out of the woodwork, and these people can divert attention from legitimate interests.

No doubt, some of these people called in false leads, deliberately leading police astray. Others may have just wanted to get their "fifteen minutes of fame" in the process. When the rumors begin and gossip flourishes, truth and fiction become intertwined, and the challenge for police then becomes how to separate the real tips and clues from hearsay.

A few of the psychics who weighed in on Jodi's case focused on the stalker aspect. They were convinced the person responsible was an area man who may have acted alone, and who may have immediately disposed of her body and the evidence on his own private property. If he had not attracted police attention in the past, and had no criminal record, it would be very difficult to track him down.

Other psychics, however, focused in on their strong beliefs that Jodi was abducted by someone she knew. Different investigators differed in their opinions as well. And the rumor mill compounded the problem by mixing up the bona fide leads with the useless ones.

Some believed that Jodi was the victim of a stalker or a stranger abduction simply because the crime happened in the parking lot of her apartment building, and that she was taken away, perhaps while still alive. If she had been killed in a fit of passion by a spurned lover or boyfriend, they say, her death would have been more likely to have happened inside a private space, like a home or apartment, with her body moved later.

Is a stalker crime more likely to happen in a public venue like a parking lot? Even the few stalker cases discussed earlier in this chapter happened inside private homes. A stalker or stranger not previously known or identified by police could have quickly and easily removed Jodi from the parking lot and buried her body in a

privately owned area, with no one the wiser.

While plausible, the stalker theory has at least one gap. As mentioned, any person serious about striking out at another would undoubtedly know the work schedule of his intended target. Without question, he would be well aware of her schedule and other habits and practices, such as how she spent her time away from work, and with whom she spent it.

If a stalker had been "lying in wait" for Jodi to come out of her apartment building that morning, he would have had to wait over an hour beyond her usual time of departure. On that particular morning Jodi did not leave her apartment until close to four thirty. Would an obsessed stalker have hung in there, or would he, understandably, have started to second-guess the operation at that time? Would he have doubted the efficacy of the plan, wondered if she took the day off, or if she was out of town? Would he have had the patience to wait for her?

According to weather records, sunrise occurred just after five thirty on the morning of June 27, 1995. Just a few days after the summer solstice in late June, daylight is at its longest, but even before sunrise, the brightening eastern sky rapidly begins to erase the dark shadows. As sunrise nears, it's only natural to expect that more apartment residents would begin to rise, too, and move about in preparation for the day. So, too, would the likelihood grow that someone lurking in the parking lot would be noticed. In other words, the later it got that morning, the riskier any intended encounter became for the perpetrator.

In fact, there was already quite a bit of movement in the vicinity around the building that morning. Whether residents or not, some early risers (or those who had been up all night) were already out and about on that late June morning. The adjoining campground still had plenty of tenants. The female jogger was putting in her miles on Kentucky Avenue. Another female resident of the building was beginning her day when she overheard two men talking outside her open window.

We already know that Jodi was on alert for her safety. Did she let her guard down that morning? If so, why? Did she fail to take normal precautions? If so, why? Was it because she was late for work and, in her haste, failed to notice critical signs of an impending attack? If other people were visible to her in the parking lot at that time, would that have given her a sense of security ("safety-in-numbers" thinking) or would it have frightened her? She must have noticed the reported van with its running lights on (if it indeed was there) at four thirty. One would think that the idling van would have given her reason to pause. Or was she simply just too hurried and distracted that morning to pay much attention to her surroundings?

Jodi had reason to be concerned. If she felt a sense of unease in the weeks before her disappearance, it was likely warranted. She wouldn't have been the first anchorwoman to suffer at the hands of an obsessive stalker. But consider crime statistics one more time. Jodi's demise is still statistically far more likely to have come at the hands of someone she knew and trusted. Someone who knew her well may have had a motive to kill her. That person is likely still alive today, and still living in our midst.

CHAPTER TWELVE

A CLOUD OF SUSPICION

> "The real questions are the ones that obtrude upon your consciousness whether you like it or not, the ones that make your mind start vibrating like a jackhammer."
>
> —Ingrid Bengis

If one were to keep a list of the persons of interest or potential suspects who have been linked to Jodi's untimely end in 1995, one name would keep reappearing at the top of the list: John Vansice. Though they had no evidentiary basis with which to retain him in the case, investigators could not then, and still cannot, clear him with any degree of certainty. His relationship to and apparent obsession with Jodi, and the fact that, by his own admission, he had been a person of interest in another long-ago homicide case, has kept his name prominent in any discussion about what happened to Jodi.

Public records in the states in which he has lived reveal much about the man whose name will forever be associated with the missing anchorwoman's final days. He's had several brushes with the law in the form of traffic, alcohol, and license revocation violations. He was, according to authorities, officially a "person of

interest" in Jodi's case. But, despite facing authorities for repeated questioning and lie detector tests, he was never taken into custody and never actually named a suspect.

Perhaps most interesting of all, however, is that over the years he has come into direct first-person contact with five people (including Jodi) who have met untimely ends under mysterious circumstances. Authorities in two states have shown interest in him and his activities, and he's been questioned in-depth about what he knows. He's submitted to polygraph exams and other lines of interrogation. We'll do a deeper exploration of those curious connections in another chapter.

It's safe to say that John Vansice is a man who's been a victim of his own anger. By most accounts, he's got a short fuse. Depending on who's talking, he could be a convincing and credible liar, or he simply may be a man with an unfortunate string of bad breaks, many of his own making. Some of his associations and allegiances might be described as questionable at best. At a minimum, this guy is a colorful character who's got a story to tell.

We don't know exactly when (Arthur) John Vansice first entered Jodi's life. We can safely presume it happened toward the end of 1994, when he temporarily took up residence in the Key Apartments following a move from Newton, Iowa, where he had lived with his ex-wife, Lorraine (Rowena) Vansice.

Marriages end for many reasons, of course, and we can assume that the Vansice marriage was splintered by various factors. Vansice has been called a ladies' man by more than one observer, and Rowena herself indicated part of the reason for the divorce was Vansice's "fondness" for women. Without coming right out and saying it, his ex-wife leaves us to assume that Vansice had a roaming eye, and that he did not keep his marital vows of fidelity.

To her credit, the former Mrs. Vansice has kept quiet about the subject of her ex-husband over the years, refusing interviews and keeping her opinions to herself. She remains mum, not wishing to be drawn into the debate over Vansice's connection with the missing

anchorwoman. One is left to wonder whether it is privacy, loyalty, or fear that keeps her quiet.

The divorce papers bearing Vansice's name is just one legal document that has appeared on Iowa's court dockets over the years. That is to say, his relatively routine marriage dissolution case is not the only time the state's court system has dealt with him. Over the years, numerous traffic violations also appear. Police have run him in for other citations, from misdemeanor speeding tickets all the way up to driving under the influence violations. He's had his license revoked following drunken driving offenses, and he's also appeared in court for driving after the revocation of his license.

Once he broke his ties with Rowena, the newly divorced Vansice wasted no time finding out about the lovely young blonde who lived in an apartment near the one he had just rented. A woman who had moved into the apartment directly across the hall from Jodi in late 1994 said on a couple of occasions that Vansice asked her about the good-looking girl who rode the scooter; he also inquired after where she worked. She was the cutie on TV and he, understandably, wanted to get to know her.

We can guess that Jodi, with her warmth and her trusting and open nature, readily encouraged him to join her wide circle of friends. More than one observer to this case has surmised that she may have even felt unconsciously drawn to the older man. Vansice was nearly fifty years old when they first became acquainted, but he could still be described as ruggedly good looking. He was tall, strong, and well built, and his ruddy complexion and sandy blond hair were said to complement his newly acquired bachelor lifestyle.

It's not an altogether uncommon phenomenon for women who have lost their fathers during puberty to be drawn to an older father figure, many times without conscious awareness. To a younger woman, an older male often represents maturity, comfort, security, and protection. Whether Jodi would agree with this assessment is uncertain, but we know she was flattered by Vansice's attention and the money he spent on her. He treated her like a prize.

During the course of the late fall and winter months of 1994 and 1995, Vansice and Jodi developed a friendship, despite their twenty-two-year age difference. And they shared at least one common interest: waterskiing. Jodi loved the sport and Vansice was said to have previously coached a waterskiing team. No doubt that mutually bonding interest became the topic of many conversations in the early days of their friendship.

Initially, we know she probably viewed their relationship as casual, platonic, and nonsexual in nature; Vansice, however, was widely believed not to have been satisfied with that perspective. Casual observers at the Other Place and elsewhere called Vansice's romantic interest in Jodi "obvious."

Some of Jodi's friends have said that Jodi assured them that she directly addressed the issue with Vansice, telling him that she thought of him as just a friend and not as a potential romantic partner. Whether she was direct enough, however, is uncertain. Jodi, described by several friends as reluctant to speak up in situations of conflict, had a tendency to shy away from confrontation of any kind. Some have questioned whether she was assertive and plain spoken enough to get through to Vansice. Throughout their friendship, he saw no less of her, and he apparently held out hope that he could win her affection.

Despite their differing viewpoints on the intensity of their friendship, Jodi and Vansice continued to spend a lot of time together, and he became increasingly obsessed, perhaps viewing her as a potential "trophy" girlfriend or wife. At the beginning of the 1995 waterskiing season, he purchased a brand new boat—said to be valued at $26,000—and christened it "Jodi."

Whether she was flattered or made uncomfortable by his gesture of naming the boat after her is not known. From his perspective, it may have been an all-out gesture to finally win her affections. He may have thought, "I want Jodi, and she loves to ski, so I'll get a boat and name it after her." Maybe he thought that taking this extra step would convince the woman of his dreams to become a bigger part of

his life. Maybe he thought that naming the boat after her would demonstrate his desire for her, showing her the significance he placed on carefully choosing a name for his new toy.

How many women would be put off by being the namesake of a boat owned by a man they did not consider special? It's an interesting question. Outside of an exclusive or committed relationship, many women would likely be uncomfortable with it. One has to wonder how Jodi felt to have her name on the boat if she was not completely enamored with Vansice. For her part, Jodi apparently never expressed to friends any reservations about her name on Vansice's boat.

We do know that she enjoyed partying on his boat, skiing behind it, and being a mascot of sorts for the watercraft bearing her name. A windswept, petite blonde in a cute bikini would have cut a striking figure posing on the back of the boat. The television anchorwoman in such a pose would have provided a great photo-op for her admirers. For his part, Vansice surely loved the admiring and envious glances of other men. No doubt Vansice liked having such an attractive mascot on the back of his boat.

Vansice the fun-loving boat-owner had a darker side, though, a side he wasn't fully successful in hiding from Jodi. More than one driving-under-the-influence violation and license revocation points to a man with a serious alcohol problem. Even if he had been successful in hiding most of his troubles with the law from her, Jodi was certainly aware of his drinking habits, as she and he often drank together, both in public and in private.

At least a few people observed her to be a hearty beer drinker herself, and she was identified by one server at the Other Place as a "Bud Light girl." One observer who shared space at the bar with her on at least one occasion said Jodi, for her tiny size (she was about five three and weighed one hundred twenty pounds), could really "put away" the beer.

When asked how Jodi acted around Vansice when drinking with him in public, bartender Lanee Good called Jodi affectionate

and physically warm toward him (as she was with most others), although Good said that she never saw the two kiss in public.

Some observers have claimed Vansice had at least a few Jekyll-and-Hyde tendencies, and that they made Jodi uncomfortable. He could be a charming and personable "hail-fellow-well-met" kind of guy. But not always. A male hair stylist who cut his hair at a Mason City salon patronized by Vansice at the time claimed that Vansice frightened some of his female colleagues at the salon; they didn't want to be around him and refused to cut his hair. The stylist admitted, however, that their dislike of Vansice might simply have been a case of what he called "salon drama."

Vansice apparently had some anger-management issues and a hair-trigger temper that could be tripped rather easily. He was generally known as a hothead, and Jodi admitted to one friend that she was intimidated and frightened by that temper. He could turn on the charm at times, and then display a flash of fury. He would "go purple" with rage, a look that Jodi said scared her when she witnessed it.

That friend recounted an incident she had witnessed after a day of waterskiing on Clear Lake, presumably not long before Jodi disappeared. Vansice, Jodi, and a handful of others were present that day, and no doubt there was some drinking onboard. At the end of the day, the others stayed in the boat when it was time for Vansice to load the craft back onto the trailer at the launch site.

After three abortive attempts to get the boat on the trailer, those aboard witnessed an example of Vansice's rage. He cursed, yelled, and pounded on the boat, venting his frustration. When she and Jodi were alone later, the friend says Jodi told her that she wanted to break off her friendship with Vansice because of his short fuse. But in that conversation, Jodi also admitted she was frightened by what he might do if she called it off.

For all her need for attention, Jodi wanted that attention to be positive. Exuding a youthful and trusting energy, she was widely considered to be a peacemaker, a conflict avoider, one who shied

from direct confrontation. One of Jodi's childhood friends confirmed that Jodi was not comfortable openly speaking up about a problem. She said Jodi would occasionally use sarcastic humor to try to get a point across, but added that, in general, Jodi sugarcoated situations and went along with them. She simply had trouble creating appropriate boundaries for herself in certain situations.

If Jodi were like some other women, perhaps she would have been assertive when addressing Vansice's temper. Some other woman might not have felt comfortable about having a boat named after her, especially outside of an exclusive or committed relationship. Another woman might have openly declared her discomfort at always being on the receiving end of an open wallet and what it could buy.

Yet another simply might not have accepted the continual "no-strings-attached" offers and might have been be direct in refusing Vansice's constant overtures. Another woman might have come right out and addressed what appeared to be Vansice's obsessive behavior. Jodi, on the other hand, was probably loath to bring up the issues and hesitant to press Vansice about any of these matters.

If she had doubts about the money he spent on her, her name on the boat, the age gap between them, his temper, or his obsessive actions, she apparently didn't voice her doubts strongly. If he did attempt to control her time, her actions, and the company she chose to keep, she did not clearly outline the boundaries. Given what we know about her temperament, she would have been far more likely to leave these issues alone and internalize her doubts. In the end, her hesitation to speak up might have been a personality quirk that cost her life.

It's not possible to know exactly how fast the relationship progressed, especially in the early days, but we do know from anecdotal evidence of friends, as well as from Jodi's journal, that it was heating up, especially from Vansice's point of view, during the last month of Jodi's life. Vansice began to call her more and more

frequently at home and at the TV station. He sent her flowers, gifts, and cards.

Early in June 1995, he pulled out all the stops in an apparent bid for her affection. Hosting a lavish surprise party for her twenty-seventh birthday, he invited many of Jodi's friends and acquaintances, as well as some of his own business associates and friends, to Sully's Bar. Located in nearby Clear Lake, Sully's Bar operated in a building owned by one of Vansice's acquaintances, Aldin (sometimes called "Stick") Stecker.

Vansice was quoted in *People* magazine (in a 1995 article about the anchorwoman's disappearance) as saying that Jodi had been "thrilled" by the June 10 party, and that "she just stood there in awe" when she arrived at the surprise bash. The Saturday night party included deejay music, dancing, at least one sixteen-gallon beer keg, and abundant amounts of food, including grilled pork burgers and a giant birthday cake, complete with a waterskiing figure on top.

The décor for the party included a custom banner, captured in a photo of Jodi, which read, *"Party hardy* [sic]*, birthday girl!"* Naturally, the spotlight-loving anchorwoman ate up the attention and referenced the party in her journal, calling it a "wild" time. Documented on video and in photos, more than one party attendee said that Vansice was "all over" Jodi that night, rarely leaving her side. He reveled in his role as host, and played his part well. In fact, he was said to have shadowed Jodi the entire evening as she attempted to connect with all of the guests gathered in her honor.

Jodi, for her part, was not unresponsive to his attention. She loved being the birthday girl, the reason for the party, and observers say she spent some of the evening on the dance floor with Vansice. They say she and Vansice did some "dirty dancing," her legs wrapped around his torso, and they lapped up the attention of her friends and colleagues, and some of Vansice's colleagues and clients. If she was the woman of the hour, he was the "big man" that night, relishing his role as host and chief escort and making it clear that he was responsible for the event.

That night was all about Jodi, and she was right in the center of the action, with everyone's eyes upon her. She was naturally delighted. Vansice, for his part, gained stature and capitalized on her delight in the spotlight.

Though she says she was sure Jodi was not Vansice's "girlfriend," Lanee Good defended Jodi's actions that night. Good attended the celebration, and agreed with the assessment Jodi wrote in her journal about the party: it was a "wild" time, and Jodi didn't hold back. Why should she? Good shared her perspective: "It was her birthday, we all had a lot to drink, and she was among friends." Jodi was happy and relaxed, in the mood to celebrate, did not have to drive that night, and felt no need to censor herself or her actions.

At the end of the evening, well after midnight, Jodi was unable to go back to her own apartment, having entrusted her key ring to her close friend Aunie Kruse. Earlier, Aunie had left the party in Jodi's car, essentially leaving Jodi stranded for a time. Jodi was said to have been frustrated to be abandoned without her keys, but Vansice did not leave her side.

After the party, the two spent some time in his van, waiting to reconnect with Aunie and reclaim Jodi's keys. About three o'clock on Sunday morning, they gave up the wait, returning instead to Vansice's place, where he apparently invited Jodi to sleep in his bed while he took the sofa. One wonders if he attempted to bring their relationship to a sexual level that night. Did he force the issue, taking advantage of the fact that they both were under the influence of a significant amount of alcohol over the course of the evening?

This possibility seems to be supported by the claims of one of Jodi's Mason City area girlfriends. Preferring not to be identified today, she claimed in an interview that Jodi had confided to her that Vansice had "almost date-raped" her in his apartment after the big birthday bash. Did Vansice put the pressure on Jodi that night to finally consummate their relationship? He had invested a great deal of time and money in his efforts to woo her. Perhaps he thought the night of her party was a good time to make the final push for what

he ultimately wanted from her: a sexual payback.

We will, of course, never know what happened when they were alone. But almost across the board, most people who knew the real Jodi remain staunch in their defense of her honor. One of her girlhood friends went so far as to say that Jodi was actually relatively naïve about sexual matters. Her friends have said that even if she had considered a sexual relationship with Vansice at some point, she had decided that she was not interested in "going there" with him.

In fact, another of Jodi's Mason City friends relayed that Jodi was aware of Vansice's obsessive nature, did not want to build a relationship with him, and instead had wanted to cool it. She maintained that Jodi had already had that kind of conversation with Vansice, and that he knew how she felt. But did she put a real voice to those words that she wanted him to hear? Given her desire to avoid confrontation of any kind, one is left to wonder if those discussions actually took place, or if they were merely occasional comments offered by a woman who wanted to avoid the conflict inherent in a serious discussion about the topic.

Those who knew her during her time in Mason City agreed that Jodi, for all her warmth, humor, and good intentions, could be a woman of conflicting messages, especially toward men. Although she was young and naturally attractive to many men in her own age group, in many social situations she tended to gravitate to older men, those with status and resources. Even if she did not intend to "put out" sexually for Vansice—or anyone else during that time—she used her considerable charm and flirtation skills to her advantage.

There is no doubt that Jodi had mixed feelings for and about Vansice. Though she liked his attention, his company, and his boat, she was very cognizant of the age gap between them, and she didn't like his angry outbursts. She was aware that her family and friends might have disapproved of such a relationship, and continually played down its importance when talking to others. When asked, she claimed that whatever was going on with Vansice was not serious. However, despite the vocal reservations she sometimes

expressed about him to others, she continued to spend time with him, more time with him than with any other friend, male or female. Why? What was it that he provided that others could not?

What woman wouldn't love the flattery that Vansice provided? He told her how talented she was, fed her ego, told her she was going to be a big TV star. He fawned over her and viewed her as a trophy. He named his boat after her. She must have liked the way he treated her and the money he spent on her, money she did not choose to spend herself or that she was unable to afford on her meager salary. But did it make her feel indebted to him, as if she owed him something in return? Or did she in fact take it in stride or view it as her due?

Did she take even more from Vansice than we know? It's still not clear, for example, how she paid for the 1995 Mazda Miata convertible she purchased early that June, a car she referred to in her journal as a birthday present to herself. Public records show that she acquired it through a private sale from a prominent area businessman, one of the owners of the Fox River Mills plant in Osage, Iowa. But there is scant evidence of any loan documentation.

How did she fund that purchase? Despite her status on television, she did not make a grand salary. Before purchasing the Mazda, Jodi drove an old Honda, the vehicle her mother helped her purchase before she headed off to college. Her girlhood friends said she "drove it till it died," but that she did not go without, despite her low pay.

Her sister JoAnn speculated that some of the money may have come from trade-in value. As we've noted, her mother, with whom Jodi was still close, may also have provided some financial help toward the new vehicle. JoAnn speculates that Jodi, ever frugal and aware of the bottom line, would have been unlikely to take on a heavy financial obligation, and may have financed a lesser amount to get the car she wanted.

Or did Jodi get the money to acquire the car in another way, one that didn't require a bank loan? At least one investigator offers an interesting opinion. He claims it does not take much of a stretch of

the imagination to think that Vansice or another potential suitor might have found it professionally or personally beneficial to offer money to provide Jodi with the car she wanted. He theorizes that some men might think it a wise investment to provide money toward the purchase of a little red convertible. View it as a virtual "down payment" or credit toward gaining favor or a full-time sexual relationship with Jodi.

As much as she might have enjoyed accepting some favors and free drinks from others, there's no evidence that Jodi was a gold digger. Could she—would she—have accepted money like that from Vansice or any other man? What if a man freely offered it? We can imagine that she might have demurred, said she really couldn't accept it. But what if he insisted, telling her that he wanted her to be safe and to have a good car to drive during the sometimes-harsh Iowa winters?

A charming and persistent suitor could have been convincing enough to assure her that a "no-strings-attached" loan would be easy enough for him, and a smart way for her to get the car she wanted. He would have made assurances, of course, along the lines of "It gives me pleasure. Let me help you because I can."

The offer could have been very, very tempting. And to make it all the more seductive, he could have stroked her ego, told her she was on her way up in the broadcasting business, that all her admiring viewers meant that soon everyone would know her name. He could have gone on, saying that she'd make plenty of money in the future with which to pay him back

Those words from an admiring, older suitor with deeper pockets than hers may have posed a tempting prospect and a beguiling pitch to a trusting woman like Jodi, a somewhat naïve Midwestern girl who gave her word and took people at theirs. She would have no reason to doubt what such a man might say. Why should she? She'd have come to him openly, without an agenda, and would have had no reason to assume that he hadn't done the same.

Perhaps Vansice helped pay for that car; he paid for plenty else.

And we have to wonder how he afforded it, given that he had recently covered the cost of his divorce. How did Vansice afford to spend as freely as he appeared to do in those months between the time he met Jodi and her disappearance?

The big surprise birthday party perhaps ran up a tab of a few hundred dollars. He opened his wallet for the venue, a couple of beer kegs, lots of food, a banner, and a big decorated birthday cake. But that kind of birthday bash for the woman he admired was a relatively minor expenditure. How did he pay for a new boat that spring, and keep on investing in real estate, all the while spending money to impress and entertain Jodi?

We know that Vansice was a seed corn salesman for Pfister, serving as district manager at one time. By all accounts, before his divorce he did reasonably well financially, keeping a middle-class split level family home in Newton, Iowa, as well as a cabin on Iowa's Holiday Lake. Within a few months of his move to Mason City, he already had purchased another home: a duplex whose lower floor he rented out and whose upper level he lived in himself. And just before Jodi's disappearance, he took possession of yet another rental home just down the street from the first duplex. Apparently, he signed the closing documents on the vacant property in the days before Jodi disappeared.

We don't know if Vansice's financial records ever became the object of police scrutiny after Jodi's disappearance. Those records might have revealed some clues. Was Vansice deeply in debt because of profligate spending and investments? Did he have another source of income? Might he have supplemented his salary and rental income with other "outside-the-box" revenue? Questions like these have led some to theorize that he may have been associated, even in a small way, with a large area drug enterprise, a possibility that we'll explore in a later chapter.

One question we'll raise now is this: Did Vansice have a connection with Dustin Honken, a man now on death row for five drug-related killings, a notorious player in that enterprise? Vansice

had at least one identifiable, albeit tenuous, connection with Honken, a man whose name will come up again later. The owner of Chris' Auto Repair, Chris Bollinger, paid the monthly rent for his shop directly to Dustin Honken.

In fact, Vansice was said to pay frequent visits to the shop, where he serviced one of the Chevy Astro vans that his employer, the Pfister Seed Corn Company, leased for him. It's interesting that Vansice chose to patronize this shop when he would have received free maintenance on the company van by simply taking it to the local GM Agency in Mason City.

In another interesting side story, Vansice was believed to be friendly with yet another woman during the time when he was also persistently in pursuit of Jodi. He and the petite and attractive forty-something married woman were said to be friends who also spent time together almost daily. They would meet for an early morning walk most days, and sometimes paired up again for afternoon work-outs at the Iron House Gym in Mason City.

This is the woman with whom Vansice was supposed to have gone walking the morning of Jodi's disappearance. As we know, that particular June morning he cancelled this regular "date": he called the woman to say that he was unable to meet her. He offered no explanation.

How did that woman feel about Vansice? More importantly, how did she feel as he began to lavish more time and affection (and money) on Jodi? Was the married woman simply Vansice's workout buddy, or was she something more? We can only guess how she might have reacted to news of Vansice's surprise birthday party for the young anchorwoman.

It would be easy to understand that she might have felt threatened and jealous by his obsessive interest in Jodi. Might she have had an interest in keeping Vansice and Jodi apart? After Jodi vanished, the woman and her husband divorced, and some say a woman who fit her description may have lived with Vansice for a time after he moved to Phoenix.

There is no question that Vansice would have had the means and the opportunity to kidnap Jodi and to kill her. He was a large man who could have easily overpowered the petite anchorwoman if he wanted to. Several people described him as very well built, with massive upper-body strength. One man described Vansice as tremendously strong, evidenced by the fact that he jumped into freezing lake water when his snowmobile broke through the frozen surface one winter. Vansice went under the ice (in presumably shallow water) to retrieve the snowmobile, and was apparently able to heave it out of the water and onto the surrounding ice.

Vansice also knew Jodi's habits and her work schedule, so he had the knowledge he'd need to track her down and surprise her. But what about a motive? Why would he want to destroy the woman with whom he was obsessed? At least four possible motives come to mind:

- **Unrequited love.** She just didn't reciprocate his feelings. He may have thought, "If I can't have her, nobody will."

- **Jealousy.** She was known to engage in conversations with almost anyone, and was apparently quite flirtatious in the company of most men. She also may have been casually dating other men during that time.

- **Fear of exposure.** Perhaps she knew *too* much about him, the telling of which would put him in some legal hot water. Perhaps she suspected his involvement in something illegal. Maybe he feared her disclosure of an attempted "date rape" (if it indeed had occurred) on the night of her birthday party.

- **Financial or legal issues.** He may have been under pressure from others in his circle of acquaintance, others who might have had their own reasons to keep her quiet, including a need to protect their own interests.

But one other idea persists as well. Perhaps he didn't attack her, but knows who did. We know that he kept a very close eye on Jodi and how she spent her time away from him. They talked at least

every day and saw each other often during the last few weeks of her life.

Some have said that he watched her, too, much as a stalker would, even when she might not have been aware of it. As noted by her neighbor, it was not uncommon to see Vansice sitting in his parked car at the Key Apartments in the wee hours of the morning. It conjures up a theory proposed by some that portrays Vansice as Jodi's hero, a "savior" of sorts.

A "knight-in-shining-armor" hypothesis is not as far-fetched as it may seem at first mention. It's happened before, and has happened since. A relatively recent example occurred in 2002 when the police chief of the tiny southeastern Minnesota town of Lanesboro was convicted of arson and other charges in connection with a fire that destroyed a downtown building that housed businesses and apartments.

Authorities say Chief John Tuchek set the fire so he could rush in to rescue his ex-girlfriend and her child from the burning building, and thereby (he hoped) regain her affection. As soon as he set the blaze, Tuchek called to report it, and then ran into the building to help his ex-girlfriend and her young daughter get out. He apparently thought that, by doing so, he could impress his ex and make her proud of him.

What relationship therapists call the "knight in shining armor syndrome," or K.S.A., happens when men try to save women in distress because it makes them feel powerful, in control, and manly. Sometimes they are afraid of women and think they won't be rejected if they fix her problems. They hide their inadequacies behind what looks like strength. They know they don't have their acts together, but instead of working on themselves, they work on someone else. Those relationships are doomed to fail, according to therapists, because any relationship is only as strong as each participant in it.

Over the years, many have commented on what they perceived to be an unusual relationship between Jodi and Vansice. As we've discovered, some witnessed Vansice's questionable behavior after

Jodi disappeared, too.

Brian Mastre, KIMT's evening anchorman at the time, offers just one more example of that questionable behavior. He says he didn't go to Jodi's surprise birthday party, and says he never met John Vansice until shortly after the apparent abduction. His first impressions of Vansice were vivid ones. The two initially crossed paths during a quickly-assembled vigil held to honor the missing anchorwoman at a downtown church near the KIMT studios, and Mastre recalls the "glassy look" in Vansice's eyes as people expressed to him their disbelief that Jodi was missing.

During the vigil, Mastre said he was also struck by how much older Vansice looked compared to Jodi, and he got what he calls "a weird vibe" from Vansice only a few days later. That weekend, Mastre and his wife had joined another couple for dinner at The Waterfront in Clear Lake, and they saw Vansice enjoying himself at the lakeside restaurant in the company of several younger women. It looked like he and the women were all headed out onto the lake through the restaurant's dock access. Mastre observed a loud and cheerful Vansice that evening wearing a T-shirt emblazoned with the words "IT MUST SUCK TO BE YOU." Jodi's former buddy was "all smiles" that night, according to Mastre, who remembers remarking to his wife, "Grief has an interesting way of showing itself."

Mastre also thought it to be strange and unusual behavior when he and other selected members of the press got a call from Vansice, who "invited them over to celebrate." Vansice's reason for the gathering caused some raised eyebrows among those invited: He boasted that he had 'passed' the lie detector test in Jodi's case.

Bizarre behavior and poor judgment aside, many have speculated over the years about Vansice's knowledge of or involvement in the attack on Jodi. Perhaps he conjured up a scheme against Jodi—and perhaps not. But if he was not directly responsible for her disappearance, the question remains: does he know who was?

CHAPTER THIRTEEN

COMMON DENOMINATOR

> **"**'Curiouser and curiouser!' cried Alice (she was so much surprised, that for the moment she quite forgot how to speak good English).**"**
>
> —Lewis Carrol, *Alice in Wonderland*

Like the surface of water broken by a thrown stone, the permutations that surround the questions "why," "who," and "how" ripple across the years. We may never learn the exact circumstances that took place that long-ago summer morning. Yet, as we've discovered, despite countless theories and lots of good old guesswork, one man simply cannot be eliminated as a person of interest. That man is John Vansice.

How is it that Vansice became so closely connected with one disappearance and three unsolved murder cases in one state and is among the players in a violent death case in another? Is he absolutely innocent of any involvement in all these cases? How has he managed to stay clear of the fallout? Might we call him the Teflon man, someone to whom most things just don't stick?

There is no small irony in the fact that the man most closely aligned with Jodi at the time of her disappearance was also said to

be a person of interest in another unsolved Iowa case, one that occurred twelve years earlier.

One does not have to go far from Iowa's capital city, Des Moines, to experience the antithesis of city life. A short jaunt east on Interstate 80 takes a motorist into the Jasper County town of Newton, population about fifteen thousand people. Newton was John Vansice's home for a number of years before he took up residence in Mason City. He shared a home there with his then-wife and two children. In 1983, he was employed by two Newton-based business partners, who had hired him to work part-time at their Copper Dollar Horse Ranch, located just a few miles northwest of town.

The idyllic central Iowa property has long since been sold and no longer stands as the ranch it once was. But for those who live in the area, it's hard to dispel the memory of a bloody attack that killed two young lovers at the ranch in 1983. Jasper County authorities remember the slayings as the only murders in the county that have never been resolved. And it appears unlikely at this point that they ever will be. Those who served as sheriff and medical examiner at the time are deceased, as are the person who discovered the bodies and an Iowa Department of Criminal Investigation detective once assigned to the case. Not only does the incident still haunt the families of the victims, but some area residents remain haunted, too, and wonder if a murderer still lives in their midst.

Whether the Copper Dollar lived up to its billing as a ranch that housed quarter horses and Appaloosas or instead served as a cover for a giant drug funneling operation depends on who's talking. In the early 1980s, the ranch was reputed to be used as the terminus for the import of ten-thousand-pound quantities of high-THC-content marijuana coming in from the Florida Keys.

Whether young Steven Fisher, just twenty years old, was employed as a ranch hand or in some other capacity in a drug operation is not clear. We know he lived on the property and shared a camper-type trailer with his girlfriend, seventeen-year-old Melisa Gregory. He'd been spending time with Melisa since he had

separated from his wife, Theresa (Terry Supino) Fisher, several months earlier.

On a chilly late-winter morning, Steve's friend and coworker Jeff Illingworth, a ranch foreman, was the unfortunate person to stumble onto the scene of a brutal crime. As he approached the barn shortly before eight o'clock in the morning on March 3, 1983, Illingworth spotted someone lying on the ground outside Fisher's trailer. Fisher's lifeless body, clad only in blue jeans, was face down in the snow and covered in blood. He had suffered savage blows to the back of his head, and his face was severely injured as well, rendering him largely unrecognizable.

The panicked Illingworth ran inside the blood-splattered trailer, only to find the body of Fisher's girlfriend, Gregory, nude and spread-eagled on the dinette. She, like her boyfriend, had died of massive blunt-force head injuries; apparently she had been dragged from the bedroom (although she had not been sexually assaulted) and killed in the kitchen area. It was thought to be the work of someone powered by extreme anger and hatred since, in both cases, the damage inflicted on the victims' faces and heads was so extreme that next of kin found it difficult to make visual identifications.

The Jasper County medical examiner determined that the murders had likely taken place sometime after ten o'clock the previous night, March 2. The trailer showed no signs of forced entry; apparently the person (or persons) who carried out the crime was known to the couple.

Later analysis of the victims' injuries by a University of Nebraska forensic anthropologist indicated that a shingling hammer or similar tool was the murder weapon. The wound pathology of a shingling hammer is unique compared to that of similar tools or weapons, given the shingling's combination of axe and hammerhead. Used by roofers and sheet rock hangers, the tool is commonly carried by carpenters.

Because Fisher was in the process of divorcing his wife, a great deal of animosity existed between his family and that of his

estranged wife, Supino. She and her twin brother, Ted, admitted they'd had a verbal confrontation with Fisher on the previous evening, when they drove to the ranch to confront Fisher about living with his girlfriend while he was still legally married to Supino. The siblings confirmed there had been a heated argument, but repeatedly claimed to police that when they left about eleven o'clock that night, neither Fisher nor Gregory had been physically harmed. Apparently no forensic evidence was obtained during the investigation that could have linked them with the murders.

How and why does John Vansice fit into this whole scenario? He brought it up himself when, years later, after Jodi's disappearance, he showed up at her apartment complex. That morning, he was heard to say, "I'm really sweating this, because I'm already under investigation for a double homicide in Newton, Iowa."

Admitting a connection with the Copper Dollar Ranch murders proves nothing, of course, about Vansice's involvement in the crime. When Vansice submitted to lie detector tests in Jodi's case, his connection to the 1983 slayings remained unclear. Yet, sometime later, an agent from the FBI's Waterloo, Iowa, office confirmed that the agency had indeed investigated the possibility of Vansice's involvement in the Copper Dollar cases.

The successful development of a homicide investigation requires a suspect with motive *and* opportunity. Since Vansice lived near the Copper Dollar Ranch and was employed as a part-time ranch worker at the time of the killings, he had the opportunity. Did he have a motive in this case? One is left to wonder. Some have expressed the opinion (and it is pure speculation) that he may have been involved in an undefined personal relationship with Fisher's estranged wife, Supino. If that had been the case, is it unreasonable to think that he may have had reason to attack Fisher? Who was the armed assailant who met Fisher outside his trailer following the departure of the Supino siblings earlier that evening?

Fast-forward twelve years, from 1983 until 1995. In 1995, Vansice was divorced and living in Mason City, where he became involved

with Jodi Huisentruit. He was drawn into a large and loosely organized social network which often congregated at the Other Place, the Sidewinder, Sully's, and similar watering holes in and around Mason City and Clear Lake. As we already know, Bill Pruin, the man who shared an attraction to Jodi and with whom Vansice had a strained relationship, was part of this group.

In early April 1995, not even three months before Jodi disappeared, Pruin was found dead in his home, the victim of a gunshot wound. His death was initially ruled a suicide, but after an appeal by the family, the coroner was apparently convinced to change the death certificate to show the cause of death as undetermined.

Now make another leap forward in time, this time another seven full years. In October 2002, the Arizona media was abuzz with news about the death of a sixty-five-year-old man who passed away two days after being detained on suspicion of shoplifting at a Scottsdale grocery store. The victim, Lawrence (Larry) Melsky, was said to have concealed items in a grocery bag (which, under Arizona law, is considered shoplifting), and then attempted to leave the store.

One of the four security guards in the store that evening was none other than John Vansice, who was then living in Arizona and employed as a loss-prevention specialist by the grocery chain. The store's guards (including Vansice) confronted Melsky as he attempted to leave the premises and, after handcuffing the suspect, led him through a hallway toward an office area in the front of the store.

An article in Arizona's *East Valley Tribune* newspaper quoted Vansice as telling police, "He [Melsky] fought, fought and fought the whole way [to the office]." Vansice and another guard struggled with the suspect in the hallway, and they both claimed Melsky broke free at one point, only to fall and hit his head on a doorframe and wall.

The hallway scuffle left him with two scalp lacerations, a knocked-out tooth, and "massive" brain swelling. The Star of David emblem Melsky wore around his neck was said to be "bathed in blood" after the incident, and he died two days later. The subsequent

medical examiner's report called Melsky's injuries "violent."

The grocery chain, in defending their guards' actions, alleged that Melsky "resisted detention" and said he "was combative and cursed and yelled when detained." In December 2002, the Maricopa County medical examiner declared Melsky's death an accident.

That ruling, however, did not end the rampant speculation surrounding the case. Melsky's family attempted to pursue further legal action, and filed a wrongful death civil suit against the guards and the grocery chain. The Phoenix Jewish community, of which Melsky was a proud member, also weighed in on the issue. The Anti-Defamation League for a time attempted to focus attention on one of Vansice's younger colleagues, Ronnie Michael, pointing toward Michael's reputation and history of involvement with a Neo-Nazi organization.

Despite all those efforts, none of the guards ever faced criminal charges in connection with the death. A later ruling from the Maricopa County Attorney's Office showed that a board of senior attorneys unanimously agreed that "based upon the ... evidence available, criminal charges would not be appropriate."

The numbers that circle Vansice are troubling;

- **1983**: Steve Fisher and Melisa Gregory in Newton. Two unsolved Iowa murders.

- **1995**: Billy Pruin and Jodi Huisentruit in Mason City. One undetermined Iowa death, and one unsolved Iowa disappearance.

- **2002**: Alleged shoplifter Larry Melsky in Scottsdale. One mysterious Arizona death.

These five puzzling, bizarre, and largely unresolved cases all share a first-person common denominator: one enigmatic man. Not many people can rightly claim a first-person acquaintance with five such peculiar cases. One might say it boggles the mind. Curiouser and curiouser, indeed.

CHAPTER FOURTEEN

THE PRUIN PUZZLE

> "Is there ever any particular spot where one can put
> one's finger and say, 'It all began that day,
> at such a time and such a place,
> with such an incident'?"
>
> —Agatha Christie, *Endless Night*

A sports bar, grill, and pizza joint known as the Other Place stands at the corner of First Street and Pennsylvania Avenue in downtown Mason City. It's a comfortable, casual place featuring an all-American menu. The wood-paneled bar, adorned with popular beer brand taps, neon beer signs, and several flat-screen televisions, stands directly opposite large front windows facing onto Pennsylvania Avenue. A sprawling dining room and upstairs party area can serve a sizable crowd.

Called the OP by regulars, the downtown landmark has enjoyed a regular clientele over its twenty-five-plus year history. Within walking distance to KIMT-TV, the Law Enforcement Center, and other downtown establishments, its enduring presence in town is no doubt due in some part to its proximity to many Mason City businesses. Like any other establishment of its type, serving lunch and

dinner and catering to the happy hour crowd every day was—and still is—its stock in trade.

As we know, Jodi Huisentruit and some of her television colleagues were regulars at the Other Place in 1994 and 1995, rubbing elbows with other professionals, cops, and business proprietors alike. It was the place where the downtown "suits" hung out, and Jodi was comfortable there. Lanee Good, the bartender/server who worked a five-day schedule, estimated that she saw Jodi at the OP two or three times a week. Of a similar age, she grew friendly with the anchorwoman, as she did with a lot of her "regulars." Good was true to her name: she was good at her job. She was familiar with the crowd that frequented the popular watering hole, and knew a lot of her customers on a first-name basis.

Another of those regulars was Bill Pruin, the forty-three-year-old divorced Mason City area farmer who made a midday habit many days of stopping by the Other Place for a beer or two. Good became accustomed to his schedule and his habits, so much so that when she spotted his pickup truck pulling up at the curb outside the Pennsylvania Avenue windows, she'd pour his favorite brew and set it up on the bar, ready for him when he walked in.

Good had said she looked forward to seeing Pruin, and it seems the reverse was true as well. In conversation with me, Good was open in admitting that she and Pruin had been casual lovers at certain points, and although she said their relationship was never serious, she always thought of him as a friend. She said she knew the bachelor farmer to be friendly with several women, and she suspected he might have had a few flings during his single years. In fact, Pruin, an attractive and well-spoken man, was considered to be an eligible bachelor in Mason City. It certainly did not harm his reputation among single women that he was also a landowner and considered by many to be a man of means.

It was apparently at the Other Place that Jodi Huisentruit also befriended Pruin, and in 1995, his name became inextricably linked with hers. The full extent of Pruin and Jodi's relationship is not

clearly known, although Jodi was said to occasionally visit him at his rural Mason City acreage. We can only guess at the level of their friendship, but those who knew them both say they were warm toward each other. When asked if she observed Jodi and Pruin to be close, Good displayed an often-used gesture to make her point. Twining her fingers, she said Jodi and Pruin were "like this."

Given this, it's not surprising that, in the spring of 1995, Good and Jodi and their cohorts were highly troubled by the shocking news of Pruin's death. William Pruin, forty-three years old, was found dead in his home on April 6, ten days before Easter, the victim of an apparent gunshot wound. Officials quickly identified the cause of death as suicide, noting that one of Pruin's guns from his gun cabinet was found near his body. On the original autopsy report, the cause of death was listed as a gunshot wound to the chest, and the manner of death was suicide. But that appears to have been a hasty and ill-advised ruling, as we will discover.

On Tuesday, April 4, 1995, Pruin simply did not show up for his usual early afternoon beer. That day, Good noted his absence at the bar, and surmised that Pruin must have had other plans that day. We know that he had been at a farm implement dealership in Mason City that morning, where he sealed the deal on a new tractor. He was said to be happy about his new purchase, and elected to drive it home, leaving his pickup truck in the parking lot of the dealership. He never returned to retrieve the truck.

Others were aware of his absence as well. While Good and those at the bar wondered aloud where Pruin was that day and the next, another friend, Bill Robinson, missed him, too. So on the following day, April 5, Robinson tried to call, leaving a message on Pruin's answering machine. Later, he stopped by Pruin's farmhouse to check in on him.

Robinson is on record as saying that the kitchen door was ajar when he stopped by, with keys hanging in the outside keyhole, but he did not enter the house. Robinson knocked and called out to his friend, and when he received no answer, he assumed the open door

meant Pruin was somewhere nearby. After all, the new tractor and a Chevy Blazer were just outside in the driveway. He left the farm, thinking it unusual that Billy was nowhere to be seen.

Another day went by before Pruin's body was discovered. On the morning of Thursday, April 6, his mother, Shirley Carroll, entered the home after she had tried in vain to reach her son; she had become concerned.

When police arrived at the house, it seemed obvious what had happened. That is, it seemed obvious at first glance. Pruin's body lay in the dining room, near the weapon that apparently killed him, all of which pointed to suicide. The initial autopsy, as noted, rendered the same conclusion. But several factors, including the fact that no one who knew Pruin believed that he would kill himself, made the suicide theory ultimately implausible.

Certainly his family held that Pruin's death was not the result of suicide. Pruin had apparently held a life insurance policy in the name of his two minor children. His death occurred within a window of time before the policy's "suicide clause" would be void, so Pruin's survivors petitioned the coroner to change the cause of death on the death certificate. They wanted to make sure his life insurance money would be paid out for the two kids.

Of course, no competent coroner would ever change a cause-of-death ruling just for the sake of a family wanting to claim an insurance check; appropriate legal considerations have to be followed, as they were in Pruin's case. Apparently enough questionable evidence existed to convince authorities to take a second look and to change the legal paperwork in favor of the family's claim. The original death certificate was amended to show a gunshot wound to the right chest as the cause of death and "undetermined" as the manner of death.

What would cause authorities to reverse themselves on a manner-of-death ruling? In this case, the circumstantial evidence was highly confusing at best, and the coroner found enough conflicting information to justify the changes on the legal death

certificate. Too many questions remained unanswered, and too many complications existed—too many to accept Pruin's death as a simple case of suicide. That answer was just too pat.

The mysteries mounted, one after another.

Pruin's body was found face down in a semifetal position just inside his dining room. His glasses were still on his face, and his body was fully clothed in his usual workday apparel: a T-shirt, sweatshirt, jacket, pants and underwear, socks and work boots. It appeared he had been shot while standing in the doorway between the kitchen and the dining room in his rural home, and when struck, had fallen back against a dining room chair before collapsing on the carpeted floor. Blood spray was observed in the kitchen. The weapon, a .44 magnum Super Black Hawk revolver, was found on the floor about two feet away from the body in the dining room. Pruin, a gun hobbyist, was the registered owner of the gun, a weapon taken from his nearby personal gun cabinet. The gun, after testing, revealed no fingerprints, neither Pruin's nor anyone else's.

Pruin had been shot near the nipple on the right side of his chest, with the exit wound below the right scapula (shoulder blade) in the back. An entrance wound of 1.8 centimeters was noted, larger than the exit wound, which measured 1.4 centimeters. Those measurements are noteworthy because they stand in contrast to the usual pattern: the exit wound of a bullet is usually larger than the entrance wound. After a bullet enters the body at a high velocity, skin tissue at the entry site has the tendency to close in on itself, making the entrance wound appear smaller.

Anybody savvy about weapons knows the .44 magnum to be an extremely powerful revolver. Some people liken it to a minicannon, because of its powerful recoil capacity and large bullet size, and any person firing such a weapon would find it necessary to brace himself. If fired at such close range, as would be necessary in a suicide attempt, the recoil would likely cause the weapon to fly across the room. Those who know guns say a weapon like that, if used in a suicide, wouldn't land anywhere near the body.

In addition, if Pruin had indeed been able to shoot himself at close range, experts said that considerable burning and blistering would have been apparent at the wound site. But there was no such evidence, indicating he was likely shot from a distance.

Yet more contradictory evidence was noted on his hands. Pruin was said to be left-handed, and had an incomplete left thumb; it had been partially amputated as a result of a previous accident. If he had pointed the weapon at himself, it would have been necessary to steady the gun with his right hand. However, *neither* of his hands revealed traces of gunshot residue.

Those who were close to Pruin found other circumstantial observations to be very puzzling as well. His keys were still in the outside door lock of the kitchen entry door. No one who knew him could remember a time when Pruin unlocked the door and then left the key ring dangling in the outside lock. The dead-bolt mechanism was the type that could be locked with a key on either the inside or outside of the door. Typically, after opening the door, Pruin took the key out of the outside lock and re-inserted it on the inside. At the scene of the crime, however, his keys remained on the outside, and the door was left ajar by several inches.

Friends cited another glaring observation that made many unable to accept the conclusion that Pruin was despondent or died by his own hand. Several claimed that Pruin would never enter his white-carpeted dining room while wearing his work boots. As a matter of fact, Good called him pretty fastidious that way; he always removed his boots before walking on the carpet and insisted that visiting friends remove theirs. Yet Pruin was wearing his work boots when he died in the dining room.

One final question looms large. Why would Pruin take his own life on the very day that he finalized the purchase of a brand new tractor, an implement he had anticipated possessing and using? As a farmer and landowner, Pruin certainly would have viewed the tractor as an exciting new "toy"; he no doubt looked forward to using it, and he was said to be happy about the purchase.

Understandably, the news of Billy Pruin's sudden death sent shock waves among those who knew him. The Other Place almost instantly became the site of talk and speculation about the manner of his death, and especially about the coroner's early suicide ruling. No one who knew him could believe it. The Pruin they knew simply would not have ended his own life. The circumstances instead pointed to a far more obvious conclusion: homicide.

Following Pruin's death, Good, Jodi, and others ruminated a lot about the case, and Jodi was open in saying that she was curious about the circumstances surrounding his death. According to those who heard her, she rightly insisted that something was fishy, and that things did not add up.

Unbelievably, the surprises were not yet over. At Pruin's funeral, a woman he was dating before he died introduced herself to his family and friends as his new fiancée. Although he had supposedly proposed marriage just two days before his untimely death, he hadn't bothered to mention his engagement to anyone close to him. Good, his sometime past lover, admitted to being disconcerted and confused by the announcement. She wondered why Pruin would have failed to say something to her about it; after all, the Pruin she knew would have been happy and eager to share the exciting news of an engagement with the important people in his life.

In the intervening years, Pruin's one-time and brief fiancée, Gretchen Tusler, has since married and changed her name. She still lives in northern Iowa today as Gretchen Castle. In an interview conducted years later, she recalled that Pruin had been in a good mood during that final weekend of his life. He had attended social functions for his two daughters, who lived nearby with their mother (Pruin's ex-wife), Avis Pruin.

But despite his overall positive state of mind, Pruin seemed to be very concerned about something in the days before his death, according to his fiancée. When pressed, however, he refused to tell her what it was. Years later, Castle revealed that Pruin knew a lot about some people in town and their connections to the area's drug

culture. When she and Pruin would go out, for example, she claimed he knew and would sometimes point out people with such connections.

Pruin himself was apparently not a heavy drug user. There were no drugs in Pruin's system at the time of autopsy. This alone is not conclusive evidence, of course, that he never used drugs. But some surmise that he may have been killed because those involved in the illicit drug trade thought he knew too much and would ruin their cover.

One other curious tidbit deserves mention in the confusing Pruin puzzle. Investigators say William Pruin's altered death certificate was not filed with the proper Iowa authorities, as would have been required within days of a death. For several years, the document simply got swallowed up in the paperwork of the Cerro Gordo County courthouse, and never was forwarded to its rightful destination in the state capital of Des Moines. Did that document just fall through the cracks, or was there another reason it didn't make it to its rightful destination?

Eighty-two days after the discovery of Pruin's body, the unthinkable happened again, and this time, it was much higher-profile news. Jodi Huisentruit had disappeared. The anchorwoman's troubling circumstances, perhaps understandably, got a lot more press than those of the farmer. The Other Place, a home away from home for both Pruin and Jodi, became Mission Central once again, a place for more shocked speculation. Patrons and employees alike may have suspected foul play in Pruin's case, but all were sure of it in Jodi's case. And this led to further conjecture.

Two young lives had been cut short: might those losses be connected? Could Jodi's disappearance be tied to Pruin's death somehow? Perhaps Jodi had been targeted because she may have known something or may have seemed to know something—either through her work or her social life—that she would have been safer not knowing, something involving her friend Bill Pruin.

Intense talk ensued: Could she have been investigating Pruin's

death in her capacity as a reporter? Did she get too close, learn something that she shouldn't have? Did she simply pay a high price for her curiosity?

It was natural for Jodi's friends to postulate that her abduction may have been connected to her interest in and her frustration about Pruin's death. If drug dealers thought Pruin had told Jodi anything about them before his death, she could have been considered a threat. The same would be true even if she had just asked too many questions about the manner of his death. If Pruin had been killed by someone who thought he had damning information, Jodi may have been targeted as well, because, as friends, she and Pruin talked and shared information.

Pruin's death and Jodi's disappearance may not be related at all, of course. But some believe that the case should be re-opened to explore a possible connection between the two deaths that happened so close together. As of this date, more than fifteen years later, Pruin's manner of death remains listed as undetermined on the official death certificate. To this day, like Jodi's disappearance, his death remains unresolved. It's just another cold case for Cerro Gordo County officials.

Two inconclusive and extremely unsettling cases involve the violently lost lives of two friends within eleven weeks of each other in 1995. In the mysterious matter of Billy Pruin's death and Jodi Huisentruit's disappearance, officials are no closer to finding a resolution. Is it merely coincidence that these two friends were taken under questionable circumstances? Is it merely coincidence that neither case has yet netted an arrest?

CHAPTER FIFTEEN

MAELSTROM IN MASON CITY

> *" . . . there's no difference between one's killing and making decisions that will send others to kill. It's exactly the same thing, or even worse.*"
>
> —Golda Meir

Maelstrom (meyl' struh m)—noun: 1. A large, powerful or violent whirlpool. **2.** A restless, disordered, or tumultuous state of affairs.
> —*Random House Dictionary, Random House, 2011*

Interstate Highway 35 bisects the United States on its north-south route from Minnesota to Texas, and separates the Iowa twin towns of Clear Lake and Mason City. Every day, thousands of motorists trekking north and south make pit stops at Clear Lake gas stations, restaurants, and truck stops, and quite a few make longer stops to enjoy the water recreation opportunities offered by the town's namesake, one of the largest natural lakes in Iowa. The town of about eight thousand residents capitalizes on its relaxed resort vibe in the summer months, and the Surf Ballroom in Clear Lake can still draw a crowd year round.

One of the Surf's biggest draws is an annual event. Every

February, the Surf commemorates the anniversary of "the night the music died," which draws fans from around the country to honor the lives, music, and influence of some long-ago rockers.

The story is a familiar one in the annals of music history. Over fifty years ago, Buddy Holly, J.P. "The Big Bopper" Richardson, and Ritchie Valens played their last concert at the Surf. On the evening of February 2, 1959, the three lost their lives near Clear Lake, when a small plane hired to transport them to their next scheduled gig in Moorhead, Minnesota, crashed during a winter storm.

The tragic event marked a watershed day for many in the music industry, including the legendary Bobby Vee of *American Bandstand* fame, who tells the story about how that plane crash changed his life forever. At the time, Vee was a high school kid who played with a band in Fargo, North Dakota. He and his friends had tickets for the highly anticipated Holly concert on February 3. Despite the plane crash the night before, the Moorhead concert was held as scheduled, and other bands filled in that night for what became a memorial event for the stars. Instead of being in the audience that night, Vee and his band ended up as a last-minute emergency replacement performing on stage in Moorhead. The rest, as they say, is musical history.

For area residents today, the twin towns are more like one, despite the interstate highway that separates them. While Clear Lake revels in its relaxed and easygoing resort status, Mason City tends to be more business as usual. So if Mason City was the workaday world for Jodi, Clear Lake was one place to which she liked to escape. Many a summer weeknight or a weekend day found Jodi and like-minded friends playing on and in Clear Lake.

Although not boasting the lake of its twin, Mason City had color of its own. On the surface, the city called River City by one of its famous natives, composer Meredith Wilson of *The Music Man* fame, would seem to be an unlikely place to be called by another, less-desirable name: "Sin City." Perhaps an appropriate name for Las Vegas, Nevada, Sin City seems an odd title for Mason City, Iowa.

What would make it so sinful? While it might be smaller than Vegas, it is said to have no less gritty an underworld.

Case in point: a woman who attended Mason City High School in the 1980s recalls a psychology teacher who freely used the "Sin City" moniker in talking to his students about their hometown. He referred to the ready availability of whatever manner of vice preferred by the sinner, including gambling, pornography, prostitution, drugs, and violent crime. Whatever the sin, the teacher claimed area law enforcement was not terribly effective in dealing with it. He actually told his students that if a person wanted to get away with murder, Mason City was the place to do it. What that teacher called a bungling police department at the time would never solve the crime!

Others have claimed that Mason City, like any number of similarly sized towns across the country, was a major hub of a highly sophisticated drug-trafficking operation dating back a number of years. That is clearly not the image that northern Iowa would like to convey to the world, but at least in theory, we all accept that a primarily rural part of the state struggles with the same issues that plague larger communities, including the presence of a pretty powerful drug subculture.

A native Mason City man who wishes to remain anonymous and who years ago moved away asserted that if he had stayed in town, he'd be dead by now. He said that he knew a number of people, many of them former childhood and school friends, who are or were involved in the drug trade, and he claimed that drug dealers could and can still be found on literally "every block" in town.

Late in 1993, when then-twenty-five-year-old Jodi Huisentruit was offered a job at Mason City's KIMT-TV, she probably gave more thought to the ready availability of her coveted job in television, and less thought to what kind of crime activity was going on in the area. She did not realize she was entering a virtual whirlpool of illegal drugs, corruption, and murder. Though much of the activity was beyond the knowledge of its business community and many

residents, northern Iowa was held in the grip of large-scale drug operatives.

As a former flight attendant, Jodi was fairly well traveled, but she was thought to be a relative innocent in the ways of the world. The wide-eyed, ambitious, and driven girl from small-town Minnesota saw only the opportunity for her star to rise. The area's crime rate and drug problems, apparently no more significant than those of any other similarly sized city on the map, would have been of little interest to her. It was likely not even part of her decision-making process when she was offered the job.

After spending some time in the business, members of the media, particularly television reporters, tend to become cynical. Like other professions (such as law enforcement and emergency medical responders), some wear their cynicism like a protective shield, because they've seen it all. They've been exposed to human beings at some of the best and worst times of their lives, in times of triumph and in times of tragedy. As a result, many learn to internalize their own emotions, mostly as a protective measure. A black sense of humor, for example, often serves as a mask for the pain of witnessing too much.

But Jodi was different. As one of her childhood friends put it, "Jodi lacked the gene that made her suspicious of others' motives [toward her]." It did not enter Jodi's mind that she might be like a lamb entering into a pack of wolves. Her trusting and guileless nature did not serve her well at this point in her life—Jodi wore her heart on her sleeve. In public, she was almost as open with total strangers as she was with friends. She didn't stop to consider the downside of sharing too much of herself. She didn't stop to consider the downside of a career move to Mason City. And she didn't stop to consider the downside of a highly visible life on local television.

Of course, no one is perfect, and no place is perfect. Even if she had known about all the issues when she moved from Alexandria, Minnesota, to Mason City, Iowa, Jodi would never have refused the offer of the TV anchor job she desperately coveted. Few people

wanting to improve themselves professionally would even consider turning down such an offer. According to her sister, Mason City seemed like to safe place for Jodi to expand her career horizons.

But in the fall of 1993, the town was said to be just one of several key links in a multimillion-dollar drug operation. Two longtime Mason City natives were reputed to be masterminding the import and distribution of two hundred to three hundred kilograms of high-quality Mexican methamphetamine per year. The operation was believed to extend to Tucson, Arizona, and San Diego, California, all the way back to Quincy, Illinois.

That's why any current discussion about what happened to Jodi invariably spins back to what was happening in the community between the time Jodi arrived in town in the fall of 1993 and her disappearance in the summer of 1995. Time and again, we're asked to consider the people she befriended, the ones she chose to trust, and the ones with whom she willingly spent her time.

Unbeknownst to her, any number of acquaintances in her professional or personal circles may have played a role in illegal drug activity. That's why people have asked, over and over again, did drugs factor into Jodi's case? The question does not necessarily point the finger at her: those who knew her say Jodi herself was unlikely to have been a user of "hard" or "street" drugs.

If she had a drug of choice, it was alcohol, and more specifically, beer. We already know she was a genial and good-natured woman who put a high value on relationships. She reached out to others easily and readily and enjoyed the party lifestyle, of which drinking was a big part. For others, of course, drugs would have been a necessary part of the party. As a party girl who liked to drink, she may have unwittingly broadcast the message that she was open to or accepted harder core drug use.

In the kinds of social circles she occupied, did Jodi somehow draw the attention of those in the drug community who could do her harm? She certainly attracted the attention of those with whom she hung out. In fact, she also often presented herself to

others—especially men—in a puzzling, dual light. She conveyed volumes through body language, leaving herself open to a lot of misinterpretation. For example, she dressed to maximally flatter her slim athletic figure and she loved to flirt, but her friends insist she was not sexually promiscuous. Her warmth and "touchy-feely" ways no doubt frustrated many a man who might have viewed her as a tease, as a young woman who was "asking for it."

A persistent theory that continues to surface in reference to Jodi's disappearance is whether she might have mixed with people in the drug scene and become privy to some damaging information that may have led to her disappearance. Did she know something, or was she *perceived* as knowing something, that would have posed a threat to major players in Mason City's drug culture?

As an anchor of the morning and noon newscasts at her television station (and, as many small-market anchors are expected to do), Jodi also occasionally reported on stories of a general-assignment nature. By necessity, most news reporters are not specialists who know a lot about one topic. Because they follow breaking news and other interesting events, they are expected to cover a wide variety of story topics in any given week. They don't normally delve deeply into any one type of story; instead, they learn a little bit about a lot of things. The stories they cover are as varied as the news itself, with some items of a serious nature, some decidedly not so serious.

For example, in the course of one day, one small-market television reporter might visit the "cop shop" and write a story about an item from the morning's police blotter. She might then swing by a local fair to grab video footage of a kids' beauty contest, and finish the day with a live shot from a hog farm about pork prices. Likely as not, he or she might show up for work the next day and have to cover a medical story. No one day is exactly alike any other in television news. The pulse of small-city life and its variety becomes part of a reporter's normal routine.

Jodi did her fair share of these types of stories in her time on the air before signing on for work at KIMT. However, after she started

working at the Mason City station, reporting was a lesser part of Jodi's overall duties. After all, her physical presence was required in the studio and on the air to produce and anchor the early morning and the noon news shows, which didn't allow for large blocks of time for general assignment reporting, much less time needed to pursue crime or investigative work.

Of course, in Jodi's on-air work, she would have often narrated many drug-related stories written by others. But it would have been highly unusual for her to have any involvement in stories requiring such lengthy investigation. In any event, those kinds of stories are not usually assigned to the rookie reporters like Jodi. She simply did not have the "chops" to be able to tackle a big crime story.

Because her long-term ambition centered on anchoring in the future, she probably would have had little interest in spending her time investigating crime. Jodi's colleague Amy Kuns speculated that stories of that type would neither have been of interest to Jodi, nor, in Kuns' viewpoint, suit Jodi's level of experience and expertise.

Jodi's former boss Doug Merbach (then KIMT's news director) has snorted at the suggestion that his morning anchorwoman may have been investigating drug-related crime stories. He said that, for one, such stories were simply not a normal part of his morning and noon news anchor's workload. But he went on to say he would never have considered assigning her such stories, nor would she ever have lobbied him for the chance to cover those kinds of issues. In fact, he said Jodi simply was more interested in spending her time on the air, and less interested in reporting. She was not terribly invested, he says, in current events, and was not what folks in a television newsroom call a "news junkie."

Merbach made it plain that Jodi was at KIMT to anchor the morning and noon newscasts, and that's exactly what she spent most of her time doing. In conversations with me, he was upfront in saying he thought Jodi's news instincts and her news judgment at the time were not strongly developed. As he put it, he sometimes found himself explaining to her why certain stories needed to appear on the air.

The occasional reporting stints Jodi performed in addition to her time on the air usually centered on more "lightweight" items. Her personality lent itself well to those kinds of stories, which included charity and human-interest items. They also met her professed desire to be involved in the community in which she lived and worked.

Nevertheless, Jodi's sister openly speculates that perhaps Jodi unwittingly uncovered or unknowingly gained some information that put her in jeopardy. Whether it would have happened through her work or personal connections is irrelevant. Though Jodi was "clean," and not a user, she could well have rubbed elbows with many others who were not.

Of course, drug traffickers want to keep a low profile and stay under police radar—they certainly don't want to be exposed by a television reporter. In her capacity, however, Jodi wouldn't necessarily have had to uncover anything to be perceived a threat. In other words, she didn't have to be in possession of such information to be considered a problem: others only had to *believe* that she was in possession of the information.

That others perceived her this way is plausible. Drug-related stories about busts, abuse, treatments, and deaths are—and were, at the time of Jodi's disappearance—a mainstay of television news on an ongoing basis. Northern Iowa was not exempt from these concerns in the early and mid-1990s. Jodi, in her role as morning news anchor, would have naturally related such stories as part of her job.

It is equally plausible that, as a local anchorperson, Jodi was subject to the same rumor mill, true or false, that plagues far more famous people. After all, guilt by association tends to stick, even if it has no basis in reality. So when a worker at an establishment sometimes visited by Jodi said she saw Jodi (along with a friend) doing drugs in the bar one evening, are we to believe that without question? When that worker further said that it seemed hypocritical of someone on television who is in the midst of a drug investigation

(which she assumed was true) to be seen doing drugs (which she said was a fact) in public, are we to believe that as well?

Jodi might have been a bit naïve about people's intentions, but she certainly was not stupid. If she valued her job and her reputation and her ability to move up in the broadcasting industry, would she have even considered doing something like that in a public venue? That's the problem with rumors, and as we've discovered, those kinds of rumors often circulate about television personalities, especially in the communities in which they are best known.

Consider what happens when rumors like these, presented as facts, begin to spread around a town by unsuspecting others. In a town the size of Mason City, it is not a stretch to think that those tales might make it to the ear of a major player.

If a drug kingpin *thought* Jodi had somehow learned incriminating information about him or his operation, she could have been considered a threat. If he *thought* she was asking too many questions, for example, he might think it was worth the effort to keep her mouth shut.

Or what if someone she knew, someone in her large circle of friends and acquaintances, just happened to be involved in the illegal drug community in some way? Perhaps Jodi inadvertently learned some information from someone in her social circles. What if one of her friends or acquaintances was friendly with drug dealers, unbeknownst to her? What if such a friend or acquaintance found it a lucrative way to make some extra money on the side?

Enter Dustin Honken. Perhaps Mr. Honken and Ms. Huisentruit never met face to face, but they almost certainly would have been aware of each other's position in the community by 1994. He would have known of her reputation and seen her work on television. She, on the other hand, might well have reported his name many times in the course of her on-air work.

Honken was reputedly a big part of the illegal drug trade in Mason City, specifically the area's growing meth subculture. Prior to Jodi's disappearance, Honken's name was frequently in the news.

Depending on who's talking, Dustin Lee Honken was either one of Iowa's most notorious criminals or just another small time dealer caught up in one more battle in the war on drugs. Prosecutors worked tirelessly at the time to send Honken to jail, calling him an extremely powerful player in the production of methamphetamines in northern Iowa. They postulated that he killed informants to stay out of prison and insisted that he would kill again.

At this writing, Honken and his former girlfriend, Angela Johnson, are serving time on death row in two facilities, both outside of Iowa. They are two of over three thousand death-row inmates in the United States today, and they were both charged in connection with five drug-related murders in northern Iowa in 1993.

That may be the end of their story, despite the inevitable ongoing legal appeals. However, Honken and Johnson were not yet in custody in connection with those crimes at the time of the Pruin and Huisentruit incidents in 1995.

Let's fill in the blanks by backtracking a little; we'll start at the beginning.

Dustin Lee Honken, a native of Britt, Iowa, first became a fixture in Iowa news in 1993 when he was arrested on drug charges in Arizona. At least one person described Honken as a community college chemistry whiz who apparently started manufacturing and selling methamphetamines the previous year. Following the Arizona arrest, he pleaded guilty to one count of manufacturing and distributing meth and one count of attempting to manufacture the substance.

However, the week before he was scheduled to enter that plea in court, he learned some distressing news: one of his main dealers who trafficked the drugs for him back in northern Iowa was cooperating with authorities as an informant in the case. The informant's knowledge of Honken's sophisticated Arizona meth manufacturing operation would be devastating to Honken's case.

That informant, thirty-four-year-old Greg Nicholson, mysteriously—and, some would say, conveniently—disappeared, along with

Nicholson's new girlfriend and her two children, just days before Honken's July 1993 scheduled court appearance. Nicholson's disappearance proved to be a very positive turn of events for Honken, as was another disappearance, one that happened barely four months later.

Terry DeGeus, another former trafficker and key witness, met a similar fate in November of that year. Before their disappearances, both missing former meth traffickers posed significant threats to Honken's freedom. After the two men disappeared, the charges against Honken simply fell apart, as neither man was available to testify against him. Because of their disappearances, Honken had gained the freedom he wanted.

Honken's involvement in the disappearance of five people in all (Nicholson and DeGeus, and Nicholson's new girlfriend and her two kids) was the topic of much innuendo and speculation. However, the case against Honken was nebulous at best, because investigators found no bodies at the time and authorities were unable to make any charges stick. The case of the mysterious disappearances started to grow cold.

As a result, Honken essentially remained a free man for some time between 1993 and 1997. He eventually was convicted in 1997 on a different drug-trafficking charge, which sent him to federal prison in Colorado.

This already-extraordinary story grows even more so, however. Honken and his former girlfriend, Angela Johnson, were both incarcerated in different facilities when Johnson and Honken started talking to their fellow inmates. In 2000, Johnson befriended and began to confide in another inmate at the Benton County jail in Vinton, Iowa.

By passing notes, conferring through a small window in the jail's recreation yard, and even yelling through the walls, she reportedly related a gruesome tale to her jailhouse companion about the murders of five people, including two children, in northern Iowa in 1993. She even drew a crude map, which she passed to her companion

in a book, indicating where those five people were buried.

Johnson apparently wasn't the only one talking, however. Honken, too, felt the need to discuss his conquests with another inmate while he was serving time for the meth-related charges. His posturing in front of a jailhouse inmate and his need for recognition, as is all-too-often the case with criminals, proved to be his downfall.

In the end, Angela Johnson, originally from Klemme, Iowa, was accused of aiding and abetting Honken in his plan to keep Nicholson from testifying against him in court. In 1993, Angela was pregnant with Honken's child when they devised a scheme. She posed as a lost cosmetics salesperson in need of a phonebook when she knocked on the door of Lori Duncan's home one evening in late July 1993. The thirty-one-year-old Duncan had apparently met Greg Nicholson only days before, and he was staying with her and her kids in an effort to "hide out" from Honken. There is no indication that Duncan herself had any criminal involvement; she and her young daughters, ages ten and six, were said to be innocent victims.

Angela Johnson apparently was so convincing in her role as a lost saleswoman that Lori Duncan opened the door to her. It was a fatal mistake. As Johnson entered the home, Honken followed, brandishing a gun that Johnson had purchased at a Waterloo pawnshop a few weeks earlier. Evidence showed that Greg Nicholson, Lori Duncan, and her daughters, ten-year-old Kandace and six-year-old Amber, were rounded up and driven to a field southwest of Mason City. There, according to prosecutors, the four were tortured, bound, gagged, and shot execution style before their bodies were dumped in a shallow common grave.

Nicholson was thus silenced, but the other former meth trafficker weighed heavily on Honken's mind. Thirty-two-year-old Terry DeGeus knew way too much about Honken, and was apparently still willing and able to point the finger at him in court. Angela Johnson proved to be a capable accomplice once again. In November 1993, she apparently called DeGeus, who was her former lover. On

the phone, she told him that she had broken up with Honken, and asked DeGeus to meet her so they could talk. He agreed to the meeting. That was the last time he was seen alive.

So when Johnson started telling her jailhouse stories in 2000, authorities finally had the ammunition they needed to solve the case of the five people missing for seven years. In October 2000, they used the crude map she had drawn in jail and discovered the bodies of the first four victims in a common grave west of Mason City. Authorities unearthed DeGeus's body a few weeks later at a site about four miles from the first, near Burchinal, Iowa.

After years of legal missteps, wrangling, and maneuvering, Honken and Johnson were finally convicted in connection with the five deaths. Honken learned his fate in October 2004, and Johnson was found guilty on all counts several months later, in May 2005. Because of the severity of the federal charges they faced, prosecutors were able to push through with their demands for the death penalty, even though Iowa is one of the states that does not currently allow for the death penalty.

During her trial, Johnson called Honken a monster and a psychopath. Her defense attorney attempted to paint a picture of Johnson as a woman trapped by the schemes of the man she loved. Jurors apparently didn't buy the story, and government indictments accused Johnson of three aggravating factors:

- She helped commit each of the five murders after "substantial planning and premeditation."

- She took advantage of the youth of the Duncan girls. The indictments cited the children's particular vulnerability.

- She intentionally "committed each offense in an especially heinous, cruel, or depraved manner involving torture or serious physical abuse" in each of the deaths.

An additional aggravating factor included in the indictment was that Johnson "intentionally killed or attempted to kill more than one person in a single criminal episode." Johnson was the first

woman in over fifty years to be sentenced to death by a U.S. federal jury.

All of this information raises the obvious question: do Honken and Johnson have anything to do with Jodi's case? Between 1993 and 1995, Dustin Honken and Angela Johnson were not in jail. They were both living and working in the Mason City area during that time.

As a matter of fact, Johnson held a job as a waitress at the Mason City Country Club, and she had actually been part of the staff on duty for the golf event banquet that Jodi attended the night before she disappeared. She more than likely served Jodi or came face to face with her on the last night of the anchorwoman's life.

More than one "tip" over the years revealed that Johnson supposedly told someone "she was there" when Jodi was kidnapped and presumably killed the morning after the golf banquet. That apparently was no more than just another idle rumor circulating at the time. While imprisoned, Angela Johnson was asked point blank by a reporter whether she had anything to do with Huisentruit's disappearance. Already on death row, she literally had little to gain and nothing more to lose if she were to admit to yet another murder. Johnson denied having had any knowledge about the case, and said neither she nor Honken had any connections to Jodi, in life or in death.

On the face of it, Jodi probably posed very little overall risk to Honken and Johnson. Honken had controlled a highly lucrative methamphetamine ring, and exercised a lot of power as a result. Sure, he could have ordered another murder. No doubt he was owed a lot of favors, and could ask any one of his minions to take care of a pesky problem: a local anchorwoman with too much information. And, after all, he and Johnson had already allegedly killed five people. Does murder get easier the second (third, fourth, fifth, or sixth) time around?

In the five murders for which he was already convicted, Honken was driven by the motive to silence a federal witness. Could he also

have been driven by the motive to silence a potentially chatty reporter? Did she possess even more damning information against him?

Where would she have learned that damning information? Let's consider that aspect as one more possible tie-in Jodi could have shared with the Mason City drug operatives. Such organizations invariably attract people looking for ways to make money or supplement their incomes.

That simple assumption leads to more rampant speculation: Was one of Jodi's friends (with or without her knowledge) involved in some way in this larger drug operation? What if that friend let some information slip, information that put her on alert? What if she had learned something during the course of a visit to a friend's home? What about Billy Pruin? How well did he know Dustin Honken and his cohorts, if at all? What about John Vansice, on the surface a rather free-spending man (a boat, two rental properties, a surprise birthday bash, not to mention lots of dinners, drinks, and flowers) in the months before Jodi vanished? Vansice knew people who knew Honken, but how well did Vansice know him and his cohorts, if at all?

Did one of those men prove to be a toxic friend to Jodi?

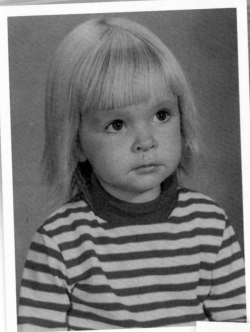

Jodi, age 2, 1970

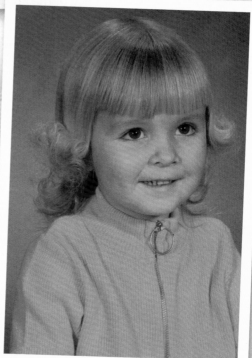

Jodi, age 5, 1973

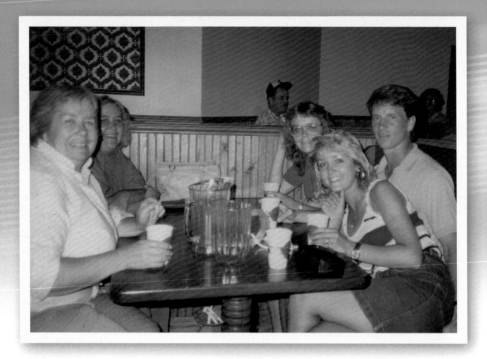

Left to right: Jodi's mom, Jane, sister JoAnn, sister Jill, Jodi, boyfriend
Tom Kintop. On the back of the photo, Jodi had written this note,
"July 26, 1987. Sitting in the Red Garter Saloon at Valleyfair.
Since it was hot we spent plenty of time in there."

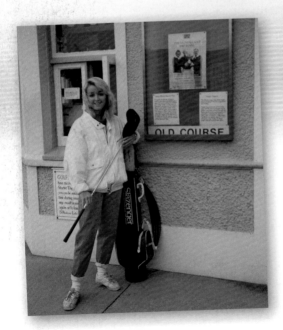

September,12, 1987, at St.
Andrews Golf Course, Scot-
land. This is the picture on
which Jodi wrote, "It was
like a dream to be golfing in
St. Andrews."

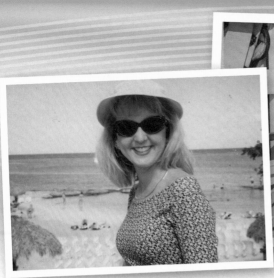

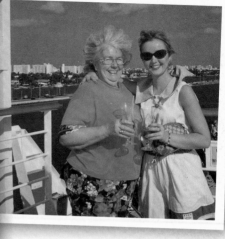

October 17, 1994,
Cozumel, Mexico

October, 15, 1994. Jodi and her
mom, Jane, aboard a cruise ship
bound for Mexico.

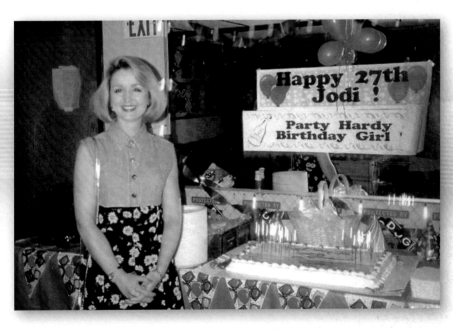

June 10, 1995: Jodi at her 27th birthday party,
just 17 days before she disappeared.

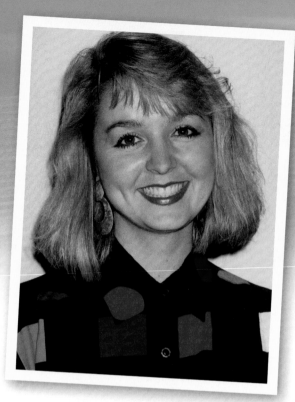

Summer, 1993

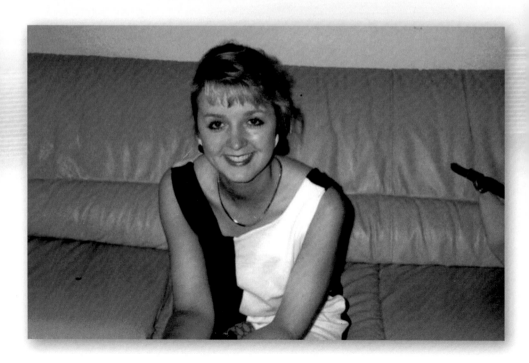

CHAPTER SIXTEEN

LOOSE LIPS

> "If nobody recognizes me, then it is a sign that
> I have ceased to exist."
>
> —Evelyn Scott

In criminal justice circles, it's an established fact that many who run afoul of the law share the impulse to boast about their misdeeds. We've already discovered that tendency to talk too much—to authorities or to other inmates in jail—can get them into deeper trouble. With all the television crime dramas on the air, most people are aware of Miranda warnings and specifically their right to remain silent. They may *know* it's better to remain silent, but lots of them talk anyway. So what makes them want to unburden themselves?

Experts cite various psychological reasons for why any suspect may want to speak with an investigator about his or her crime. One of the reasons is paranoia, according to some officials. A suspect is never quite sure what information police possess. The suspect knows that police are investigating the crime, and will most likely follow media accounts about it to determine how much police know and what leads they already have.

Uppermost in the suspect's mind, however, is how to escape

detection and obtain firsthand information about the investigation and where it is heading. According to police, that kind of paranoia and simple curiosity motivates suspects to voluntarily start talking with authorities. Some of them have even appeared at police head-quarters as concerned citizens who have pertinent information about the case.

This impulse may make psychological sense when one is *guilty* of a crime. But what's going on when people begin to implicate them-selves in crimes they may know nothing about? Is it simple attention seeking behavior, or is it something more?

That's what happened when three people, each at different times and in different places, all happened to talk just a little *too* much about the disappearance of a young anchorwoman. These three people, all supposedly not guilty in Jodi's case, nevertheless impli-cated themselves into the investigation by simply letting their mouths get the better of them. As a result, the media spotlight did linger a bit longer on these individuals, two men and one woman.

First, consider the story of Cynthia Marie Sweeney. In December 2006, the Jodi Huisentruit case took on a decidedly weird twist when a twenty-five-year-old woman traveled from her hometown of Anoka, Minnesota, to Mason City, Iowa, to tell police a tall tale.

Sweeney made some pretty sensational claims when she sat down with authorities in Mason City, spinning a story about the things she witnessed as a thirteen-year-old runaway. Her story included graphic accounts of how six men tortured and killed Jodi Huisentruit in a barn near Mason City. She provided vivid and grue-some details of what she witnessed and what the men did with the anchorwoman's body. The account certainly garnered the attention she sought: the media, understandably, pounced on the news, and two Minnesota television stations gave Sweeney's claims wide airplay, a move roundly criticized by many viewers.

Within days, however, Sweeney recanted her story. When police could not verify her claims and continued to press her for details, Sweeney buckled and confessed the story was all fiction. She

subsequently faced charges of providing false information. And it's still not clear why she did what she did; perhaps she herself cannot identify her own motivation. Some surmise it was simply an attention-seeking gesture, and she certainly got her share.

Nearly a year later, Sweeney sounded remorseful yet matter-of-fact when she appeared in a Cerro Gordo County courtroom to make a statement. She said,

> I understand that by lying to police, not telling them the whole story, people had to do extra work and use extra resources. I am sorry I did not tell the whole truth. I understand that I have to pay a fine, and pay back some of the costs. I am prepared to do that.

In November 2007, Associate Judge Carolyn Grupp issued a six-month jail term for Sweeney, and suspended all but thirty days. Judge Grupp addressed Sweeney after the sentencing, telling her that the impact of her actions was far-reaching. In her post-sentence statement, Judge Grupp said,

> This false report has impacted your life. It also had a significant impact on law enforcement and on a grieving family. Not just the Huisentruit family, but the entire family of north Iowa, which has followed this tragedy. It renewed wounds and sent law enforcement on a wild goose chase.

Next, consider the story of Tom Corscadden. Thomas Gary Corscadden, who lived in southern Minnesota at the time Jodi disappeared, may have come under the microscope for a brief time immediately after the disappearance. Across the state line, Minnesota's Mower County authorities had long been aware of Corscadden's history as a sex offender, so Iowa officials probably gave him at least a cursory glance during their initial investigation. His later actions, however, apparently warranted some closer scrutiny.

In and out of the Minnesota prison system for years, Corscadden was said to have made interesting comments about Jodi to prison officials, thereby implicating himself into her case. While living in Austin in 1995, he was said to be a big fan of KIMT's morning and noon news anchorwoman, and made a point of watching her whenever he could, calling her "my girl" when he saw her on the air. Corscadden's former wife told police that he was definitely drawn to Jodi on television. She also revealed that he contacted a TV station in Mason City (presumably KIMT) during the first three months of 1995 and was angry when he was unable to get tickets to a TV show. For his part, he acknowledged making phone calls to the TV station and trying to take his children to a show there. While this may sound like the actions of just another run-of-the-mill fan, Corscadden had a troubling history.

According to the Minnesota Attorney General's Office, Thomas Corscadden fits the profile of a classic sex offender. His criminal history includes rapes and attempted rapes, incest, and a history of voyeurism and exhibitionism. He was convicted of several sexual assaults, including an assault on his own daughter.

While serving a military tour of duty in Southeast Asia in the 1970s, Corscadden admitted to raping a least one woman in Vietnam at gunpoint. The Attorney General's Office said Corscadden claimed he held a gun to the woman's head and gave her the option of sex or death.

In March 1996, a court agent's conversation with Corscadden, who was held at the time at the Minnesota Security Hospital in St. Peter, Minnesota, prompted some suspicion. When the agent mentioned Mason City in the conversation, Corscadden reportedly smiled and said, "Jodi Huisentruit." When the agent said she didn't think Huisentruit was alive, Corscadden is reported to have said, "No, she's dead." Then he repeatedly asked to talk about her case.

During a psychological evaluation four years later, he talked again. According to records, in 2000, Corscadden "spontaneously brought up" the Huisentruit case during a discussion of his

sexual past.

The owner of a light-colored van, he traveled frequently and routinely around southern Minnesota and northern Iowa in 1995. He was said to have business connections in Mason City and traveled there often, sometimes several times a week. He was also known to frequent nude dancing bars in that city and others. On the day Jodi disappeared, he reportedly was working in Albert Lea, Minnesota.

Corscadden, no stranger to police over the years, on one occasion drew the attention of an officer when his van was sighted at the Key Apartments in Austin. He was thought to often use his van, dubbed by police as "the poor man's porn palace," for sexual liaisons with prostitutes and other willing (and we can assume some unwilling) players.

The van earned the name "porn palace" because it was carpeted and equipped with a mattress and other items, including handcuffs, print pornography, lubricants, and sex toys, among other things. The van may have served as a home base for Corscadden's known avocations of window peeping and seeking prostitutes.

Police questioned Corscadden extensively in connection with the Huisentruit case, but apparently found no compelling evidence to link him with the crime. In 2004, he passed a lie detector test administered to him in prison, and a palm print taken from him did not match prints found on Jodi's car. In June 2010, the fifty-eight-year-old Corscadden was reportedly under intensive supervised release in Minnesota's Carlton County.

A former friend of Thomas Corscadden, Randy Seward, still lives on a farm in rural Mower County, near Dexter in southern Minnesota. Seward also warranted a close look because of his connection with Corscadden. Years ago, officials visited Seward's farm site, armed with a warrant. They reportedly unearthed a fire pit on the property, and explored an area bordering a tree-lined windbreak. That visit, however, proved fruitless, and apparently merited no followup action.

Finally, consider Tony DeJuan Jackson, who's been called the "rapping inmate." In 1998, Jackson, a convicted serial rapist, also came under police radar when he admitted that he had bragged about being involved with Jodi's disappearance. Tony DeJuan Jackson was twenty-one and working in Mason City when Jodi went missing. As a matter of fact, he lived in downtown Mason City, just a few blocks from KIMT-TV. Convicted of four Minnesota rapes in 1997, Jackson currently serves time at Oak Park Heights, a maximum-security facility in Minnesota.

While in prison during the winter of 1999, Jackson wrote the lyrics to a rap song, which some thought contained references to Jodi's case. Imbedded in the lyrics were references to a body "stiffin' in Tiffin." That clever rhyme naturally raised a few eyebrows among those who lived in and around the northern Iowa town of Tiffin.

Area farmer Doug Campbell recalled an officer paying a visit to ask questions about a place in the area that might fit the rap reference. That led officers to conduct a search in and around a silo on an abandoned farm site in Johnson County. Police brought scent dogs to the rural Tiffin site, and one of the dogs reportedly reacted to an odor in the silo. Officers later discounted the alert, attributing it to the scent of animal remains.

Despite his past admission that he had bragged about his part in the case, Jackson repeatedly denied his involvement. Mason City police and others could not then—and cannot now—find a definitive connection between Tony Jackson and Jodi Huisentruit. He has since been discounted as a viable suspect.

Yet, the rumors persisted about Jackson. Someone made the claim that a Mason City drug dealer wanted to offer fifty thousand dollars to Jackson's family if he'd take the rap for Jodi's death and confess to her murder. We can assume it was just that: another rumor.

In the fifteen years between 1995 and 2010, dozens of such rumors, links, tips, and theories have been suggested, explored, followed up, and eventually discarded. Attempting to chronicle every avenue of exploration over the years would be an exercise in

futility. Officials have methodically and sometimes exhaustively investigated possible connections with other deaths and disappearances, especially those of females in the Midwest. Almost every theory has come to a decisive dead end. Not one of them so far has netted an arrest or a definitive answer.

Chapter Seventeen

BARE BONES

> ❝Life, struck sharp on death,
> makes awful lightning.❞
>
> —Elizabeth Barrett Browning, "Aurora Leigh"

Those who have lost loved ones know that the approaching anniversary of a traumatic loss is sometimes more painful than dealing with the anniversary itself. And once it has passed, although we never forget, we often experience a sense of relief. It is difficult enough to go through this once a year; the Huisentruit family had to relive that painful pattern at least twice in 2004.

On June 27, 2004, nine years to the day after Jodi's disappearance, area television stations and other media noted the observance, but with no attendant "new" news to report about the case, it remained low-key. A small article in the Minneapolis, Minnesota, *Star Tribune* newspaper noted that her family and friends would quietly gather to remember Jodi.

Three years had passed since a Mason City court judge declared Jodi legally dead, a pesky but necessary legality that allowed her next of kin to finally settle estate details. Such cases normally take years, because the lack of a body precludes authorities from routinely

issuing a death certificate. Without that vital piece of court paper, it becomes problematic to settle the missing person's financial and legal affairs.

So the anniversary came and went. But almost three weeks after that quiet day, the morning news on Minnesota and Iowa TV stations was urgent, compelling, almost raucous in comparison. A landscape worker had discovered the remains of what were thought to be human bones near a pond located behind a large, newer home just outside the Mason City limits. The discovery had been made only a couple of miles from Jodi's former home, the Key Apartments.

At first, authorities, although hopeful themselves, were unsure what they were dealing with. But they had to issue a statement, and they wanted to keep hope realistic, at least at this early stage. They were quick to state a disclaimer for the press that the bones might simply be those of an animal. Despite the statement, inevitably many in Iowa's Cerro Gordo County Sheriff's Office and the Mason City Police Department quietly held out hope that this was the big break in the Huisentruit case.

The bones were carefully exhumed and rushed to an autopsy lab in Iowa's capital, Des Moines. Dental records searches were scheduled.

It was easy for the police, the media, and the public to jump to the obvious conclusion. So many years after her disappearance, many hoped and prayed for the day when Jodi or her remains would be found. It was a watchful and tense time for all involved. In a figurative sense, many seemed to be holding their breaths for the test results. But forensic experts can't be rushed through such a deliberately slow process.

As people waited, the pressure was building in Mason City and beyond. News crews from all over the Midwest again converged at the law enforcement center in Mason City. The Cerro Gordo County Sheriff's Office scheduled a news conference for noon. That office was pressing the Des Moines authorities for something, anything, definitive.

Some were certain it was Jodi's body that had finally been located. Others, like her sister JoAnn, of Sauk Rapids, Minnesota, were less optimistic. That day, she was quoted as saying that she felt that they were not Jodi's remains. She added that it would be almost painful after all the years if her sister's body were to be found in such close proximity to the parking lot of her former apartment building.

Jodi's mother, Jane, then eighty years old and living in Long Prairie, Minnesota, would only say that she still thought of her beloved daughter every single day. Other family and friends noted that a funeral, a celebration of Jodi's life, had never been held, and it would be a relief to bring some closure to her life and the case.

At noon on Thursday, July 15, Cerro Gordo County Sheriff Kevin Pals faced the expectant cameras and the bank of microphones set up in the law enforcement center. He read a prepared statement to the assembled media. Amy Kuns, Jodi's former coworker and the last person to have spoken to her before the disappearance, attended the news conference.

The announcement was broadcast live by many TV stations in the region. But it was anticlimactic at best: a bitter pill to swallow. The sense of disappointment among those gathered was palpable that day. Instead of providing a link to an ongoing high profile case, officers instead now faced a new and different case.

The remains were identified as those of a Caucasian adult male, identity unknown. There was absolutely no way the bones could have been those of the missing anchorwoman.

The remains found in the summer of 2004 were later identified as belonging to another missing person, a man who had been missing for ten years. But this one was not such a high profile case. In fact, many couldn't even recall it.

James Perkins, forty-four years old at the time of his death, was last seen alive when police were called to investigate a possible assault. Police actually found him hiding in an empty grain wagon, armed with a hatchet and a knife. But Perkins proved to be an elusive

target. Upon discovery, he leapt from the wagon, fled into a swampy ravine, and disappeared.

It is still not clear how Perkins met his end, and it's not clear how his remains became interred in the location where they were finally unearthed. What became all too clear in that summer of 2004 was that they were not those of Jodi Huisentruit.

Chapter Eighteen

SECRETS

> "'What is the most dangerous possession in the world, Mr. Falkland?'
> 'No use at riddles,' replied the young man cautiously. Dobree picked up the speaking-tube. 'Someone else's secret,' he remarked..."
>
> —Marjorie Bowen, *The Shadow on Mockways*

Jodi's killer did a masterful job of hiding his evidence. No one disputes that. And no one truly knows where Jodi's remains are hidden, though most insiders believe her body is buried reasonably close to the site of her abduction, either in northern Iowa or in southern Minnesota.

If Jodi's abductor (and presumably her murderer) wanted to get her out of Iowa—for whatever reason—he would have had to drive a minimum of two to three hours to reach Iowa's other neighboring states of Nebraska, South Dakota, Missouri, Wisconsin, and Illinois, thus increasing the chances of being discovered with a body in tow. Mechanical problems, a flat tire, or a speeding or road-rule citation by an alert cop or state trooper would have dramatically increased the chances of discovery.

Taking Jodi far away from the site of her abduction would also have posed another knotty logistical problem for the perpetrator. What if it was important for him to be seen back in his regular weekday and workday routine in Mason City or elsewhere as soon as possible? That could have been a critical issue—not to mention a handy alibi.

That's the thinking pattern of one unidentified informant who proposed what he called a "likely spot" for hiding evidence that early June morning. Almost like a shot in the dark, the informant began to home in on a body of water no more than a few minutes north of the Key Apartments. He makes no secret of why he made his assumption. He simply drew a circle on the map several miles in diameter, with the Key Apartments at the center of the circle. He theorized that Jodi's abductor hadn't had much time to get rid of his evidentiary burden before he had to be seen back in his hometown doing business as usual.

What's referred to in the area today as the Plymouth Road ponds lie just north of a development of newer homes (most built since 1995) just outside the Mason City limits. They're easily accessed by traveling north on Kentucky Avenue and continuing north on Plymouth Road. The houses become farther apart as the road continues north into more rural parts of Cerro Gordo County, and the road at one point separates two ponds or lagoons.

Although each covers a substantial area, the ponds are believed to be relatively shallow, in some areas perhaps no more than five or six feet deep, with occasional deeper spots. The informant identified one of the ponds as easily accessible by a vehicle, and as an ideal place for the quick and relatively easy disposal of a body. With daylight approaching and time of the essence on the morning of Jodi's disappearance, the abductor, he theorized, would have known that alarms would be sounding soon in many quarters about the missing anchorwoman. It was critical for the abductor to move fast and act decisively.

Even if quickly dug, a shallow grave would have been problematic.

It would have been too easily spotted; casual observers often discover such graves. Dumping the body in water surely would have appeared to the attacker as a cleaner and faster way to hide the evidence and keep it hidden, as long as it was done right. Of course, the attacker would have surmised that the body would have to be submerged and stay submerged, presumably with some type of anchor. One way he could have accomplished this was with what are commonly called "suitcase anchors." They are concrete blocks with imbedded, large ring-eye bolts or bent rebars; they can be lifted, just like suitcases. Hence, the name.

These kinds of anchors are inexpensively and easily made at home, too. A coffee can or other container, a bag of cement, and a ring-eye bolt: these simple items can make an expendable and cheap anchor. And they are anchors that boaters, for example, don't mind leaving behind, if necessary.

Crude or otherwise, they can be useful in boating and a variety of other applications, too, as counterbalances or counterweights. Depending on who makes them and how they are fashioned, they can sometimes be traced back to the person who used them.

Suitcase anchors proved to be part of a damning trail of evidence in another highly publicized disappearance and murder in Modesto, California, in 2002. When seven-and-a-half-months pregnant Laci Peterson disappeared on Christmas Eve that year, her husband, Scott, came under immediate surveillance, despite his protestations of innocence. Several months later, San Francisco Bay yielded one of its secrets, one that put the spotlight squarely back on Scott.

In April 2003, a male fetus and the partial body of a woman were washed ashore separately, and the bodies were positively identified as those of Peterson and her unborn son. And prosecutors finally had some circumstantial evidence they felt could conclusively link Scott Peterson to the murder of his wife.

Part of the evidence presented in court surrounded missing homemade boat anchors, empty concrete bags, and concrete residue found in Peterson's warehouse and truck. Prosecutors theorized

that the fertilizer salesman dumped his wife's body in the San Francisco Bay, using several homemade boat anchors to ensure the body's submersion.

In December 2004, two years after his wife disappeared, Scott Peterson was convicted of first-degree murder in the death of his wife and second-degree murder in the death of their unborn son, Conner. In 2005, Peterson was sentenced to death by lethal injection. Maintaining his innocence, he remains on death row in California's San Quentin State Prison while his case is on appeal.

The kind of homemade boat anchors that made the news in that California murder case years later could well have been used in Mason City's high-profile disappearance case in 1995. Of course, tides of the kind that washed Laci Peterson's body ashore are not present in a pond in the landlocked state of Iowa. A body in a pond or lake would be unlikely to surface if appropriately weighted, by whatever method.

The unnamed informant who zeroed in on the north Iowa pond as a possible resting place for Jodi found his reasoning so convincing that he brought in another expert. He contacted a female acquaintance with expertise in the use of cadaver dogs, and persuaded her to bring her canines from her home in Alaska to Mason City.

They explored the area along Plymouth Road. The Alaska woman has handled her dogs in several other stubborn cases around the country, and has reason to believe a body could have been hidden on the northern edge of the westernmost pond. As their handler led them around certain key areas of the ponds, the canines reportedly "went crazy" on a scent.

The informant shared his information with the Mason City Police Department, which he said assigned a search diver to the area. That search proved fruitless, however. Other experienced divers have said that the pond water is dense with silt and other particulates—so dense that it's impossible to see a hand in front of one's face. In addition, after so many years, it's likely that an anchored body—if it is indeed there—is covered with several inches of muddy silt.

If a full-fledged search were conducted in the area, and *if* remains were found—two big *"ifs"*—it would bolster the firmly held beliefs of our unidentified informant. By whatever means—draining the pond or digging through the muck—the informant believes it could crack the case wide open again. In his opinion, if a search turned up remains, not only could experts determine if the remains were those of Jodi (through DNA testing), but it could well provide definitive evidence to be used against the murderer.

The area in focus is widely known around Mason City as a place to party in the summer. More than one police officer has responded to complaints about drunken and naked revelers in the remote, wooded areas north of the ponds. Evidently, the area is still used for such purposes today. On walks through the well-used dirt paths, strollers can easily come across stray shoes, beer cans, and liquor bottles.

This enterprising investigator's strong opinions, as well as the fact that cadaver dogs picked up on a strong scent, may strike us as pointing to the truth. We may—or may not—feel equally sure of the opinions of another kind of investigator, namely that of a psychic. More than one psychic has, of course, weighed in on this case with equally strong opinions. Since Jodi has not been seen since the day she disappeared, and no arrests were ever made, conjecture and opinions from professional and amateur investigators tend to share equal billing with observations offered by intuitive types and psychics.

Like more run-of-the-mill investigators, some psychics who have looked at the case believe that Jodi was killed and her body secreted in the woods or water, probably relatively close to where she was kidnapped. Again, the two aforementioned reasons are the basis for this belief: the need for haste and secrecy was paramount, so it's not likely the perpetrator(s) drove great distances to get rid of the burden. And, as mentioned, large areas of relatively open yet remote spaces in southern Minnesota and northern Iowa provided lots of options.

At least two of the mediums involved in the case say they strongly

sense that another nearby body of water, this one in southern Minnesota, was a likely place for Jodi's perpetrator to dump and run. These two unnamed clairvoyants are convinced that Jodi met her end in a southern Minnesota state park.

I visited the area in question. To be clear, I claim no psychic or intuitive powers, and so cannot endorse any specific observations made by those who do. But exploring the area in question did seem critical, so I determined to follow the lead of those two mediums who have stressed strong opinions about Jodi's possible burial site. On a crisp autumn day, feeling just a little crazy for considering it, I made an exploratory trek to Myre-Big Island State Park, just north of the Iowa border, near Albert Lea, Minnesota. A couple of willing co-conspirators joined me in the quest.

Myre-Big Island Park is just one of many parks under the jurisdiction of the Minnesota State Parks system. Named for late Minnesota Senator Helmer Myre (pronounced My'ree) and for the scenic island in the midst of Albert Lea Lake, it's a nature lover's paradise. A relatively short forty-minute drive north of Mason City, the nearly sixteen-hundred-acre park offers recreation, relaxation, and lots of private space in summer and winter, and provides access to campsites and hiking trails, snowmobiling, and fishing areas.

The region's large lake, along with the prairie, wetlands, and dense woods, offers peace to solitude seekers, and may, according to at least two psychic observers, be Jodi's final resting place. At least one of those psychics strongly asserts Jodi crossed a state line before someone buried her body.

One park employee who has worked at Myre-Big Island Park for close to twenty years, Cindy Schmidt, claimed that investigators were on hand to ask questions and search the park shortly after Jodi's disappearance. Schmidt said that although she has long been aware of the rumors concerning Jodi's case, she was satisfied that investigators found nothing amiss in the park, and she claimed with confidence that Jodi is not buried within the park lands.

That might be a too-hasty assertion, however. It would have

been virtually impossible for officials to comb the entire 1,596-acre park of vastly varied vegetation. On Albert Lea Lake's Big Island alone (its acreage only a fraction of the entire park), visitors see, according to a park brochure, "an excellent example of a northern hardwood forest, featuring maple, ash, elm, and red oak trees," among others. But the island is also home to "a large wetland area, which provides nesting sites, food, and cover for diverse wildlife." Might it, in fact, have also provided cover for humans in the process of carrying out one or more nefarious acts?

In fact, according to a disclaimer on the park map provided to visitors, lands exist within the boundaries of the park that are barely explored and not under jurisdiction by the DNR (Department of Natural Resources); visitors are advised to check with the park manager if they plan to stray from the paths and trails shown on park maps. In other words, the park includes giant unpopulated and unpatrolled areas.

Some who have investigated the crime remain skeptical that Jodi's killers would have ventured into a state park to dispose of her body. They argue that passing through monitored park areas (especially on a summer night) would have made such people more vulnerable to discovery. Further, in their opinion, park visitors would have been more vigilant and observant during the first few days following such a highly publicized incident. Simply put, in the wake of such widely disseminated news, people would have been more likely to notice and be suspicious of others' actions.

However, the park gate on the west side entrance to Myre Big Island Park, with easy five-minute access from I-35, remains open twenty-four hours a day, and at night, no one mans the park's entrance building. Only certain areas within the park are gated at night, including the site of the White Fox campground on the mainland, and the one at the Big Island campground. Those roads are gated in the evening to prevent the lights and noise of after-hours motorists from disturbing campers. Otherwise, any motorist can drive undisturbed and unimpeded into the park lands and over the

natural land bridge that connects Big Island to the mainland.

Even during daylight hours, it is a simple matter to step into the main gate office and pay an admission fee, with no car identification or inspection required.

The Minnesota sanctuary conceivably could have been an area where a killer familiar with the park and its practices could have carried out his heinous deed. Five valid reasons come to mind:

- The relatively short drive across state lines from the scene of the crime.

- The ease of entering the park unimpeded, and the park's proximity to I-35, a major interstate.

- The previously mentioned large, unpopulated areas within the park lands.

- The lack of any official presence in the park lands at night.

- The availability of parking lots (for campers, hikers, and other visitors) within the park, where an unattended car late on a summer night would not draw undue attention. (Those who live in rural and farming communities know how easily inhabitants identify outsiders, and how observant they can be to patterns outside the norm. Late at night, a car parked on a rural road somewhere is likely to draw much more attention and conjecture among area residents than a car legally parked in a state park's campground parking lot.)

The claim of one medium and intuitive counselor—one who wishes to remain unnamed—was particularly compelling. In 2006, on a visit to the Mason City area with investigator Gary Peterson, this medium (a California native who had passed through another part of Minnesota on a trip to elsewhere only once, and who had no prior knowledge of the area) correctly directed Peterson to the Mason City apartment building inhabited by Jodi. She further was able to point out Jodi's former apartment, and without prodding, identified another ground-floor apartment from where she believes

an elderly person peered through curtains that morning and watched the crime being carried out under the cover of darkness.

This medium was also able to discern the parking spot where Jodi's car had been located at the time of the crime, and could re-enact how Jodi was likely attacked in the predawn of that June day. Peterson, for one, says he was impressed by her ability to identify so many factors about the crime without previous knowledge. That's pretty high praise coming from a no-nonsense man who spent years as a newsman and who currently works in the medical and legal death investigation practice.

Following her success at the site of the crime, the medium and her cohorts were driving away when she says she found herself visualizing a map of sorts in her head. She asked her husband for a pencil and quickly drew out a rough sketch of roads, paths, and landmarks. When asked what she was drawing, she claimed she didn't know where it was, but insisted that it was important. She simply said that she felt that Jodi was leading her.

In addition, she claimed a number occurred to her, and when she mentioned it to Peterson, he was unsure if it meant anything or if in fact it was an exit or road number. Later that day, Peterson and the others were able to find a Minnesota state highway corresponding to that number. That highway, perhaps not surprisingly, led off I-35 to the entrance of Myre Big Island Park.

The map the medium drew that day roughly corresponds to the visitors' map provided by the park system. In fact, some have said the current park map could easily be superimposed over the crude sketch. The medium's map seems to include some of the landmarks that are quickly identifiable near the parking lot on Big Island, which is far enough away from the camp areas to avoid observation by late night partiers and campers.

The standard picnic shelter and a concrete bathroom building are there, but so is an outdoor chapel of sorts (with a roughhewn pulpit and benches). It overlooks Albert Lea Lake and is understandably a popular site for summer weddings. Beyond the chapel, a trail

leads off, beckoning a hiker, birder, or nature lover further into the woodlands and wetlands of the island.

It is interesting to note how other factors roughly correspond to the medium's version of events, too. The medium shared another "communication" she claims to have had with Jodi, describing a paved asphalt trail that diminished into a dirt path, which, as it wound deeper into the woods, was crossed by many exposed tree roots. Casual hikers who have visited the park can attest to both the diminished asphalt trail and many such exposed roots. Jodi would have tripped and stumbled on those roots if she were still under the power of her own two feet while being led or pushed deeper into the park.

The psychic, still insisting she was being led by Jodi, also described the sound of running water. Whether from a well, a culvert, or a drainage pipe, the running water was described as being near the area where the medium believed Jodi's remains may be found. There is, in fact, at least one such plastic drainage pipe near that path on the island, through which water may have been running as a result of recent rains in the area during the time of Jodi's disappearance. All of these factors correspond to what can be seen on a tour of Big Island Park today.

Might Jodi's body be buried in this park? It seems virtually impossible for someone to be able to dig a grave of any depth in the heavily forested part of the island, with the profusion of under-ground and exposed roots of many mature trees. It would have been far easier to dig a shallow grave in the wetlands area closer to the lakeshore on the northeast end of Big Island. The sometimes-spongy ground, with its wetland plants such as cattails, water lilies, and wild iris, would have yielded far more easily to an insistent shovel.

For that matter, digging a grave wouldn't even have been neces-sary in the swampy, high-grass areas where hikers rarely venture. The area would have easily "swallowed up" anything dumped there. Not only would the wetlands have provided important initial cover, but it would not have taken long for summer's profuse and

rapid vegetation growth to provide a nearly impenetrable wall. Before long, recently disturbed ground would not be easily identified.

Digging of any kind, incidentally, is strictly prohibited in all Minnesota state parks. Those who wish to fish are advised to bring their own bait.

Even if it were legal to dig with abandon, it would be virtually impossible to determine a specific burial site among the acres of wetlands. And were we to find a grave, what evidence might be left, anyway? A mostly intact human skeleton and skull would probably still be identifiable, although a body simply dumped or even wrapped in something like a tarp would have been exposed to a great deal of natural damage after such a long time. Certainly, no soft tissue would remain. Bones might be separated, scattered, or missing by now. Parts of synthetic clothing could still be intact. But other natural forces over fifteen-plus years would have nearly obliterated any evidence of a long-ago grave.

Whether Jodi is buried there is anybody's guess.

Chapter Nineteen

THE CLAIRVOYANT CONNECTION

> " You must know better than I do, Inspector, how
> very rarely two people's account of the same
> thing agrees. In fact, if three people were to
> agree exactly, I should regard it as suspicious.
> Very suspicious, indeed. "
>
> —Agatha Christie, *Spider's Web*, act II, scene 2

In television dramas, police are sometimes portrayed as working closely with psychics as a way of solving crimes. It's entertaining and thought provoking and heightens the dramatic impact of the show; as a result, some people assume it happens that way in the real world. It is rarely that easy, however. Let's just say that, in reality, that kind of Hollywood-generated partnership is rare.

That doesn't mean that investigators totally ignore psychic tips, however. Mason City Detective Lieutenant Ron VandeWeerd said that his department never actively sought out the help of visionaries to solve the Huisentruit case, but that many over the years came forward to offer their visions, dreams, and hunches. Many of those stories are vague descriptions of messages from the "other side," some offer ideas about the abductor(s), and yet others point to burial

places. A few are more specific, but not a single one so far has led to any kind of break in this frustrating case.

Nevertheless, in recent years it's become almost expected in many long-running murder investigations for psychics and other intuitive readers to get involved. Many cases across the country have employed their talents. For the most part, the practice has been viewed by police and lay people alike as relatively harmless, along the lines of "It can't hurt, and it just might help."

"Jodi's here with us. She wants to be found." During a conversation in the autumn of 2009, a New England clairvoyant involved in the case shared those words with me. The "intuitive counselor"—or "medium," as she prefers to be called—shuns the term "psychic," which she says conjures up a sensationalistic "woo-woo" image of those in her profession. She says she cannot predict the future, as some believe, but she claims that she can "read" energy levels and discern the "voices" of those who have passed.

She said that Jodi has indicated that her only concern from beyond the grave is regret for the trauma suffered by her family (particularly her mother), and that she'd like to have some earthly closure for them. Despite that, the medium insisted that Jodi is now at peace, and wants those she loved to move on, because life is meant to be lived.

Without preamble or presumption, the New England "intuitive counselor" began to spin an incredible tale of how she got pulled into the case several years ago. This intuitive, whom we'll call Chloe, does not want to be identified by her real name. She recounted how she received a call "out of the blue" from another woman (whom we'll call Maria), who said that she felt the need to connect with "a bright light." The two agreed to meet for dinner in Los Angeles.

Recalling this time, Chloe said, "You know how when you have a phone conversation with a person you've never met, and you sometimes picture them in your mind?" Chloe said that her preconceived ideas about how a person will look based on their voice and mannerisms on the phone are usually very close to the mark. But in this

case, she said that she was *way* off base.

She walked into the lobby of the California hotel where she had arranged to meet "Maria," and didn't see anyone who fit the mental image she had formed. So she was surprised when a very thin—"like ninety-pounds thin"—woman with long black hair approached her.

During dinner, an incredible conversation ensued. Maria, who had suggested the meeting, began by saying, "I'm working on a case, and it's about a woman named Jodi." She went on to reveal how Jodi had reached out to her, telling Maria to find a "bright light." Maria had heard about Chloe and her work through another acquaintance, and decided to start there. Chloe, who strongly believes in synchronicity, stopped her, saying "Don't tell me anymore." Chloe believed she was the bright light Jodi was seeking, and didn't need any more convincing to get involved in the mystery surrounding Jodi.

During the conversation with her new friend, Chloe revealed her surprise about how wrong her intuition had been about Maria's appearance. Chloe said, "When we talked on the phone, I pictured a face with Swedish features. You know, a sweetheart-shaped face, dimples, big eyes, and chin-length blonde hair with bangs." Maria's response showed her amazement. "You just described Jodi! She's really pulling at me!"

At home later that evening, Chloe, who said that she had never heard of Jodi Huisentruit or the case before that time, looked up Jodi's photo on the Internet for the first time and "gasped" when she saw it. It was exactly the image she said she had pictured when speaking to the woman on the phone.

When we spoke, Chloe said that she is convinced that the tiny black-haired Maria served as a messenger of sorts. Chloe believed that the ensuing series of events were engineered in synchronistic ways: she then met Gary Peterson, one of the men involved in the investigation into Jodi's disappearance.

Thus pulled into an investigation she hadn't sought out, Chloe said she was intrigued. The California native was on the verge of a cross-country move to the East Coast, and although the most direct

route wouldn't take her as far north as northern Iowa, she decided to include a stop in the Midwest, a part of the country she didn't know much about. During that 2006 trip, she met with Gary Peterson for the first time, and learned more about the case to which she felt drawn.

She revealed to me that Jodi communicated with her at times, and that the communications were so strong that Chloe is convinced that she knows a great deal about what happened to Jodi that final morning. In fact, this medium relayed to me one of the most plausible—and shocking—scenarios meant to explain Jodi's disappearance. She claimed that the agent of Jodi's demise was a man known to Jodi, and that he may have had help in the disposal of her body.

This is the medium's account. When Jodi finally arrived home the Monday evening before her disappearance, she may have received a visitor. According to Chloe, someone close to her appeared at her door and, as tired as she may have been, Jodi did not turn him away. She allowed the man to come in, and they talked until well into the night, which explains why Jodi overslept. It also may explain the raised toilet seat in the bathroom.

There may have been some unexpected and surprising (to Jodi) talk of marriage that evening, talk initiated by the man. Chloe surmised that Jodi's friend proposed marriage because he was under pressure from others to "do something" about what Jodi was learning concerning some activities in which he and these others were involved. Whatever knowledge she held, she was seen as posing a threat to the group's secrecy.

In previous weeks, Jodi had inadvertently learned some new information about her friend and had begun to become wary of his activities and his motives. In other words, something didn't "smell right" to her. When I asked Chloe why Jodi had not chosen to pull away completely from this man, given the troubling information she had stumbled upon, Chloe simply replied, "You know that old adage, 'Keep your friends close, but your enemies closer'? She felt she

needed to keep an eye on him."

If Jodi had friends who questioned her alliance with this gentleman, the man was in a similar situation. Some in his acquaintance found his association with Jodi to be cause for concern. They thought her occupation as a well-known news reporter made her a loose cannon. They simply didn't like him hanging around with an observant anchorwoman who was in the position to expose them.

When pressed, the man had assured the others that he was confident he could talk her into marrying him, perhaps thinking that she would have to keep her mouth shut once they were legally wed. What he didn't count on, however, was her flat refusal of his proposal.

Perhaps he was armed with a ring that night (we will never know), and as charming as she had known him to be, Jodi, according to Chloe, said she just couldn't or wouldn't consider becoming his wife.

Understandably, he was angry as he left, baffled as to how to proceed. But it didn't take him long to piece together a desperate plan to keep her quiet. According to our intuitive friend, Chloe, this man drew someone else—someone also known to Jodi—into a sordid plot patched together in the wee hours of that Tuesday morning. The plan would "take care" of the threat Jodi posed.

Chloe claims the two co-conspirators may even have been able to obtain the use of a painter's or contractor's van, which was driven into Mason City from another town and brought to the Key Apartments very early that morning before Jodi was to leave for work.

Chloe sensed that the two men experienced time pressure to return the van quickly to its owner in another Iowa city, perhaps some distance away. So the driver was anxious to do what needed to be done, and was impatient because Jodi was running late that morning. The medium related her vision of these two unidentified men, one sitting in the van, and the other outside, waiting for Jodi to exit the building.

The man inside the van, according to Chloe, quizzically pointed

to his watch, while the man outside indicated with his arm and shoulder gestures as if to say, "I don't know where she is!" They were both apparently willing to wait, however, knowing that Jodi *had* to report to work and would have to come out of that door sooner or later that morning.

Meanwhile, Jodi, running very late and no doubt disoriented by the jarring early morning phone call, the late night, and lack of sleep, hurried to grab up the items she needed and rushed to get to her car and to work. She may have dropped her keys or other items in her rush to get out of the building, and was forced to retreat once or twice on the way to retrieve them. So, as Chloe recounted to me, Jodi was distracted and simply didn't pay attention to the unknown van near her car in the parking lot.

Arriving at her car and intent on getting the key into the lock, Jodi was surprised from the rear by her attacker. In an instinctive, defensive reaction, she flung her arms out, letting go of the hair dryer and other items she had been carrying, and yelled, "No . . . Don't!" At least a few people inside the apartment building that morning heard this scream.

She may have been kept quiet and forced into submission or made unconscious by a substance-soaked rag over her mouth and nose. Chloe also sensed that Jodi experienced pressure to the throat, and speculated that Jodi may have been strangled. In the panic of the moment, the attacker may have momentarily lost his grip on Jodi's petite body, allowing her head to strike the outside rearview mirror of her car. Or he might have purposely struck her head against the mirror as a way to ensure her cooperation.

Chloe says she sensed an ever-present, cloying aroma (something like turpentine, mineral spirits, or paint) of which Jodi was aware while she was constrained in the van. This medium does not think Jodi was dead when she was initially restrained, because Jodi, though in and out of consciousness as a result of her head trauma, relayed to Chloe that she was aware of at least two men talking in the van while they drove away from the apartment complex.

In fact, the medium was adamant that Jodi lived perhaps up to thirty-six to forty-eight hours after her abduction, and was possibly confined during that time in the trunk of another car, or in a vacant home or nearby apartment. That home, too, according to Chloe, was never searched in the aftermath of the kidnapping.

During the eventful forty-eight hours during which the community became aware of the shocking events and began search efforts, the man in question was no doubt torn about what to do and probably checked on Jodi periodically before he killed her. The feelings he had for her conflicted with the growing recognition that he now had no choice but to kill her and get rid of her body.

Jodi may have been led to her death, perhaps heavily drugged or injured, sometime the evening following her abduction or perhaps the next night and buried where she was finally killed. According to Chloe, the end came as she was strangled, perhaps a final blow to the head ensuring her death.

Chloe shared her strong feelings of a negative emotional or sexual energy between the two men involved, one older and one younger. She speculated about a sort of physicality or sexual chemistry between Jodi and the younger man, who was confused and threatened by the connection between her and the other man. He may have found her attractive and exciting as he tried to deal with his complicated emotions and his desire to compete for her affections. The younger man did not want to be involved in this spur-of-the-moment nighttime operation.

Chloe felt a strong reaction of an eyewitness—and elderly resident—to this string of events. In fact, she insisted that a witness observed the assault from inside the apartment complex, specifically from a street-level apartment in which the eyewitness lived at the time. That witness never identified him- or herself and, in fact, may have told the police that he or she didn't notice anything unusual that morning. According to Chloe, this response was simply a self-protective gesture by someone who greatly feared retaliation.

Chloe's story is just that: a story, a version of events served up by

a psychic. Whether the story is true or not is wide open to interpretation. But Chloe is not alone in her strong opinions about the case. A number of psychics have made their own independent assertions. Whether you, as a reader, agree with her version of events or others, Chloe has remained steadfast in her insistence that, although Jodi is at peace, her spirit wants someone to find her body so that those she loved on earth can have peace as well.

Another "seer," this one a male who doesn't mind being called a psychic, shared with others that Jodi's spirit has often sat at the foot of the bed of an older woman, most likely her mother. He said that Jodi communicated to him that her mother may have doubted her feelings about her daughter's presence, but Jodi wanted her to know that she was there, and is now acting as a family guardian angel of sorts. The psychic said that he pictured her holding up a family portrait and tearing her image from it, letting it float to the ground. The past is past, according to this seer, and Jodi simply wants to be remembered lovingly (not longingly) for who she was and what she stood for.

Yet another psychic, this one a Canadian "psychic criminal profiler" has a vastly different view of who was responsible for Jodi's disappearance. In May 2010, as part of his North American tour, Robbie Thomas appeared at the Sioux City, Iowa Convention Center. Thomas's website was pretty dramatic in hyping this stop on the tour:

> You will witness never been seen real time investigative work with a Psychic Detective LIVE as information will be passed along to assist in this case. What you will witness is raw, emotional and extremely intense situations at times during the reading session so we advise it is for mature audiences only!

Thomas's appearance in Sioux City bore out what he had shared with investigator Gary Peterson in a radio interview two years

before. One night in 2008, Thomas was featured on Minneapolis's KTLK-FM's Darkness Radio, a program focusing on the paranormal, and the May 2010 event was mostly a repeat of the ideas introduced on that earlier radio show. Mr. Thomas took his audience behind the scenes of what he believes happened to Jodi Huisentruit. He explained how he works with investigators and criminal profilers and attempted to describe some details about what happened to Jodi.

Thomas maintained that not one, but two males were involved in Jodi's disappearance. One had been infatuated with her and stalked her, though she may not have been aware of it. He was thought to be an acquaintance she had met during a social event in the days before she disappeared.

Thomas was quite detailed in his description of the attacker. Just under six feet tall with a slender, 175-pound build, the attacker had brown or light brown hair. Freckles or pockmarks may have marked the right side of his face. But the man was charming, even charismatic. He chose his words well, and Jodi and he had chatted casually and easily at a social event in the days before she disappeared. The two may have even had a conversation about their shared birth date or birth month.

In those days of land telephone lines, the man made several phone calls to her in the newsroom, alternating the origin of the calls so he could not be traced. During those conversations, he most likely did not identify himself, but was able to casually confirm that she would be in attendance at certain events. Thomas maintained that the man knew what Jodi was doing the night before she disappeared. It was all part of a plan for this man, who may have been involved as a repeat offender in other stalkings, as well as incidents related to his compulsive disorder. He may have firmly believed "this was the time" to act on his impulse.

Thomas further maintained that this man and another unidentified male companion took Jodi, and that they felt they were "mocking" the authorities, as if to say, "You've got nothin' on me." The psychic says one of the men drove a light-colored van and the

other parked a car in the rear of the parking lot. The van was considered the primary vehicle used in the crime, perhaps the one noted in the area before Jodi's disappearance. One or both of the men later came back to retrieve the car from the parking lot some time after the crime.

Neither man lived far away from the abduction site, according to the psychic, perhaps within a range of twenty to thirty miles. He believes they positioned themselves in the parking lot as early as two thirty that morning, knowing that Jodi's usual time of departure from the building was three or three thirty. Through previous surveillance, they knew that when they saw a certain light go on in Jodi's apartment, Jodi was likely to emerge from the building just a few minutes later.

According to Thomas, the two men were surprised to see the light already on in her apartment when they arrived in the parking lot, and became increasingly agitated and angry when she did not come through the door. Unbeknownst to them, Thomas said, she was still asleep, having left the light burning all night long. But they were determined to wait it out, and they did. Psychic Thomas claimed that he knew the first names of the two males, but would only reveal the initials T and J.

Mr. Thomas did not offer details about how the men approached Jodi by her car, but he felt strongly that her body was weighted somehow and trapped in water by a concrete embankment beneath a bridge in a secluded area, along with some of the evidence linked to the crime. Another bridge may be visible from the site, as well. He noted that the numbers 367 or 376 come into play, which may be bridge markers, road signs, or other references to that area. Thomas also mentioned another communication about a reference "to that area [where] they will find evidence as well." He said that in the communication he heard, "Open the door; open the door I need to talk to you," and other unintelligible things.

Not all psychics who have weighed in about Jodi's disappearance have gone into the detail of these two accounts. And, as can be

expected, not all agree about who was responsible and what happened after she was taken. Some believe she was killed shortly after her abduction, while others think she may have been kept alive for a day or two afterward. Perceptions and interpretations of the events surrounding her disappearance vary widely. There is one point, though, on which they all tend to agree. If there is to be any comfort in the loss of Jodi, it is this: she has made it clear to them that the time to mourn is past.

In addition to the psychics who have publicly immersed themselves into the investigation, others with strong feelings about the case have offered their opinions on the FindJodi.com website. As a result, interesting and thought-provoking messages continue to surface online. The writers, identified only by their screen names, have a variety of perspectives, some bizarre and some practical. It makes for entertaining reading, if nothing else. One unnamed writer who identified him- or herself as from the "Psychic Visions second group" posted an interesting message in 2006:

> The person who abducted Jodi meant her no harm, originally. He has no criminal record, nothing but a few speeding tickets (perhaps he got one the morning he kidnapped Jodi with her in the vehicle or a warning of some sort?). There is nothing obvious about him. He is quiet, polite; no one would suspect him of harming anyone. The reason he took Jodi is because he thought they were meant to be. He made a special trip in to see Jodi that morning (and other mornings to learn her schedule). I don't think he is from Mason City, but he is within the broadcast area. He lives in a rural area (fairly remote, no near neighbors or paved roads) and owns quite a bit of land and outbuildings. Because he has such a clean record, the police have never checked his property and have no reason to, which is why much of the evidence has never been found. He didn't intend to kill Jodi, just to be with her. He thought she would realize he was her true love and they

would live happily ever after when he took her. He held her captive and tied up for a long time before she died. I am not sure how she died. I believe her body is in an open field like area near water, but not the river that flows through MC [Mason City], either the Cedar River or another river in the area (areas surrounding Charles City, Greene, Ionia, New Hampton—he's from south of MC)—(there is an old suspension bridge in Charles City which matches some of the bridge descriptions from psychics who have posted . . .). It may be a small stream, but I think there has always been water there which means it hasn't dried up and in which case it is most likely not a stream but a river. He buried her there because it seems so peaceful. When she died, he still believed she was the one he was meant to be with, but that she just couldn't see it, and he couldn't make her believe. Since Jodi has died he is either married or living with someone. She suspects, but not because of anything he's said, just a suspicion, a feeling she had that something isn't right. He's told no one ever, and no one but he and Jodi knew he was the one who took her. (. . . he may have repainted it (the van) but he hasn't re-registered it since he took Jodi—it's in one of his buildings or on his land). . . .

A December 2007 posting, authored by a web user called "psychic reality," focuses on Jodi's burial:

> . . . I saw a woman being dumped in the woods. . . I saw a male figure, face unknown, carrying her and laying her in the weeds. He comes back later with a shovel . . . the woods are west of her apartment about twenty minutes away. The man was wearing dockers, light color and a darker three button shirt . . . he was wearing tennis shoes, light color, and wears a watch on his left wrist, silver band. I did not see a wedding band or any visible marks from one. He acted very

nervous, and as he laid her on the ground, he was careful with her body. He dragged branches over her to hide her. He leaves and looks back several times to see if he can see her from the road. He drives away. The next vision I had was of him digging in the wet dirt. It is almost dawn. He laid her in the grave, about sixteen inches down and covered her with branches and weeds. He did not strip anything off her body, like jewelry or take anything of hers with him. She lays on her left side, her knees bent slightly, her arms tucked as though she were sleeping. He was not crying or showing any signs of emotion . . . he was like a robot. He threw (the shovel) into the weeds on the opposite side before he drove back out . . .

. . . I kept hearing him whispering her name, "Jodi, Jodi . . . " I will add that this man, whoever he is, acted alone and was very remorseful afterward . . . I do not believe he has been back to the woods since that morning . . . I had the "sense" that he didn't mean for this to happen.

The FindJodi.com website contains a posting from another person (web name Karenza), who wrote an interesting message titled "Visions of Jodi":

I saw Jodi being abducted—there is only one man involved—he was in the area covered by the Mason City tele-vision station . . . he was obsessed by Jodi's image—he thought if he could meet her in person—he could convince her he was the man for her. Often people who are obsessed about another person—be it male or female—convince them-selves that the target will love them in return. I don't believe he intended to kill her at all—but when she became fright-ened of him and tried to fight him off—something in him snapped—he killed her to quiet her screams—but he was

sorry to the point of being devastated by the loss of her . . . after he realized he had killed her—he knew he had to get rid of her body before he was discovered. He was near the river between Mason City and Nora Springs . . . ready to remove her body . . . but he spotted an early morning fisherman and left the area. He then drove north, crossed the Minnesota border—he then waited in a safe area . . . till night came. During that day he thought of ways and where he might discard her body. He knew of a place—a park where there were many swampy areas. He drove to the park while still daylight—found a camping spot—he went fishing to look normal. When it got dark that night—he checked to make sure all the campers in the park had their lights out. The hour was past one a.m. He walked to a hill where he knew a swamp was at the bottom of the hill . . . After he rolled her body into the swampy area—he sat and rocked back and forth asking Jodi quietly why didn't she love him? . . . He has managed in his mental state to block it from his memory. The park is located approximately 35 miles north of Mason City. . . .

There is a chapel located in the park—the area where she is located is very swampy—a backwater off a lake. The reason no one has seen the body—it is in a swampy area that has lots of trees that have fallen into the area—some were there already before he rolled her body into it. The actual site of the body is NOT in the lake, but near by the lake. He has never been questioned by the police—he is totally unknown to them.

He had never harmed anyone before Jodi and has not done so since.

This posting is particularly interesting because it becomes very specific about the burial site, and the description matches those mentioned by at least two other mediums, at different times and in different venues. The mention of the outdoor chapel in the park and the swampy area near the lake coincides with the observations made by others. The park that this contributor references could easily be the aforementioned Helmer Myre State Park.

Another 2007 posting by "Psychic Reality" is eerily haunting and oddly confessional in nature. It's entitled "Psychics know," and is an account about an emotionally unstable man who cannot handle rejection:

If a woman tells a man no and still accepts his gifts including friendship, is she stringing him along or just playing with him? If he gives gifts and shares time with her and she smiles and still says no is she sending the wrong message? Now, take a young woman and any man and have him fall madly in love with her, someone he knows does not want him, but he fantasizes about her and chases her in his own way, and one day he snaps. She finally says NO and this time she means it. He can't handle rejection and sits there all night thinking of what he can do to convince her of his undying love and devotion, then she doesn't go to work on time. He sits there, staring at her apartment. " . . . Why is she not awake? Where is she?" The mind snaps, and it becomes, "Who is she seeing?" and he cannot handle it any longer. He waits and tells himself, "I am just going to talk to her," but when she comes running out, late and a bit disheveled, he tells himself it is because she was with another. He grabs her, screaming, kicking, and he drags her to his vehicle, all the while trying to keep her quiet . . . he just wants to talk to her . . . but she yells, screams, and [kicks and] just as he gets to the vehicle, something terrible goes wrong. He drags her inside and holds her down. He has his hand over her mouth

and she still fights. He has to stop her fighting and before he knew what happened, she was suddenly quiet. Suddenly dead. He hides her. No one must know what happened. Like a butterfly, she was beautiful as long as she had her wings, but when held too tightly, she crumpled in his fist . . . and the butterfly dies.

I saw this after I read the whole website. He knows who he is and he didn't mean to kill her. He just wanted to talk to her, make her see how much he loved her, make her listen, make her hear him. I believe Jodi had a stalker. I believe it is one man, not a "they" or "them" . . . just one sick person who couldn't handle her rejections, and poor Jodi didn't even know she was rejecting him. She didn't know. She was just doing what butterflies do, flapping her wings and living . . . until he decided to hold her in his hands . . . just for a moment.

The views of psychics, whether shared with investigators or me directly or offered online, may contain some truth. No matter how one feels about psychics and clairvoyants, their opinion may reflect reality more clearly than do the rumors in the rumor mill, which has worked overtime where Jodi's story is concerned.

And over the years, rumors and hearsay have circulated rampantly, especially on the Internet. This will likely continue as long as Jodi remains missing and the case has a following.

One persistent man who writes online continues to insist to all who will read that he can prove the connections between Jodi's disappearance and the murder of two other Midwestern women. One of his fervent claims is that authorities in St. Cloud, Minnesota, have the clothes that Jodi wore the morning she disappeared, as well as a knife that was used as a murder weapon. Authorities, maintaining that this man's online ranting and opinions have no basis in truth, continue to debunk his claims.

Other fascinating rumors occasionally arise. Someone swore he or she saw Jodi waitressing at a truck stop. Yet another observer claimed that Jodi anchors the news in Alaska. And yet another has told a faintly exotic story of her kidnapping by an Arab sheik for the purpose of keeping her in his harem. As long as the crime remains unsolved, people will tell stories and conjecture will continue. Those pieces that fit into the larger puzzle have yet to be found. That information may go to the grave with the person who ended Jodi's life.

Is Jodi's killer a regular visitor to the online community? The founders of the FindJodi.com website, Gary Peterson and Josh Benson, are convinced that he checks the site periodically. Others are sure of this, too. Perhaps the person responsible has even posted a message of his own from time to time. As recently as January 2008, "Psychic Reality" weighed back in on the website with an ominous warning for Jodi's killer:

> I do know he reads these posts and is keeping his eye on everything people say and do here. He WILL make a mistake soon. Right now, he is very sure he is clear and well hidden, but he still wonders and that will be his downfall. . . .

Does Jodi's abductor lie sleepless at night? Is he haunted by his deeds? We can only hope.

CHAPTER TWENTY

WHODUNIT?

> "To get power over is to defile.
> To possess is to defile."
>
> —Simone Weil

Four simple but very important obstacles stand in the way of solving the mystery of what happened to Jodi Huisentruit. Otherwise talented and observant investigators remain stymied by these critical missing elements:

- the lack of an apparent motive
- the lack of physical evidence at the crime scene
- the lack of a genuine eyewitness
- the lack of a body.

Someone has lived for years with the secret of precisely how events played out on the morning of June 27, 1995. Only that person knows how to write the final chapter of this mystery. Only that person has the power to end years of searching.

Where are police today in the search for Jodi? Unfortunately, not much further than they were on the day she disappeared. The

Mason City Police Department, although it still entertains tips and receives a handful of related calls every month, has obviously gone through many changes since June of 1995. Jack Schlieper, Mason City's Chief of Police in 1995, is deceased. Others who worked on the case now serve in different positions in the department, and yet others have retired. In June 2010, on the fifteenth anniversary of Jodi's disappearance, the Mason City Police Department announced that a new officer would take a fresh look at the facts of Jodi's case.

Meanwhile, Gary Peterson and Josh Benson continue to maintain the FindJodi.com website, which still has a sizable following. Though officially retired from the case, Iowa private investigator Jerry Koerber still follows his instincts, keeping his eyes and ears open. And South Dakota's Jim Feldhaus is reluctant to pull away from the case; he still makes occasional calls. Peterson, Benson, Koerber, and Feldhaus all have their opinions, of course, but choose to keep them close to the vest, unable to prove anything.

One of them believes Jodi simply may have stayed in the wrong place at the wrong time, or among the wrong people, for just a little too long. "It's like staying in a burning plane too long before parachuting," Feldhaus said. "Pretty soon, the chute won't open and it's too late. She stayed . . . too long."

Jodi's case still has something of a cult following, surprising after these many years. In Internet chat rooms, interested observers across the country discuss the rumors and the facts about the missing anchorwoman. They share "where-were-you-when" stories, and offer good wishes to her family. Realistically, no matter what their private beliefs, her family knows she is not coming back. It's difficult for anyone to completely disappear, and decidedly more so for someone with celebrity status.

It is likely that Jodi's body is buried somewhere in Iowa or Minnesota, although we may never find the exact location. Her closest relatives and friends still carry her in their hearts, but life has gone on for them, as it must for all of us after such a loss.

To this day, JoAnn Nathe keeps up a vigil of sorts for her beloved

sister. For many years, she received a plethora of interesting leads and tips. They still show up on occasion, and some are downright bizarre, like one mysterious note she recalls receiving in the mail. About this note, JoAnn said, "I opened it up and there was a sentence on there: 'The man in the gray house north of Jodi's apartment has been stalking her.' Lo and behold, I checked that out and the man died."

Whenever she receives letters and tips, she dutifully passes them on to authorities. She remains steadfast in her support of, love for, and belief in her sister. Her feelings are summed up best when she says, "I'm not going to give up. Somebody knows something and they need to come forward."

Several of Jodi's friends, including Stacy Steinman of Minneapolis and Tammy Baker of Iowa City, say they have both reached welcomed places of closure. It took some time, however. They both recalled harrowing days of grief.

Steinman currently thinks fondly of her old friend, but she chooses not to follow the ongoing dialogue and news about the case, calling much of it "garbage." In an interview with me, she mentioned a vivid dream she experienced sometime after the abduction, one in which Jodi appeared to her. Steinman said that when she woke from the dream, she was comforted by the feeling that she had spent the night talking to Jodi, and she's now satisfied that Jodi is at peace.

Baker remembered hearing the dreadful news just after she had shared a wonderful weekend with her friend. She hadn't wanted to believe it. She said, "I yelled and screamed and cried . . . and . . . called her number." With a sad smile, she remembered Jodi as a woman who "took care of her friends."

But Baker also remembered when she finally let go. Like Steinman, she saw Jodi in a dream. Baker says Jodi hugged and told her, "I'm happy. Please don't hate the man who did this. I love you." Tammy remains convinced that her friend brought her a cherished gift that night: a sense of peace and the ability to move on.

CHAPTER TWENTY-ONE

FADE TO BLACK

> " No one worth possessing
> can be quite possessed. "

—Sara Teasdale "Advice to a Girl"

She knew she was in the right business. Of course, there were always the naysayers, the people who tried to hold her back, but they didn't matter. What mattered were her approach and her response.

From the beginning, it fed her soul to hear warm comments from those who watched her shows. She hadn't been on the air a week when people first started to recognize her in public—and they said wonderful things to and about her. She felt like this was part of her mission: to make the world feel good.

She considered Mason City just a stop along the way. Even though it wasn't the be-all and end-all and she didn't plan to stay forever, she wanted to leave a legacy there. She truly loved giving her time in the community, whether it was playing in a golf tournament, emceeing an event, or serving as a judge in a local talent contest.

She loved to be in the public eye, and she loved being able to walk into a public place and know that others recognized her and pointed her out. Some of her fans were reluctant to say anything directly, but she knew they noticed.

She loved catching sight of one of her pretaped promos on television in a bar, restaurant, or store. She always liked the attention, felt at home in the spotlight, and the camera flattered her, too. She knew that, with persistence, hard work, and a bit of good luck, she'd go places. Everybody said so, and she was determined to reach the lofty goals she had set for herself.

But that alarm clock was unrelenting, brutal sometimes, and she hated having to get up at in the darkest hours to get ready for the early morning broadcast. She liked her nights out, and she wanted time with her friends, too. The savage morning wake-ups made her social life a real challenge.

But she knew she had to pay her dues, and that's exactly what she resolved to do. That's the way it was for everyone in her chosen business. And there were other annoyances: the newsroom politics, the low pay, and the occasional sicko in the audience. She'd just keep putting in her time until the right offer came along.

Her big break was going to happen—and while on the air in Mason City, she felt that she'd see it soon. She had been sending out resumes and tapes, and had gone for a couple of interviews, one in Biloxi, Mississippi, on the Gulf Coast, and one right up the road in Minneapolis, but by the summer of 1995, nothing had happened yet. She really would have preferred to go back to her home state and work in Minneapolis, but she knew it was still likely she'd have to put in some time at another station before she'd be seen as ready for that market.

Were these thoughts in Jodi's mind the morning
she disappeared? We will never know.
What really happened to Jodi Huisentruit?
We can only imagine.

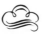

A clanging pulled her out of a deep sleep. Pure reflex propelled her hand. It slammed the bar on the alarm clock, but the noise continued. Barely focused, knowing she only wanted the noise to stop, her brain sorted it out and finally recognized that infernal din as the phone. Her hand groping, she found the receiver and mumbled hello.

"What time is it?" she groaned. She was letting Amy down again, and felt bad about it, but these early mornings were a bear. She resisted being awake, wanted to burrow down further into the pillow. An ingrained sense of duty was the only thing that propelled her from the warm cocoon of her bed. There was no time to think about any of it. She had to move.

Although she felt horrible, adrenalin began to kick in. After the world's fastest shower, she moved to the closet and grabbed the closest and the cleanest blouse, pants, and jacket. She had amassed a few good pieces to mix and match, to make things look like different outfits on the air, and knew she always looked good in them. She had to look good, head to toe. Behind the on-air news desk, it didn't much matter what she wore below the waist. But it was a different story on the set of a one-on-one interview.

No time to agonize about her makeup or hair now. She usually took care of that right before the newscast, anyway. A brush and plenty of hair spray would hold her hair long enough to get through the first show. Tossing her makeup sac, hair dryer, and spray into a tote, she slid into her favorite red leather shoes and was ready to go.

Grabbing her keys from the counter, she glanced at the clock and bolted for the door. Only twenty minutes had passed since Amy's call, but she was very late and it would be a scramble to get everything done in time. Flustered, hurried, and distracted, she wondered if she'd forgotten anything and she slipped out her apartment door into the hallway.

She locked the door, hurried down the hall, then dropped her

keys on the stairs. She backtracked momentarily to retrieve them and then burst out the building's front door. She felt like a mess, but nobody was around this early in the day to see what she looked like.

Good thing the station wasn't far and there wasn't any traffic at this time of the morning. Not to say Mason City *had* traffic jams, anyway. When she hit the big time, she'd worry about traffic.

Approaching the door of the Mazda, she had the key poised to slide into the lock, and barely had pushed it in when she froze. Beefy hands clamped her shoulders. Instant panic struck. Arms flailing reflexively, she dropped her bag and fought to be free.

But those hands meant business. Her gut clenched as they wrenched her around to face their owner. Instant recognition . . . then . . . Oh my God . . . his eyes. "NO . . . DON'T!"

He felt wistful, and said goodnight with some reluctance. He wished she would stay. Even the dark night seemed sunny when Jodi was around. She was like a breath of fresh air for his tired spirit.

When he saw her to the door, she hugged him, planting a quick buss on the cheek and flashing that megawatt smile. The words were out of his mouth before he even had a chance to think.

"Let's get married."

She looked at him and laughed, gave his shoulder a playful push, then waved her fingers and clattered down the stairs. "Be careful what you wish for!" were her last words as she ran around the back to her car.

He sighed, leaned against the jamb, and watched her go. What did he have to do to make her understand?

What did he have to do to make *them* understand? They were always pestering him with annoying questions: "Are you crazy?"; "What are you doing with that anchorwoman?"; "What happens if she finds out?"; "They say she's asking a lot of questions; you've gotta keep her quiet! What are you going to do about it?"

He'd had an idea, and assured them things were going according to plan. It was time to carry it out.

He'd give her some time to get back home, and he'd go over to hash things out with her. She'd be thrilled, wouldn't she? A big rock on her finger . . . he'd convince her with sweet talk—after all, she was *this close* to being his. When they were married, she'd have to keep her mouth shut about what was going on. To protect herself and her job, she'd stay quiet.

Anyway, what woman wouldn't love the money? And they looked good together. He was so proud when she was on his arm. He knew other men envied him. It was a perfect plan—his cronies didn't have to worry. She wasn't going to rat them out . . . he'd make sure of that.

And so he went to her apartment.

Of course, she let him in—she always did. And she heard him out. But if that quizzical look in her eyes didn't stop him, the quiet, nearly whispered answer did.

"No."

It stung. He tuned out, not believing he had heard her right.

"It's not right."

"You have to leave. I have to sleep."

How he got to his car, he didn't know, but he couldn't—wouldn't—turn the key. He sat in the driver's seat, fuming—angry at himself, angry at her. Why couldn't he get through to her? Why couldn't she see what he had to offer? She was so stubborn, so unpredictable.

He had felt they were really growing closer, and it felt good to be needed by her. In his mind, they had become attached. Every so often, she'd make some predictable noise about just being friends, but then she'd go back to being her usual affectionate and funny self.

Did she really think he wanted to be just her friend? He had invested his time, his money, his position. He held his head high in town because of her, and he wasn't about to lose her. He knew he had told her no strings were attached, because that's what she wanted to hear. But that was a lie and he knew it. Hell, *she* knew it.

He resented that she had no recognition of what she *owed* him.

He didn't have long to wait. It was already late when she sent him packing. She wasn't going to get much sleep tonight, but it seemed she did fine without it plenty of other times. He determined to wait it out until she came walking out of that door at three o'clock. He settled back in his seat, thinking.

It was impossible for him to visualize life without Jodi. She had become very important to him, and he couldn't bear to lose her now, not after all this time.

The loner had planned it carefully, and she didn't know how easy she had made it for him: she was an open book! He knew where she lived, knew where she worked, and she was so easy to follow. She looked just as good—even better—in person than she did on TV. He'd even talked to her a couple of times in the bars. Her friends would try to pull her away, but she always stopped to say hello to him. He knew they were destined to be together.

This one was different from the rest. She would elevate him, and he would no longer be considered a loser. Ever since he first laid eyes on her, he had known it was just a matter of time. The others he had tracked had taken space in his mind for a few months—a season, maybe—but his yearning for this one knew no bounds. She'd been his soul mate from the very beginning.

He had never had much success with women, but this time would be different. She was so sweet when she started to talk directly to him through the television, and he could see her vulnerability. From the beginning when he watched the first part of the morning show in bed, it was easy to fantasize about the time they'd be together. Her smile was enchanting, and he *knew* she saw him. She was like a doll, with the face of a Barbie, the lips of a Kewpie. He hated to miss even a minute of the show, because he knew she spoke directly to him. The recognition was in her eyes.

Whenever he followed her in his truck, he made sure to remain anonymous behind the darkened windows. He felt that it was important he didn't reveal himself to her until the right moment. He'd feel a jolt of excitement when he saw the flash of fear, and the sheer vulnerability in her face would make him want her more. He knew that they would hold each other and laugh about it all someday. When she was his, they would laugh about all of it. She'd be as hungry for him as he had been for her all along. It was inevitable that they would be together. She just didn't know it yet.

But she'd know soon. It was just after three o'clock. He could hardly contain his excitement: any minute now he'd have his soul mate in his arms.

Midnight passed, the rain stopped. Humid air still hung heavy, although the temperature had cooled considerably. But the men's ardor had not cooled; the two were stoked with excitement about the plan. Not a soul was in sight when they met at the agreed spot. It was finally time to put this plan in motion. They had watched her and talked of it for weeks. What had started as the unlikely burning threesome fantasy was now becoming reality. She would be theirs.

By two o'clock, I-35 was virtually deserted. The nondescript white van shared the road with the occasional determined trucker and caffeine-fueled motorist punching out the miles, making time. As they cruised the route they'd done a million times, the driver was careful to keep his speed controlled. He didn't want to attract attention from a zealous cop on the graveyard shift.

Exiting east onto 18, the van slowed, the driver obedient to the speed limit as they passed into the city limits of Mason City. It was pushing three o'clock when the van turned off Kentucky Avenue, gliding into the parking lot at the Key Apartments. But no worries ... she rarely got out of there earlier than that. She was usually much later. Anyway, they could afford to be patient—she'd

come out soon.

Over the last few weeks, they'd developed their plan. They'd cruise the bars in between tracking her movements. Morning and evening, they'd found her habits to be fairly predictable. She had been on the air as usual yesterday; now sitting in the parking lot, they knew she'd be exiting soon.

Before and after their treks to the girlie bars, they'd watched her from this spot and others, and last night was no exception. They'd even had a brainstorm while she was still at the country club. Good thing that guy she sometimes hung out with wasn't around. To throw her neighbors at the Keys off track, one of them made a point of climbing the stairs of her building and loudly pounding on her door.

He frowned as he scanned the face of the building. There was only one interior light burning in a first-floor unit. The two windows of her apartment on the second floor were still dark. She usually had at least a bedroom light on by now. But her red ride was right where it was supposed to be, so there was nothing to do now but wait for her.

That old Honda tin can she drove up until a couple of weeks ago had been ready for the junk heap, and she looked really good in the new Mazda with the black rag top. Was there anything better than a blonde babe in a red convertible? She was worth waiting for, so they stayed at the back of the lot and killed the ignition.

The minutes ticked by . . . 3:30 . . . a small light came on in a nearby apartment, but was out again a minute later. Then 3:45 . . . still no lights, no movement. Her place stayed dark. What the hell?

Agitated, wanting to do something—anything—he turned the key in the ignition, but left the headlights off as he eased the van out of its spot and approached the building. Pulling up by the curb near her exit door, he stepped out of the vehicle, careful not to slam the door.

He wanted to pace, but knew instinctively that much movement would draw attention. Catching the eye of his cohort in the passenger seat, the man on foot impatiently pointed to his watch, spread his

arms to pantomime his frustration. His buddy in the van shrugged broadly and held his arms up in response.

They had all the gear they needed in back: a mattress and all the tools. They had talked about this idea: a threesome. He'd bet she might even like it when they got going. He had heard some stories about her wild ways; the guys said it was just like she was asking for it. And that time they saw her in the bar, she really talked to them. Hey, she practically posed the invitation. She was not like some of those chicks who acted so high and mighty and wouldn't even give them a second look.

He was edgy, watching the minutes tick by, and didn't know how his buddy could stay so calm. He just sat there in the van.

The phone broke the silence. He heard the ring through the open window, and even though he didn't hear her voice, knew when she had picked it up. The light finally illuminated. He reflected that she was a lot later than usual today, but no matter. It soon would be time to act. And he couldn't wait.

She could make anybody crazy, he thought. They had a great time all afternoon, so he was not especially sorry the game had to be called on account of rain, either.

The petite blonde stood out in her pretty little golf shorts; she sure knew how to package the goods. She turned the heads of lots of men that day. She was charming: funny, smiling, laughing, high-fiving.

The atmosphere in the clubhouse was festive despite the rain, and the booze had flowed before dinner. She could flirt with the best of them, and he began to entertain the possibilities. He knew she was single, and didn't think she had a boyfriend . . . maybe she really was interested in him. She sure acted like it. Although she worked the room, too, she was easygoing in the club atmosphere, asked him about his work, and laughed at all of his jokes. They'd had a good time.

But he was disappointed when, after dinner and dessert, Jodi began to say her good-byes. She had the usual reasons: Her morning news show demanded an early start. She had to get some sleep. Three o'clock came too early every day. But she grinned and was encouraging when he asked if she'd like to go out sometime. She gave him a hug, said thanks, and was gone.

The night was still young, so he lingered at the club. Moving easily among colleagues, neighbors, and other acquaintances, he nursed a few more drinks, reluctant to go home. But damn, he couldn't shake her image from his brain.

There was no reason to hurry home. He and his wife mostly lived their own lives anyway, and she wouldn't say much if he came in late.

He never would have guessed a woman like Jodi would be interested in him. But she'd been so encouraging, batting those big brown eyes. She was funny and really seemed to enjoy his company. She laughed so hard at his lame jokes, and showed a lot of interest in him. She'd be surprised and probably excited if he dropped by her place at bedtime.

He would suggest a nightcap. He knew the Key Apartments. It was a big complex, but he figured that it wouldn't be too difficult to find her place. Who knew? He might get lucky. What did he have to lose? He remembered an old Scottish proverb his old man used: "Fools look to tomorrow; wise men use tonight." No time like the present, he thought, and he began to say his good-byes to his friends at the club.

Sure enough, checking the mailboxes at the entrance of the first building closest to the drive, he saw her name, and bounded up the stairs. A decisive rap on the door drew no response. He took a step back, put an eye to the keyhole . . . the lights were out. She couldn't be in bed already. He pounded a little harder, more urgently.

"Jodi, open up. I know you're in there!"

Maybe she'd just used the excuse of an early wake up to shake him off. As he left the parking lot, he wished he had asked her what

kind of car she drove.

Now what? When they had talked at the country club, she mentioned the Other Place. He'd been there lots of times, too, and wondered why he hadn't seen her there. Is that where she was now? He didn't understand how she could go to sleep so early anyway. Maybe he'd go and look for her.

Bellying up to the bar, he ordered another drink, and struck up conversations with a few folks at the bar. Oh, yeah; Jodi was here quite a bit—that whole TV crowd hangs out here . . . hadn't seen her tonight though.

The drinks were going down easily now . . . what time was it? Jodi's image dominated his brain. He wanted her. At last call, he had one more for the road. His confidence bolstered, he made up his mind to go back to Jodi's.

He was paranoid about cops, and sure didn't need a DUI, so he took his time driving back to Jodi's place. When he got to the Keys, he glanced up at the window he now knew belonged to her apartment, and saw the lights were still out. He'd love to go up there again, but she might not be thrilled if he woke her up.

Confused, he couldn't concentrate. His head was swimming, and he'd lost all sense of time. So leaning back against the headrest and closing his eyes, he made the one decision that came easy to him: to listen to the gentle sound of the rain on the windshield.

After what seemed to be only an hour or two of oblivion, he roused. Where was he? Oh, yeah. Glancing at his watch, he was shocked to see it was after four o'clock.

Nature called. He opened the door, relieved himself by a tree in the park, and zipped up. He yawned, stretched, vigorously rubbed his face, and ran his hands through his hair. He thought about Jodi and figured she had already left for work. She'd made it clear last night that she had to get up way before this. Never mind. He'd give her a call later. Meanwhile, he was in desperate need of some more sleep and a hot shower.

He'd just gotten back into the car and leaned to turn the ignition

key when he saw movement in the light at the door. There she was! She was clearly in a hurry, distracted, and yanked a tote bag up onto her left shoulder as she wrestled with her car keys. Here was his chance to talk to her.

Just as she reached her car door and began to insert the key into the lock, he confidently strode up from behind, unceremoniously grabbed her by the shoulders, and flipped her around. As she came around, her left arm flew out defensively—reflexively—scattering some of the items in the bag. A grunt of protest was all she could manage.

As he pushed her back against the driver's door, her head fell back against the roof of the convertible, and her eyes met his. There was instant recognition, replaced a moment later with fear.

Panicked, she yelled "No . . . Don't!" Oh, damn; why did she have to make a scene? He needed her to shut up, and impulsively clamped his right hand over her mouth with more force that he meant. He didn't know his own strength, however, and her small frame crumpled easily under the pressure. Her knees buckled, and her feet lost purchase on the asphalt. Her head struck the outside rearview mirror, and she went limp in his arms.

Oh my God. What? He didn't mean . . . he just wanted to talk . . . he wanted her to know him.

He held her limp body and knew he had to make a decision. There was no time to check for a pulse. He couldn't leave her like this, and he certainly couldn't stay. Dawn was coming, time was running out.

He had to hide. Had anybody heard? Was anybody watching? Jerking his head around, he grappled with Jodi's inert frame, grabbed the straps of her tote bag, and dragged her by the armpits to his car. He had to get out of there—get her out of there—and figure out his next move.

Pulling into the lot, he saw the Mazda right where it was supposed to be. And the lights were on in her apartment. The golf banquet must have wrapped up by now. It wasn't that late; she'd be glad to see him.

He was up the stairs and through the inner door when he thought he heard voices coming from her place. Who was in there with her? He rapped firmly.

"Jodi, I know you're in there! Open up!"

He could have sworn he heard some movement and a hush inside. He knew it was useless to peer through the peephole, but he did it anyway. How dare she not open the door to him? Who was in there?

His fist pounded the door in frustration. Even the thought of another man with Jodi was enough to make his blood surge. He could feel the relentless pulse, the pressure in his veins.

Damn her! She apparently wasn't going to answer. He had no choice but to go back to the car, but he kept his attention squarely on those windows. He saw fleeting shadows, and after a while, the lights went out, but nobody came out that door.

He'd wait all night if he had to.

He was jolted from a dead sleep when the phone rang. Jodi stirred next to him, slamming and groping until she picked up the receiver. He listened to her mumbling, looked at the clock, and knew instantly there would be no chance of another encounter like last night's.

She was rueful, yet gracious, when she rolled over. She looked like a million bucks even now. She told him she had no choice, brushed her lips across his face, and murmured that she looked forward to seeing him later.

As she left, she reminded him there was no rush, but to lock the door after himself. Then she was gone.

Contorted, uncomfortable, with her elbow behind her, the bone pressed hard on a corrugated metal floor. Her head throbbed and she felt an urgency, but couldn't move . . . had to do the news . . . no focus. . . . In and out of consciousness, she was only mildly aware. She struggled to stay awake, but it was impossible.

What was that smell? Where was she? She'd been moved, maybe more than once, or had she dreamt that? This must be a night-mare . . . I have to wake up!

Her swollen tongue craved the relief of water. She was alone, trauma dulling her senses and emotions, but she knew thirst, cold, hunger, hurt. And she knew moments of prayer, flashes of anger at having been put in this position, and instants of hope that his feel-ings for her would override everything else. Of course he'd help her, wouldn't he? She lost all sense of time as the hours wore on, and had no idea if it was day or night.

Yet she knew an odd and wonderful freedom, too. Weightless, she rose to the ceiling and saw her body below.

Was that really her? In dispassionate observation, she saw the wound, her hair matted with blood, the crumpled, childlike torso curled in to itself. She felt no pain: only release, freedom and a perva-sive peace. She was drawn to an all enveloping light and sensed Daddy nearby. He beckoned and she was torn, filled with love and longing to go with him. No Daddy; not yet. Wait for me!

As she re-entered her inert form, she became aware of pain again. This was no dream. How had she reached the ceiling? She wanted to go back there . . . go back to the light. Daddy was waiting for her, and she wanted to go to him.

She knew the oppressive weight once again. Though she neither saw nor heard, her body felt the vibration of heavy footfalls on

wooden stairs. Only semiconscious, she sensed his presence as he entered the room and crossed the floor to her. Was he here to help? She couldn't open her eyes. She felt his hand on her cheek, the press of the rough fabric on her face. She faded again with that awful smell in her nostrils.

JODI'S NETWORK OF HOPE

We see it time and again. Change often results from an experience of grief. If there is a silver lining to this cloud, it may be in the way that Jodi's family and friends have bonded to carry on the memory of her. While remaining protective of their memories, they've also found a way to move forward. They've channeled their grief and loss into a positive new direction, a direction they firmly feel that Jodi would have approved. Thus began Jodi's Network of Hope.

The message on the Network's website is simple and straightforward:

> Jodi's spirit was generous, thoughtful, hard-working and fun loving. She was also selfless when it came to her friends and family and the causes she believed in. She participated in many community events that were near and dear to her while she was with us. We are blessed to have known her, and we do our very best to honor that spirit and continue her good works through the work of Jodi's Network of Hope.

The nonprofit network, created ten years after Jodi's disappearance, is a way for her legacy to live on. It has a twofold focus: providing important safety training for adults and children, and

awarding scholarships to young people in Long Prairie, Minnesota, Jodi's hometown.

Its mission statement reflects the dual focus. The organization hopes to inspire kids to participate in educational opportunities that will help them reach their full potentials (thus the scholarship aspect). But just as importantly, the mission of the network is to promote personal-safety training and awareness for adults and children.

The website offers awareness and advice, and cites familiar, yet alarming, crime statistics. Fully 80 percent of attacks on girls and women are carried out by men they know. These men are typically friends, either intimate or casual; neighbors; relatives; coaches or teachers; or other men the women think they can trust. The sequence always follows a consistent pattern, because attackers have to isolate the victim first:

1. Connect

2. Isolate

3. Attack

Those who teach the safety workshops say that creating even one break in that otherwise consistent process can deter or prevent a tragic situation. Further, it is important for a victim to resist being isolated, because the attacker will be thwarted when he cannot carry out his plans in privacy.

According to the website, stranger abductions account for about 20 percent of the attacks on girls and women, and are considered the most dangerous encounters. Statistics indicate that if an abductor is able to subdue and isolate a victim, the consequences are tragic. Ninety percent of the time, serious sexual assault, rape, disappearance, or death will occur. Again, the sequence is consistent:

1. Abduct

2. Isolate

3. Attack

In these cases, safety-workshop leaders teach that resistance is vital, acting as a valuable deterrent. About 80 percent of women who put up fights against their attackers believed that the simple act of resistance was beneficial and saved their lives.

Jodi's Network endorses two separate safety training programs, one for children, and another called "Not Me!," which is aimed specifically toward women. Volunteers teach the programs in business, group, and school environments.

The network, administered by one of Jodi's childhood pals and supported by family and friends, is growing. Fundraising events are vital to its support, and one of the chief events held each year is an activity Jodi would have loved. An annual golf scramble at the Long Prairie Country Club draws more support every year from Long Prairie and the surrounding business community.

Much of the money raised goes into the rapidly growing educational efforts aimed at fighting attacks on and abductions of young women. But some of the funds are diverted into another equally important aspect of the Network's work: scholarships.

With her resourcefulness and spunk, Jodi Huisentruit might have been called the embodiment of gumption. So a $1,000 Gumption Scholarship was created in 2009 and is awarded to a Long Prairie High School graduate who demonstrates that quality. According to the website, "Grades are important, but we are looking for more than good grades. We are looking for a can-do, never-say-die spirit, and someone who has applied that spirit in positive ways, academically, athletically, creatively and in the community."

In addition to the high school scholarship, the sixth-grade Hope Award was created in 2005, honoring select sixth graders with a $300 scholarship.

To learn more about the foundation's efforts, or to learn more about engaging Jodi's Network of Hope services for your school or group, contact Jodi'sNetworkofHope.com.

ACKNOWLEDGEMENTS

Over the past year or two, this book became a mission of sorts for me. Some might say it consumed every waking moment, and I wouldn't put up much of an argument. But I couldn't have done it without a host of willing partners.

First and foremost, of course, the ultimate thanks for this "mission accomplished" go to Jesus. Here am I, Lord. Use me.

Gary Peterson, longtime newsman: Thanks not only for sharing your voluminous files, scribbled notes on scrap paper, and contacts, but also for being my "front man" in some cases. You opened the door. I couldn't have done it without your inspiration, encouragement, and frequent fact checking.

Gladys Peterson, Gary's wife and professional cohort: Not only are you a willing and talented accomplice with a shrewd eye for detail. Hey, you're a stellar cook, too! Thanks for opening your home to me and for keeping the coffeepot on. I have great respect for the work you two do, and value your friendship.

Josh Benson, now of WFTV-TV, Orlando: you set the pace with your research and legwork. Now that you're in Florida, don't forget your Minnesota roots!

Jerry Koerber, Iowa investigator extraordinaire: Thanks for your valuable input, for tromping through the woods with me, and for sharing some of the crazy stories from your years in law enforce-

ment. Those could fill another book!

Brit Ernst, chief editor: Serial commas aside, I value your input and cherish the pride you hold in me. I like to think I know where you got your talent (and your wanderlust)! And thanks for your continual admonishments to "write the damn book!"

Marilyn Vereide: Thanks for the few well-timed kicks in the butt, along with more advice along the lines of "write the damn book!" You know the difference between hearing and listening, and your support and pep talks are awesome.

Donn, my even-tempered and ever-patient husband: Who else would put up with my hare-brained lifestyle? I couldn't have done it without your ongoing encouragement, support, love, and belief in me. You have great talent for keeping your ears open while studying the backs of your eyelids!

My many friends and family make the journey worthwhile. Thanks for your faith in me; I wouldn't have survived without the support system you provide. You know who you are. Some former television colleagues and friends reappeared at just the right times: it seemed to be engineered that way. I am blessed to have shared the walk with all of you.

And to those I met along the way:

JoAnn Nathe, Jodi's sister, and Maureen Seliski, her cousin: Family knows. Thank you for your trust in me.

Staci Steinman and other longtime friends who became Jodi's family of the heart: You gave me your trust and so much more . . . insight into Jodi's wonderfully quirky personality and character. I never would have gained that kind of revealing perspective in Mason City.

Lanee Good, who straddles the Mississippi: Your name fits!

Bob Link, now of KIMT-TV, Mason City: I'm not the only one who thinks you should have kept a copy!

Doug Merbach, Jodi's former boss, now of KAAL-TV, Austin: Thanks for giving me your blessing to pick up the torch.

Brian Mastre, now of WOWT-TV, Omaha: It came in just under the wire!

N.O'B., the wise woman of the east: Your scenarios kept me spinning.

Jennifer Manion, my practical, talented, and well-spoken editor: Your labors definitely bumped up the quality of this manuscript by several notches!

Lastly, many thanks to those many contributors who chose to remain anonymous, for whatever the reason; your written and verbal contributions proved invaluable. You, too, know who you are, and I thank you. God bless you!

BIBLIOGRAPHY

FindJodi.com

Jodi'sNetworkofHope.com

Stuck in the Box: A Life in Local TV News, Donna McNeeley,
Recommended Books, 2008

"The Dark World of Park Dietz," *John Hopkins Magazine*,
November 1994

"Dr. Park Dietz: Dangerous Minds," *The Independent*, August 16,
2006

"Why Suspects Confess," *FBI Law Enforcement Bulletin*,
March 1991

The Quotable Woman, compiled and edited by Elaine Partnow,
Anchor Books, 1978

The Random House Dictionary, Random House, 2011